Gerhard Richter

D1332465

TATE GALLERY

cover
Abstract Painting [743/1] 1991 (detail) (cat.59)

ISBN 1 85437 084 7

Published by order of the Trustees 1991
for the exhibition of 30 October 1991 – 12 January 1992
© copyright 1991 The Tate Gallery and the authors All rights reserved
Published by Tate Gallery Publications, Millbank, London SW1P 4RG
Reprinted 1991
Edited by Sean Rainbird and Judith Severne
Designed by Caroline Johnston
Typeset by Servis Filmsetting Ltd, Manchester
Printed in Great Britain by Balding + Mansell plc, Wisbech, Cambridgeshire

Contents

7 Foreword

9 Acknowledgments

11 Variations on a Theme: The Painting of Gerhard Richter
SEAN RAINBIRD

22 Retrospective Ahead
STEFAN GERMER

33 Revolution and Restoration: Conflicts in the Making
of Modern Germany
NEAL ASCHERSON

40 Colour Plates

108 Gerhard Richter: Notes 1966–1990

125 Catalogue List

131 Biography

132 Bibliography

138 Lenders

139 Photographic Credits

Foreword

Gerhard Richter is now recognised as one of the foremost painters of his generation and it has been a great privilege to collaborate with him in the preparation of this exhibition. It is more than a decade since the Tate last presented on a solo show with a Continental European or American artist and the chance of working together with Gerhard Richter provides an ideal opportunity to renew and extend the Tate Gallery's commitment to art being made today.

Richter's impact has been singular and widespread. His career has been devoted to exploring the potential of his chosen medium in a variety of surprisingly diverse ways. The apparent opposition between abstract and figurative styles of painting has been suspended through his single-minded exploration of the possibilities of painting as a vehicle of its own realities and as a conveyor of truths about the way we see the world.

This is the first survey of paintings from all stages of Richter's career to be organised in this country and it is particularly appropriate, considering the growth in international awareness of German art over the past decade. It has been selected by Sean Rainbird of the Tate Gallery's Modern Collection.

We are particularly pleased that the artist has agreed to publish a selection of his journal notes, statements and letters to accompany the essays in the catalogue. They supplement our understanding of his art and provide fascinating insights into individual groups of work. We are confident that they will be of lasting interest to visitors at the exhibition.

I should like to thank the many lenders to the exhibition, who have generously agreed to be separated from their paintings for a number of months. Many of Gerhard Richter's paintings are large and some are in a delicate condition. However, several crucial loans of major works have, exceptionally, been agreed for this show. Without the support and the enthusiasm of all the lenders, this exhibition would not have been possible. My thanks go also to the contributors to the catalogue, Neal Ascherson and Dr Stefan Germer, for texts which will provide an invaluable introduction and context for Richter's work. Finally, I am most deeply grateful to the artist for his contribution to the selection of the exhibition and to his thoughtful and active engagement throughout the planning of this show. I am delighted that his exhibition should inaugurate a new series of major exhibitions of work by contemporary artists at the Tate Gallery.

Nicholas Serota *Director*

Acknowledgments

Organising this kind of survey of an artist's work from the last thirty years is inconceivable without the contributions of many people. My greatest thanks are to Gerhard Richter, whose commitment to the exhibition and close involvement with the selection and catalogue have enabled us to assemble a coherent body of work which includes not just major, large-scale paintings, but also smaller works in which many pictorial ideas are first explored. Always generous with his time and advice, this exhibition would not have been possible without Gerhard Richter's support and enthusiasm. I would also like to thank the contributors, Neal Ascherson and Dr Stefan Germer, for their perceptive and engaging texts, and Michael Robinson and Julia L. Bernard for their translations from the German. My warmest thanks go to all the lenders, named and unnamed, who have been generous enough to lend this project their support. Their willingness to lend key works, even where the size of many paintings present problems of transportation and conservation, has enabled us to bring together a most absorbing group of paintings and I am particularly grateful for their understanding and willing co-operation. I would like to thank Elmar Brandt and Karin Herrmann of the Goethe-Institut, London, for their support of the conference that accompanies this exhibition, and to the organisers, Andrew Benjamin and Peter Osborne. Many other people have offered advice, support and assistance in a variety of ways, most particularly Christel Raussmüller, Kasper König, Michael Hue-Williams, Joachim Jacoby, Anette Kruszynski and Mieke Chill.

We enjoyed the closest and most efficient collaboration with the artist's assistants in Cologne, Lydia Wirtz and Angelika Thill, in locating lenders, finding visual material, giving advice on the texts in the catalogue and many other essential tasks. Assembling an exhibition such as this depends largely on successful teamwork. I would like to thank my colleagues in many different departments for their advice and support in the preparation of this exhibition. My special thanks go to the Director, Nicholas Serota, for his advice and encouragement, to Sarah Tinsley and Helen Sainsbury of the Exhibitions Department for their patience and attention to detail in a hectically busy office, to Helen Douglas in the Library for her accurate and comprehensive bibliography, to Iain Bain, Judith Severne, Tim Holton and Caroline Johnston in Publications for their care in the preparation of this catalogue, and finally to colleagues in the Modern Collection, particularly Richard Morphet for his helpful suggestions, and Fiona Robertson, Julia Gardiner and Katy Sallis for all their willing support.

Sean Rainbird

Variations on a Theme: The Painting of Gerhard Richter

SEAN RAINBIRD

I want the painting to be very heterogeneous, but nevertheless, everything has to be of one mould, as contradictory as it may be. The contradictions have to be there but must coexist, must converge.[1]

Determined Heterogeneity

Almost every essay on the work of Gerhard Richter opens with comments concerning the bewildering, not to say confusing, heterogeneity perceived in his painting of the last thirty years. His work seems to move at will between figurative and abstract modes of representation and demonstrates a contrasting variety of methods for applying paint onto canvas. Richter himself has designated certain groups of work, calling them 'figurative', 'constructive' and 'abstract'. But although these broad distinctions in Richter's work can be easily identified, the divisions separating the different groups that comprise his output are never clear cut. Nor are the phases confined to specific periods. Often first appearing tentatively or experimentally in smaller-scale works, a visual idea will frequently appear well before the main body of paintings that relate closely to its theme. Examples of particular types of paint application sometimes appear in pictures years before the ideas are taken up and developed further. Throughout his career, Richter has drawn on his past works as a reservoir of visual objects containing ideas to re-evaluate and redevelop, a self-reflective enterprise centred on painting as a vehicle for reality that continues to surprise.

'Breaks in style as a stylistic principle' is a description by Klaus Honnef[2] of Richter's working method, one that seems geared to the avoidance as a matter of principle of aesthetic categories and of any ideological ties to specific modes, subjects or outside social or political considerations. Richter's rejection of style (as something inherently narrowing, and as marginal to his chief concerns of producing coherent compositions that contain an intrinsic, convincing reality) underlines his unorthodox approach. The artist originates the varied codes of reality generated in all his work, yet ultimately asserts the independent reality of each individual picture, whether based on photographs, or arising independently or by association from colour and structure in the abstract paintings of the last fifteen years.

Richter grew up in Dresden (at that time in the German Democratic Republic) and trained as a painter before leaving for the West two months before the Berlin Wall was erected in 1961. He completed his studies at the Düsseldorf

1 Dorothea Dietrich, 'Gerhard Richter: An Interview', *The Print Collector's Newsletter*, vol.16, Sept.–Oct. 1985, p.128.
2 Klaus Honnef, 'Schwierigkeiten beim Beschreiben der Realität – Richters Malerei Zwischen Kunst und Wirklichkeit', in: *Gerhard Richter: 36 Biennale in Venice German Pavilion*, Venice 1972, p.16.

Academy under Karl Otto Götz. His reasons for leaving the East centred around the stifling of artistic freedom there and the promotion instead of a dominant style in art (Socialist Realism). By contrast, Richter responded to the uninhibited 'unashamedness' of Fontana and Pollock, whose work he saw at the second Documenta in 1959. Forced to question his own way of thinking and working, Richter sought a new beginning in Düsseldorf. He largely destroyed his early paintings from the 1950s and early 1960s, before setting 'Table' (cat.1) at the head of his worklist, a chronological ordering of his output maintained since 1962. Very little of his early work survives, therefore, although a few works have come to light since the reunification process in Germany began – in particular, the recent *Ausgebürgert* exhibition, featuring work by artists who left East for West Germany, contained a nude seen from the back painted by Richter in the late 1950s.

Richter began using photographs as supporting visual material for his painting in the late 1950s after finding they fulfilled his desire to discover visual material which had no art-historical associations. However, it was only during the early 1960s that the photographs themselves became the direct source of his painting. Photography, which initially attracted him through the element of surprise with which its products were so casually and massively consumed in magazines and newspapers, presented him with a series of images from which he realised he could make pictures. They provided both the motif, the muted colour range (an effect which conveniently drained them of emotional weight) and the means for continuing painting during a period when many of Richter's contemporaries gave up painting altogether. While many concentrated instead on happenings, actionism, Fluxus (which interested Richter for the manner in which it radically broadened the concept of art) and other less formal approaches to making art, Richter never seriously considered abandoning painting. He has mentioned in past interviews the importance for his early career of the American Pop artists, particularly Rauschenberg, Lichtenstein (for his anti-artistic mode of depiction) and Warhol, who each around the same time began using mass media photography as an essential component of their pictures' conception and imagery. In Britain, Richard Hamilton followed a similar path, recalling in 1969 'somehow it didn't seem necessary to hold on to that older tradition of direct contact with the world. Magazines, or any visual intermediary could as well provide a stimulus'.[3]

The volume and diversity of photographic material available through television, magazines and newspapers allowed an extraordinary range of visual experiences and events to be relayed to an ever wider audience and redefined the culture of visual representation in painting as well as other fields. When unable to find the unremarkable images he sought from these outside sources, Richter photographed them himself. 'Kitchen Chair' (1965, cat.9) and 'Flemish Crown' (1965, cat.7) are early examples of paintings based on the artist's own photographs (fig.1), later included in his photographic compilation entitled 'Atlas'. At the end of the same decade, Richter began basing figurative paintings exclusively on his own photographs. This is now his normal procedure, as in the candle and skull still lifes of the mid 1980s, the nostalgic recent landscapes and the portrait of Betty (1988, cat.49).

By including his own (as opposed to found) photographs as the starting point

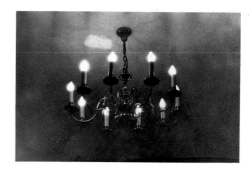

fig.1 Photograph from 'Atlas': taken by the artist

3 Richard Hamilton, 'Photography and Painting', *Studio International*, vol.177, no.909, March 1969, p.120.

fig.2 Photograph from *128 Details from a Picture*, 1978

of paintings, Richter both underlined and significantly augmented the self-reflective element in his working process. This was especially evident in the exchange between the appropriated photograph and the tentative, doubting attitude which defined Richter's approach to each successive painting. The visual perfection of photographs, which challenged him as a painter to emulation, led eventually to a loss of immediacy: in his attempts to get rid of the personal touch, the artist eventually felt a concomitant loss of directness and of the ability of his pictures to move and engage the viewer. Meanwhile, the dominance of the subject matter in photographs caused him to give up using them regularly as models for paintings in the mid 1970s, in preference for allowing structure and colour alone to generate and determine the picture. His visit to Greenland in 1982, where he photographed large numbers of icebergs, resulted not in the expected series of paintings, but in a limited edition book of photographs. This located precisely Richter's deep-seated doubt in his ability to find images that stimulated paintings, indeed to find the starting point for each new painting. His book *128 Details from a Picture* (fig.2), made in 1978, provides further evidence of his examining the efficacy and potential of painting as a vehicle of reality. A single abstract painting was photographed by the artist 128 times from different angles, suggesting in didactic fashion the infinite perceptual possibilities – and myriad realities – arising from each abstract painting that contains not a mimetic representation of reality, but rather an equivalent and equally convincing pictorial reality.

These admissions of despair of finding an effective pictorial reality culminate in their most extreme form in the 'Greys', 'Four Panes of Glass' (1967, worklist no.160), the mirrors (of 1981, fig.3) and grey painted panes of glass of 1977 (worklist nos.415–16). In these works, Richter attempted to structure this insufficiency without recourse to the narrowing constraints of style or any other self-imposed, or outside, visual convention. These works suggest the impossibility of fixing a single image of reality. They thus provoke a response in the viewer to perceive the infinitesimal, possible realities framed by the artist's construction, or in the case of the blanked out grey-painted glass panes, the suggestion and the simultaneous negation of this same potential. These radically reductive paintings and simplified constructions appear to confirm the artist's inadequate and partial view of reality. Only through continuing to make paintings in opposition to this realisation, could the artist challenge this negation and attain a position of hope that might mitigate, or even overcome, this perceived inadequacy and despair.

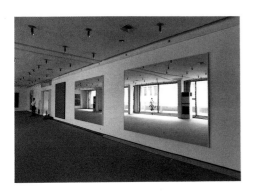

fig.3 Installation shot of 'Mirrors', 1981

The Photographic Readymade

Richter recognised in photography the potential of the readymade object to free painting from its representational function. The readymade, conceived as an art object, was by definition mass-produced and non-unique, and therefore subverted traditional notions of originality and artistic creativity. Duchamp's introduction of the readymade into the discourses of art opened, for Richter, the decisive possibilities that he sought for his painting: pictorial objectification and the denial of the traditional function of the artist as creator. 'The invention of the

readymade seems to me to be the invention of reality, in other words the radical discovery that reality in contrast with the view of the world image is the only important thing. Since then painting no longer represents reality but is itself reality (produced by itself).'[4] His own pictures of the 1960s openly display their source in photographs (readymades) cut from magazines, containing margins, texts and captions which Richter, with minor modifications, integrated into his pictures. But equally this perception of the independent status of the painting as an object later enabled Richter to construct abstract paintings in which an independence from ideological constraints and aesthetic codes is asserted.

Richter's absorption with the possibilities of photography (still evident in the nostalgic mood of his recent landscapes) can be traced in the complex, interwoven relationships between photography, his paintings, prints and his 'Atlas'. 'Atlas' is an open-ended compendium of mounted photographs selected by Richter, which he has used since the early 1960s to stimulate paintings, to note visual ideas and to create imagined environments for pictures (such as the Colour Charts and cloud paintings). He selected them not for their distinctive features, nor for their reinforcement of emerging trends or dominant hierarchies – social, artistic and political – but for their ubiquitous ordinariness, their lack of celebrity. The anonymous titles of his early paintings served to neutralise the photographic content still further. Only very occasionally, as in his highly coloured, easily recognisable portrait of Queen Elizabeth II (1967; worklist no.168, fig.4) ('a significant personality', as he called her) did his concerns appear to overlap with those of the Pop artists. More typically, his photographic images avoided the front-page sensationalism or iconic aspects of Warhol's paintings, masking the identity of the subject or referring indirectly to the newsworthy element (a disaster, narrow escape or murder perhaps) that generated the image in the first place.

Despite this deliberate indifference on the part of Richter, however, it is clear from his choice of photographs (collected in 'Atlas' whether used for pictures or not) that his fascination was not indiscriminate. From the beginning he selected images connected with sex and death, two fundamental human experiences. In the case of the latter category in particular, the most obvious agents of destruction (diving Stuka fighter planes and 'XL 513' cat.2, for example) were collected alongside images that disclosed the fatal events causing their inclusion in magazines and newspapers only subtly, if at all. Frequently the connection becomes apparent only through reading the accompanying text or caption, included by Richter within his painting in order both to draw attention to the contradiction between the juxtaposed visual and written codes for mediating a view on reality and to confirm the mundane sources of his imagery. The calm of the smiling family photographed on the beach in 'Terese Andeszka' (1964, cat.3) is, for example, subverted by the cropped line of text along the bottom edge of the canvas, which reports a miraculous rescue. Here, as elsewhere, Richter allows the text to reinforce his own disavowal of the pictorial content – to cast doubt upon the ability of the photograph to convey any absolute visual truth beyond being a trace that something (without further analysis of what it was) happened in the past which survives in the continuous present of the photograph.

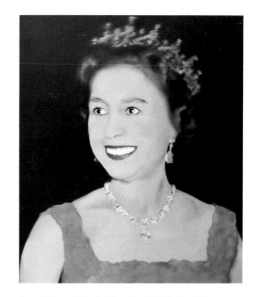

fig.4 'Queen Elizabeth', 1967, Wiesbaden Museum

[4] Gerhard Richter, journal notes from 30.5.90, see p.124 below.

The Soul of the Model

Richter believes that neither personal familiarity with nor direct observation of the depicted subject are relevant to the process of painting. 'I believe that a painter has no need to see or know the model, and that there is not an aspect of the "soul", the being or the character of the model that requires expression. A painter has no need of "seeing" the model in a particular, personal manner, as a portrait cannot be any more like the model than being a likeness. Thus it is much better to paint a portrait from a photograph, because one is not painting a particular person, but rather a picture that has nothing in common with the model. The similarity with the model in one of my pictures is not merely only apparent and unintentional, it is also completely useless.'[5] With few exceptions, Richter determinedly withheld (through neutral titling and a levelling of celebrity to anonymity) information that would excite curiosity about the image's content. Thus, Brigitte Bardot is treated in 'Mother and Daughter (B)' (1964, worklist no.84) not as a cinematic icon, but as a family member, in keeping with the general character of the family and crowd photographs upon which most of Richter's contemporaneous pictures were based.

Richter made no judgements about the transferral process from photograph to the final image on canvas. Personally, he eschewed photomechanical processes, but suggested that all artists who based pictures on photographs were involved as painters, whether the method of transferral was based on collage (Hamilton, Vostell), silk screen (Warhol, Rauschenberg) or any other means. Richter saw nothing unusual in his methods of transferral through squaring the enlarged photographic image on to the canvas and in later using an episcope (like Hockney). Although admitting that the photographs' subject was of first rank importance to his pictures – after all, an apparently heterogeneous selection, preferring the banal and unsensational, was made with conscious indifference – Richter from the beginning questioned the aura of meanings that traditionally attached to content. The 'personal' dimension is entirely absent from his pictures of his then dealer Alfred Schmela, likenesses painted in 1964 using passport photographs as models (worklist nos.37/1–3). His determinedly neutral stance towards the subjects of his paintings and a need to counteract the intrusive dominance of the pictorial subject within them, enabled him to deflect attention to what he held to be the more essential aspects of painting in his work of the 1970s and beyond. The breakdown of figurative dominance began with the Townscapes and small-scale abstract, 'smeared' paintings of the late 1960s, before developing to the extreme position of the Grey Paintings from the mid 1970s. Beyond this, in the 'soft' and 'free' Abstract Paintings of the seventies and eighties, Richter rediscovered the potential of the pictorial subject in richly coloured, informal structures.

5 Dieter Hülsmanns, 'Das Perfekteste Bild: Ateliergespräch mit dem Maler Gerd Richter', *Rheinische Post*, 15 March 1966.

Painting as Vehicle for Reality

Initially, photography solved for Richter a number of pictorial problems linked to the long history of painting, which did not seem to him of primary interest. These consisted in particular of questions of form, composition, and qualitative judgements arising from choice of subject matter. Through assembling and depicting photographs, Richter felt able to eliminate traditional areas of artistic invention from the process of painting – consciously to withdraw his personality, to negate what he believed to be a false idea of 'creativity' and to establish a detached stance towards his pictures. Photography supplied pictures unconnected to him in their origination, possessed of their own intrinsic objectivity, free of connotations.

While admitting that photographic processes themselves were open to manipulation (through retouching, faking, etc.) Richter attributed to the photographic medium a greater objective realism than he could achieve in painting from the model. In 1966 he stated that by painting after photographs he 'avoided a certain stylisation that is unavoidable in painting after nature'[6] and which he was determined to avoid. The lack of codes determining the nature of the photographic image, beyond the technical manipulations of aperture, focus and development required to fix it, presented Richter with a paradigm to apply to making pictures. 'There was no style, no composition, no judgement. It liberated me from personal experience. There was nothing but a pure picture. Therefore, I wanted to possess it and show it – not to use it as a means for painting but to use painting as a means for the photograph'.[7] Painting could aspire to the condition of photography, providing not merely a simulacrum of reality, but by becoming a reality itself. His brushing across the wet surface of his early works, thus distorting and blurring the clarity of the image, and the added tints of colour in some of his paintings of the early 1960s (similar in intention to photographic retouching) underlines Richter's preoccupation with painting achieving both the objective, uncoded status he perceived in photographs and his indifference to mimetic codes of representation, even early in his career.

His brushstrokes, while undoubtedly and irrevocably associated with the hand that made them, deflected the attention they drew to themselves. Rather than expressing the manual engagement of the artist, they focused instead on the processes forming the completed painting, the structure of the canvas, the versatility of the medium, assisting the painter in his striving for anonymity behind his craftsmanship while simultaneously demonstrating a clear motivation. His recent Abstract Paintings extend these concerns, by creating an equally concrete reality, although one without an equivalent in the natural world, which allows colour and structure to stand alone and visual ideas to emerge only through association – mainly indicated through the titles, such as with the 'Forest' paintings (1990, cats.54–7), or 'July' (1983, cat.37).

In their making, the Abstract Paintings continue Richter's strategy of self-effacement behind the material processes that form his paintings. Since 1980 he has used spatulas of different lengths to spread the paint evenly across the canvas. Although this shift in working practice, now Richter's dominant mode of paint application, marks a caesura in his work, the beginnings of this approach can be traced back through his earlier work, less as a logical progression, but

6 Dieter Hülsmanns, 'Das Perfekteste Bild: Ateliergespräch mit dem Maler Gerd Richter', *Rheinische Post*, 15 March 1966.
7 Rolf Schön, 'Interview', in: *Gerhard Richter: 36 Biennale in Venice German Pavilion*, Venice 1972, p.23.

fig.5 Studio photograph of '1024 Colours' (cat.28) in progress, Düsseldorf 1973

rather through the similar qualities of paint distribution achieved by other means. Already in the individual brushstrokes of the impastoed Townscapes, Alpine landscapes and Inpaintings, one can perceive the germ of Richter's later technique, where channels or skeins of paint merge colours along the path of individual brushstrokes, alternately losing their individual identity, subsumed within the overlayerings of the whole, or remaining visible on the surface of the canvas. With a noticeable increase in skill dependent on the level of experience, each gesture dictated the mix and distribution of colours, more or less control being exerted over the results, in a manner that required a complex net of overlayerings and overpainting as a condition for arriving at the finished image.

A series of subjective 'yes/no' decisions during the painting process determined the artist's progress toward a final affirmative decision that the painting can go no further and was thus completed. This advance is based on procedures of refinement, obliterative layering and overpainting that demand a constant exchange between construction and destruction, composition and anti-composition as a way forward. Richter's paradoxical position, of seeming helplessness in attaining convincing compositions and a simultaneous wilfulness as the motivation for achieving just that, are well illustrated by the surprising underpaintings in many pictures. The science-fiction, perspectival patterns underlying the four 'Forest' paintings (illustrated as works-in-progress p.103) indicate the dissatisfactions, the inner resistance Richter needs to overcome and the strength of purpose he needs to generate, in order to complete a painting of lasting interest. Richter has readily admitted to maintaining only partial control during the process of painting and acknowledges the importance of chance as a central component in his working method. Chance plays a crucial role in the painting process, he concluded, 'in the way in which it destroys, while at the same time being constructive.' 'It creates', he concluded, 'something which, naturally, I would gladly have devised and done myself . . . I've come to see the necessity for chance as a universal condition, and I regard it as thoroughly positive.'[8] Chance plays a decisive part, not merely in the aleatory method Richter devised for distributing the sequences of colours in his Colour Charts (cat.28 and fig.5), themselves an attempt to demonstrate that any colours may be arbitrarily combined and still retain overall, convincing coherence as a work of art – rather like achieving a convincing sequence of random numbers to win a game of bingo.[9] But the role of chance is no less decisive in the complex overlayerings evident in the most recent Abstract Paintings where the artist retained only partial control over the distribution of paint while working with broad spatulas which gradually obliterated underdrawings quite unrelated to the works' final appearance. This conscious relinquishment in matters of traditional artistic control is counteracted by a variety of strategies: the constructive, or structured elements of individual compositions; or, in the case of 'Abstract Painting' (1990, cat.53) and other works since 1988, the deliberate gouging or scraping down of channels of paint towards the concluding stage of painting. These energetic interventions convey a profound personal involvement and reintroduce a direct and emotional engagement with the process of painting.

8 Benjamin H.D. Buchloh, 'Interview with Gerhard Richter', in: *Gerhard Richter: Paintings*, Art Gallery of Ontario, Toronto 1988, p.26.
9 Klaus Honnef, 'Schwierigkeiten beim Beschreiben der Realität – Richters Malerei Zwischen Kunst und Wirklichkeit', in *Gerhard Richter: 36 Biennale in Venice, German Pavilion*, Venice 1972, p.15; the author quotes a comment from the artist about the analogy of a random selection of numbers in a bingo game as a way of describing the distribution method of colours in his Colour Charts.

Worklist as Structure

> I like to compare my process of making art to the composing of music. There, all expression has been subjugated to the structure and is not simply shouted. That is why my paintings take such a long time. I interrupt the progress of one painting and return to it after a longer pause to make sure that the painting will not be all in one mood, but be more carefully controlled.[10]

Richter's worklist, maintained since 1962, first published a decade later and comprising a chronological ordering of his entire production including some works subsequently destroyed by the artist, now stands at well over seven hundred works. Of these, many are multipart and still more are subsumed within the list as subdivisions of single numbers. The ordering principle of the artist's works, while not denying his role as originator, serves paradoxically to objectivise the artist's individual contribution, giving equal value and weight to widely differing works. The self-conscious nature of the categorising list can be seen in Richter's self-referential offset print of 1969 'Picture Index' (fig.6), depicting three columns of core information about his worklist up to that point. The universal inclusion demanded as a premise of the worklist operates in opposition to the distinct subgroups within Richter's oeuvre, which resist analysis as individual units in their relationship to the whole. A common perception among commentators, and one Richter has on occasion brusquely rebutted, is that the volume and the thematic variety of his output prevents critics and viewers forming a view of the parameters governing this extensive body of work.[11] Beyond the fact, that is, that the majority of his work is in oil and on canvas and that these are without exception quadrilinear.

Subgroups are easily identified by their linked characteristics – photopictures, townscapes, colour charts, greys, seascapes, for example – yet these characteristics are generally perceived in their differences to one another, rather than by what links them to a common core of artistic activity. This perception of a widely differing set of visual products has enabled Richter's oeuvre to be segmented, and the individual groups of work judged distinct from one another and obstructing a focus upon the artist as originator in terms of his work as a whole. Yet the centrality of the artist as originator of the work, however heterogeneous, is never in doubt. Not merely through their common signature and provenance, but also in their unmistakeable characteristics, Richter's paintings and his modes of working are instantly recognisable. Within a wider context, his means have been little emulated and suggest an irreducible reservoir of identity that mark them as products of one hand, whatever their outward differences and opposition to stylistic orthodoxy.

The manner in which he has tested the parameters of oil painting in terms of technique, form and content, allied to his willing submission to the limitations and challenges imposed by his chosen medium and format, has attracted many commentaries examining his role as an avant-garde artist and in particular as a painter of post-modern heterogeneity beginning his career during the final epoch of late modernism. To some critics, his insistence on painting as a vehicle for artistic activity is interpreted as a stubbornly reactionary stance during an era

10 Dorothea Dietrich, 'Gerhard Richter: An Interview', *The Print Collector's Newsletter*, vol.16, Sept.–Oct. 1985, p.128.
11 Gerhard Richter, letter to Walter Grasskamp, in 'Gerhard Richter 18 Oktober 1977: Presseberichte', Museum für Moderne Kunst und Portikus, Frankfurt 1989, p.111.

fig.6 'Picture Index', lithograph, 1969

No.	Title	Year	Size		No.	Title	Year	Size		No.	Title	Year	Size
1	Tisch	1962	90 x 113		82	Drei Geschwister	1965	150 x 130		163	Großes Wellblech	1967	260 x 200
2	Eisläuferin	1962	135 x 110		83	Große Personengruppe	1965	170 x 200		164	Portrait Wunderlich	1967	200 x 200
3	Hitler	1962	110 x 130		84	Mutter und Tochter (B.)	1965	180 x 110		165	Kl. Akt	1967	115 x 75
4	Trockner	1962	105 x 70		85	Onkel Rudi	1965	87 x 50		166	Gitter	1967	150 x 150
5	Sargträger	1962	135 x 180		86	Frau Niepenberg	1965	140 x 100		167	Gewölk	1967	180 x 150
6	Fußgänger	1963	140 x 176		87	Mutter und Kind (S.)	1965	120 x 150		168	Königin Elisabeth (bunt)	1967	70 x 50
7	Hirsch	1963	150 x 200		88	Kuh II	1965	155 x 110		169	Douplata, Mailand	1966	277 x 292
8	Schloß Neuschwanstein	1963	190 x 150		89	Liegestuhl II	1965	100 x 200		170	Stadtbild M 1 - 8	1968	je 45 x 90
9	Tote	1963	100 x 150		90	Schwimmerinnen	1965	200 x 160		171	Stadtbild Ma	1968	277 x 292
10	Alster	1963	60 x 80		91	Kind auf einem Esel	1965	65 x 60		172	Stadtbild Ha	1968	180 x 150
11	Nase	1963	78 x 60		92	Frau, die Treppe herabgeh.	1965	200 x 130		173	Stadtbild Mü	1968	180 x 160
12	Hände	1963	30 x 45		93	Krankenschwestern	1965	48 x 60		174	Stadtbild P 1 und P 2	1968	je 102 x 92
13	Bomber	1963	130 x 180		94	Horst mit Hund	1965	80 x 60		175	Stadtbild P	1968	200 x 200
14	Sekretärin	1964	150 x 100		95	Zwei Frauen mit Torte	1965	76 x 100		176	Stadtbild D	1968	200 x 200
15	Kuh	1964	130 x 150		96	Mann mit zwei Kindern	1965	80 x 110		177	Stadtbild F	1968	200 x 200
16	Oswald	1964	130 x 110		97	Küchenstuhl	1965	100 x 80		178	Stadtbild 1 - 8	1968	je 53 x 43
17	Schärzler	1964	100 x 130		98	Stuhl in Profil	1965	90 x 60		179	Gebirge 1 + 2	1968	je 102 x 92
18	Stukas	1964	80 x 80		99	Kl. Stuhl	1965	88 x 50		180	Wolken	1968	140 x 150
19	Mustangs	1964	88 x 150		100	Herr Heyde	1965	55 x 65		181	Gebirge (Himalaja)	1968	200 x 160
20	XL 513	1964	110 x 130		101	Roter Akt	1965	40 x 30		182	Gebirge (Fl-Pass)	1968	200 x 160
21	Vögel	1964	150 x 190		102	Kl. Landschaft	1965	50 x 40		183	Gebirge (Schweizer Alpen)	1968	200 x 160
22	Ferrari	1964	145 x 200		103	Portrait Dwinger	1965	110 x 80		184	Gebirge (Zeichnung)	1968	200 x 160
23	Terese Andeszka	1964	170 x 150		104	Portrait Laszlo	1965	90 x 70		185	Gebirge (Zeichnung)	1968	200 x 160
24	Christa und Wolfi	1964	150 x 130		105	Familie Hötzel	1965	78 x 50		186	Gebirge (Pyrenäen) Z.	1968	150 x 180
25	Helen	1964	110 x 75		106	Mädchen mit Sonnenbrille	1966	105 x 70		187	Gebirge (Engadin) Z.	1968	80 x 110
26	Familie n.a.H.	1964	150 x 180		107	Portrait Liz Kertelge I	1966	105 x 70		188	Alpen	1968	200 x 150
27	Philipp Wilhelm	1964	150 x 130		108	Portrait Liz Kertelge II	1966	65 x 70		189	Alpen (5-teilig)	1968	200 x 650
28	Frau Marlow	1964	77 x 96		109	Brautpaar (blau)	1966	50 x 50		190	Mondlandschaft I	1968	200 x 150
29	Frau mit Schirm	1964	160 x 95		110	Zero - Rakete	1966	92 x 73		191	Mondlandschaft II	1968	200 x 260
30	Familie	1964	150 x 180		111	Mädchen im Sessel (lila)	1966	90 x 110		192	Schlieren 1 + 2	1968	je 200 x 260
31	Renate und Marianne	1964	135 x 170		112	Turnerin	1966	90 x 70		193	Wellblech	1968	200 x 200
32	Prinz Sturdza	1964	150 x 110		113	Gartenarbeit I	1966	130 x 150		194	10 abstrakte Bilder	1968	je 50 x 50
33	Arnold Bode	1964	170 x 110		114	Gartenarbeit II	1966	135 x 130		195	Weinernte	1968	95 x 115
34	C. Deresl	1964	90 x 90		115	Zypernmandelgras	1966	130 x 150		196	Trinkende Frau 1 - 4	1968	je 95 x 115
35	Familie E. am Meer	1964	150 x 200		116	Sammler mit Hund	1966	90 x 90		197	Frau W. mit Kindern	1968	200 x 160
36	Liegestuhl I	1964	60 x 95		117	Familie Liechti	1966	68 x 85		198	Weihnachtsmarkt	1968	67 x 87
37	Schmela 1 - 3	1964	100 x 125		118	Gruppe unter Palmen	1966	120 x 150		199	Korsika I	1968	86 x 91
38	Rokokotisch	1964	90 x 70		119	Versammlung	1966	160 x 115		200	Korsika II (Sonne)	1968	86 x 91
39	Verwaltungsgebäude	1964	98 x 150		120	Reisebüro	1966	150 x 130		201	Korsika III (Schiff)	1968	86 x 91
40	Familie Schmidt	1964	125 x 150		121	Jagd	1966	160 x 180		202	Brücke (am Meer)	1968	98 x 102
41	Portrait Dr. Knobloch	1964	100 x 90		122	Liebespaar im Wald	1966	170 x 200		203	Durchgang	1968	200 x 200
42	Portrait Schniewind	1964	210 x 56		123	Tänzerinnen	1966	160 x 200		204	Fenster SB 1 4-teilig	1968	200 x 400
43	Turmspringerin I	1965	190 x 110		124	Helga Matura	1966	180 x 110		205	Fenster SB 6 4-teilig	1968	200 x 400
44	Turmspringerin II	1965	80 x 80		125	Helga Matura mit Verlobtem	1966	200 x 100		206	Arkade SB 5 4-teilig	1968	200 x 400
45	Neger (Buba)	1965	145 x 200		126	Matrosen	1966	150 x 200		207	Fenstergitter GB 4 5-teilig	1968	200 x 300
46	Gr. Sphinx von Gise	1965	150 x 170		127	Scheich mit Frau	1966	140 x 145		208	Säulen SB 3 7-teilig	1968	205 x 700
47	Sphinx von Gizeh	1965	120 x 150		128	Zwei Liebespaare	1966	115 x 160		209	8 kl. Schattenbilder	1968	je 50 x 55
48	6 Oelskizzen	1965	50 x 50		129	Hirsch II	1966	130 x 150		210	2 kl. Türen	1968	je 50 x 50
49	Mailand: Dom	1965	130 x 130		130	Acht Lernschwestern	1966	je 95 x 70		211	Korsika IV (Haus)	1969	115 x 150
50	Phantom Abfangjäger	1965	140 x 190		131	Große Pyramide	1966	190 x 240		212	Korsika V (Feuer)	1969	60 x 85
51	Rotes Collier	1965	100 x 120		132	Mädchen auf einem Esel	1966	65 x 70		213	Alpen II 3-teilig	1968/69	200 x 450
52	Korridor	1965	150 x 135		133	Volker Bradke	1966	150 x 200		214	Alpen (Stimmung)	1969	200 x 200
53	Ägyptische Landschaft	1965	150 x 165		134	Ema (Akt auf einer Treppe)	1966	200 x 130		215	Waldstück (Okinawa)	1969	174 x 124
54	Vorhang I	1965	200 x 180		135	Zehn Farben	1966	135 x 120		216	Waldstück (Chile) I - III	1969	je 174 x 124
55	Vorhang II (weich)	1965	200 x 190		136	192 Farben	1966	200 x 150		217	Stadtbild TN 1,2,3	1969	je 174 x 124
56	Vorhang III (hell)	1965	200 x 195		137	Zwölf Farben	1966	60 x 55		218	Stadtbild SL 1,2,3	1969	je 124 x 124
57	Vorhang IV	1965	200 x 190		138	Fünfzehn Farben	1966	200 x 150		219	Stadtbild 1,2,3	1969	je 124 x 124
58	Vorhang (Morandi)	1965	90 x 65		139	6 kleine Farbtafeln	1966	je 70 x 65		220	kl. Landschaft am Meer	1969	71,5 x 105
59	12 Röhren	1965/68	170 cm		140	18 einzelne Farbtafeln	1966 ca.	250 x 450		221	Landschaft bei Hubbelrath	1969	100 x 140
60	Portrait Klinker	1965	100 x 80		141	Sechs gelb	1966	200 x 170		222	Wilhelmshaven	1969	50 x 70
61	Neger II	1965	150 x 180		142	Sechs Farben	1966	200 x 170		223	Grünes Feld	1969	99 x 125
62	Telefonierender	1965	70 x 150		143	3 Grautafeln	1966	je 200 x 150		224	15 Skizzen	1969	je 70 x 70
63	Mädchenkopf (verw.)	1965	75 x 100		144	10 große Farbtafeln	1966	250 x 950		225	Königsallee (grau)	1969	60 x 70
64	Ringcanzali	1965	68 x 77		145	Lachmann	1967	45 x 55		226	Vierwaldstätter See I - IV	1969	je 120 x 150
65	Portrait Ema	1965	105 x 90		146	Lampe	1967	90 x 90		227	Landschaft mit kl. Brücke	1969	120 x 150
66	Waldstück	1965	150 x 155		147	Zwei Frauen (Jalousiebild)	1967	200 x 200		228	Ruhrtalbrücke	1969	120 x 150
67	zwei Fiat	1965	130 x 200		148	Osterakte	1967	140 x 150		229	Eifellandschaft (Straße)	1969	120 x 150
68	Alfa Romeo (mit Text)	1965	150 x 155		149	Studentin	1967	105 x 95		230	gr. Eifellandschaft	1969	150 x 200
69	Kahnfahrt	1965	150 x 190		150	Spanische Akte	1967	160 x 200		231	Wolken 1 + 2	1969	je 200 x 150
70	Ungeschlagene Papiere	1965 ca.	25 x 30		151	FlMädchen	1967	90 x 100		232	Zeichnungen 1 - 6	1969	je 200 x 150
71	Portrait Müller	1965	80 x 60		152	Akt (bunt)	1967	105 x 95		233	Seestück (Gegenlicht)	1969	200 x 200
72	Portrait Ströher	1965	80 x 60		153	Schwestern	1967	65 x 75		234	Seestück (Welle)	1969	200 x 200
73	Frau mit Kind (Strand)	1965	150 x 110		154	Badende (braun)	1967	160 x 200		235	Seestück (bewölkt)	1969	200 x 200
74	Kissen	1965	100 x 108		155	Diana	1967	200 x 190		236	Wattlandschaft	1969	67 x 87
75	Klorolle I - III	1965	65 x 70		156	Gymnastik	1967	110 x 80		237	Landschaft	1969	80 x 100
76	Wiesenfeld	1965	150 x 180		157	Olympia	1967	200 x 130		238	Landschaft mit Wolke	1969	91 x 86
77	Flämische Krone	1965	90 x 110		158	5 Türen I	1967	je 205 x 100		239	Seestück 1 - 2	1969	je 200 x 200
78	Tiger	1965	140 x 150		159	5 Türen II	1967	je 250 x 110		240	Seestück 1 + 2	1969	je 170 x 170
79	Motorboot	1965	170 x 170		160	4 Glasscheiben (Objekt)	1967	je 190 x 100		241	Seestück 1 + 2	1969	je 140 x 140
80	10 Oelskizzen	1965/66	45 x 45		161	Wellblech (8-teilig)	1967	110 x 640		242	Wolke	1969	100 x 80
81	Portrait Prof. Zander	1965	150 x 140		162	Wellblech (2-teilig)	1967	200 x 320		243	Abendstimmung	1969	120 x 150

when art's practices and materials have inalienably altered and expanded. At the same time art criticism has expanded to embrace discourses based on many disciplines outside of traditional art-historical discourse. Yet within the self-imposed discipline – indeed personal necessity – of painting, Richter continues to fascinate, irritate and confuse.

'Confuse', in one of its rarer, historical meanings, provides both the clue and underlines apparent paradoxes within Richter's work. Aside from indicating a bewildering mix (the definition most frequently applied to Richter's output), it also embraces the meaning simply of mixture and blending. Not in the sense of disorder or disorientation, but as a co-mingling of strands. An analogy from the sphere of music can help in our seeing Richter's output within a broad and unifying framework, as was suggested by the artist in 1984 in a partly unpublished conversation with Zdenek Felix.[12] As with the modern-day symphony orchestra (or indeed, grand piano), perfected in its instrumental development and range and scarcely modified since the late nineteenth century, Richter maintains a determined loyalty to artistic means that were paradigmatic and predominated until roughly the same time. Then, both conventions were called into question and in part superseded by radical questioning of practice

12 Interview with Zdenek Felix, part published, part audible on soundtrack of the video 'Kein Wagner-brei. Gerhard Richter', made by V. Chappey and D. Zacharopoulos, Paris 1984.

and originality in the early twentieth century. However, the conventions of both painting and music-making with an unchanged ensemble of instruments throughout the twentieth century, continue to resist their apparent obsolescence as vehicles for artistic expression. The function of the essentially nineteenth-century orchestral structure still serves in the interpretation of wide areas of contemporary music (Birtwistle, Nono, Penderecki, Reimann, etc.) in opposition, it would seem, to the technical advances offered by electronic instruments and the tonal flexibility of computerised and synthesised sound. We might find here a parallel with Richter's capacity to find an expressive potential for painting during three decades when its efficacy and suitability was widely questioned, substituted or negated.

Within the confines of this analogy linking the survival of the orchestra with the survival of painting, the range of instrumentation is limited in each discipline. In his paintings, Richter, as indicated above, chooses traditional formats – rarely exaggerating or distorting the rectangular canvas shape. The edges of his pictures (usually unframed or only minimally battened) function in a way Richter has linked to music: 'The painting ends there. That is the frame, within which one works. In music it is time, one hour or five or a two-minute piece. Everything needs a measure just as the open door has a frame, as Musil said, otherwise it would be without boundaries.'[13]

Richter also chooses a carefully circumscribed although intrinsically flexible range of paint applications. Initially this involved using dry or wet brushes of differing widths and stiffness. Latterly he has also used long spatulas with straight though flexible edges to load and distribute paint in sweeping movements of the arm and upper body. If canvas, brushes and spatulas might find a parallel with the score and system of notation in music, then colour is what determines the quality of what in music would be touch, timbre, tone and register: the variety of responses that can be drawn from the finite instruments of the orchestra, aware all the time that means of assimilating new sounds (such as producing percussive effects with the soundbox of stringed instruments) continue to expand even where the actual development of the instruments has remained static for the last hundred years. In a recent interview, in which he was asked about the contrasting applications of paint in his pictures, Richter confirmed a parallel strategy to the production of diverse musical sounds from different instruments. 'I think that this comes from music. It would be like playing music with one instrument only. When you sound a note on the violin it sounds totally different than played on a trumpet, etc. It would be too boring to use only one instrument.'[14]

With colours on the canvas, their distribution and texture form the unique character of each painting, setting it both in context and apart from others that may be distinct or related (though not necessarily adjacent in conception or execution). It is particularly with his abstract paintings that Richter has indicated an affinity to musical composition. Once the natural visual dominance of the object is removed, new possibilities emerge, enabling a convincing picture to be generated without a readily identifiable subject: 'Objects have too much importance – they give the painting a specific direction. Colour and structure are not given a chance to stand on their own. Because abstract painting does not represent – there is no man or table or whatever – one must only make sure that

13 Dorothea Dietrich, 'Gerhard Richter: An Interview', *The Print Collector's Newsletter*, Sept.–Oct. 1985, vol.16, p.132.
14 Ibid., p.131.
15 Ibid., p.130.

fig.7 'St John' (cat.48), 1988, Tate Gallery

the relationship of colour and structure is right, like composing music, like Schönberg and Mozart.'[15]

Extending the analogy with music one stage further, as Zdenek Felix suggests, the different groups of work that overlap and comprise Richter's output, could be seen as corresponding to the various highly contrasting types of musical composition – études, sonatas, concertos, fugues, etc. – which conglomerate to form the composer's own 'Verzeichnis' or worklist, without inexorably giving rise to the type of disorientation that frequently confronts the viewer in a survey of paintings by Gerhard Richter.

Viewed in the light of this musical analogy (and one that does not attempt to find philosophical or visual equivalences of title, content or form, as in the work of Kandinsky or Klee), Richter's worklist – at once a most personal and public confirmation of the presence of a single originator behind an assembly of contrasting works – provides for an overarching unity, the defining parameter within which to assess his work. Richter's cumulative worklist, compiled with rigorous exactitude, does moreover, reflect a credo of unabashed openness, making no public differentiations about quality and laying equal emphasis on each single object in the list. With its tendency towards ordering, concurrent with the making of individual pictures, the artist signals a very different, non-hierarchical intention to that embodied in the catalogue raisonné, a more familiar tool of art history. Richter's worklist (in its initial form) avoids the attendant scholarly apparatus of retroactive compilation, logging as it does, not the reception of individual objects in exhibitions, the literature and collections, but giving solely a chronological history of origination rather than one of context beyond the studio walls.

Richter remains, then, an artist whose determinedly heterogeneous output resists a unified appraisal even while it submits to overall classification. Yet the perplexing scope of his work regains a measure of consistency when the motivation for his paintings becomes clear: a consistent attempt to construct a pictorial reality that does not seek to regain the 'loss of centre' in painting, perceived by Hans Sedlmayr in his book of that title, but one that, acknowledging the fundamental uncertainties resulting from this loss, asserts a central role for the artist within an inherently pluralistic modern society.

Retrospective Ahead

STEFAN GERMER

Translated from the German by Julia L. Bernard and Michael Robinson

It is obviously not sufficient to repeat as an empty statement that the author has disappeared. It is equally insufficient to repeat endlessly that God and Man have both died the same death. What one must do instead is to define the space opened up by the disappearance of the author, to investigate the distribution of gaps and cracks therein, and to explore the unoccupied spaces and functions revealed by these disappearances.

Michel Foucault, '*Qu'est-ce qu'un auteur?*'[1]

I

It is no accident that retrospectives occupy a prominent position in contemporary culture. Lining up an artist's oeuvre along a chronological continuum in such a fashion seems better suited to refuting the assertion of the 'death of the author', to reintroducing concepts like 'unity of oeuvre', and perhaps even to restricting understanding of an artist's output to retelling the biography of its creator, than any other procedure. Retrospectives are an institutional response to the fact of the author's function having fragmented and dispersed: they are a disciplining technique which aims at facilitating the public's orientation with respect to contemporary art by proffering it the fiction of an artistic personality. But assembling pictures under the heading of the artist's name can as easily hinder as enhance understanding of each individual work, for the series will always triumph over the experiential event. Even before confrontation with an individual picture has begun, attention begins to shift instead onto the artist's entire oeuvre or his personal situation.

Nevertheless, perhaps a retrospective is precisely the right context within which to approach Gerhard Richter's work. For his production has retrospective aspects, which cannot be explained by recourse to a concept of biographical continuity, but rather have to be understood as a reflection of the artist's sophisticated level of awareness of his medium's historical situation. Richter's work can be seen as a painterly reply to Hegel's assertion that art – as an expression of the spiritual – is a thing of the past; for aside from providing unmediated pleasure, artworks also call upon our judgement, so that we 'subject a work of art's content, its representational means and the appropriateness or inappropriateness of these to our thoughtful contemplation.' Hegel concluded: 'Therefore, the *science* of art (art history) is to a greater extent necessary in our time than during previous periods when art in itself was still fully satisfying. Art invites us to intellectual contemplation, directed not to the end of conjuring such art back into existence, but rather in order to scientifically establish what art had been.'[2]

1 *Bulletin de la société française de philosophie*, July–Sept. 1969, p.81.
2 Georg Wilhelm Friedrich Hegel, *Vorlesungen über die Ästhetik. Theorie Werkausgabe*, vol.13, Frankfurt am Main 1979, pp.25–6.

Richter is in accord with Hegel's description of the situation and at the same time contradicts it. If the philosopher means to suggest replacing artistic production with art-historical reflection, and thereby acknowledge the triumph of philosophy over painting, then the painter would demonstrate that not only can his hastily dismissed medium survive this philosophical funeral invitation, but it can even challenge philosophy's axioms and cast its self-righteousness into doubt. In other words, Richter's work also invites us to engage in intellectual contemplation, imposing this not as a philosophical discourse but rather intending it as a graphic indication of what art *could* be following its dismissal by philosophy. Richter's painterly reflection on the possibilities of painting follows Hegel's thinking both in its construction and in principle: it is structured historically as well as systematically, and dialectically conceived. It is not arbitrarily that Richter insists upon the primacy of contemplation; for he is well aware that, because it cannot be appropriated by reflective discourse, such prioritising of individual experience poses the greatest provocation to the generalising assumptions of philosophy.

Rather than aiming at a retrospective construction of Richter as author, this essay will engage in discussion of retrospection as a central feature of his artistic production, investigating in turn this notion's four components: its historical awareness, its systemic nature, its dialectical character, and its insistence upon directness of apprehension.

II

Richter's statement that painting requires obsession, an inner conviction of a kind that could convince us that painting might help to change mankind, is often quoted. Likewise frequently cited is his warning that anyone not sharing his conviction would do better to keep his hands off painting, since painting considered in itself is a completely idiotic activity. These statements of Richter's combine the avant-garde's previous pretension to 'change the world' by means of art, with the sceptical recognition that today this point of view can only be maintained on an individual basis. Together, faith in painting's capabilities and doubt of its possibilities do not constitute solely a personal credo, but they also describe the historical situation within which the painter works. Behind Richter's words lies an historical recognition that in our century painting has become a superfluous medium. Modern painting is always too late – whether *vis-à-vis* other media, or because of history's increasing velocity, or even with respect to previous alterations of its own medium.

Because of its connection with craft, painting is a medium that operates slowly. Yet this only became apparent and problematic with the development of more rapid media based upon mechanical processes, forcing painting into a competition in which it would inevitably be defeated. Late nineteenth and early twentieth-century avant-garde painters attempted to escape from this pressure of competition, either through concentrating on the spiritual dimension of art-making, or on physical aspects such as facture, texture and gesture – thus opening up to their medium domains inaccessible to mechanical reproduction.[3] These two strategies successfully asserted the medium's autonomy, but they

3 Meyer Schapiro, 'The Liberating Quality of the Avant-Garde', *Artnews*, vol.56, no.4, Summer 1957, pp.36–42; reprinted as 'Recent Abstract Painting', in: *Modern Art: 19th and 20th Centuries*, New York 1978, see pp.217–19.

could not prevent the displacement of painting as a means of picture production from its previously central position within society. On the contrary, the more esoteric the content of painting became, or the more strongly it stressed the superiority of handicraft in an age of mechanical reproduction, the more alien the surrounding world came to seem. Because it clung to qualities dismissed as irrelevant by its social context, painting became an anachronism.

Rather than passively accepting this impending marginalisation as an inevitable fate, the radical avant-garde attempted to actively participate in painting's demise by deconstructing its symbolic, concrete and imaginary dimensions – as has been demonstrated by Yve-Alain Bois with respect to Duchamp's ready-mades, Rodchenko's 'Last Paintings', and Mondrian's systematic reduction of painting to its basic components.[4] This attack upon their own medium altered artists' position in relation to society. It transformed them from defenders of a practice that had become anachronistic, into executors of a socially necessary process. Artists in this context thought that their work anticipated an inevitable development: the end of art as an autonomous practice, or better still, art's dissolution into the social fabric. It did not matter whether this took the form of a pictorial nominalism, as was the case with Duchamp,[5] who worked out the implications of artworks' commodification and demonstrated that their status was based upon convention; or as in the case of Rodchenko, a destruction of bourgeois idealism via art's transformation into revolutionary practice; or finally, as was the case with Mondrian, by means of a dissolution of the boundary separating art from life.

This perspective – provided by anticipation of its own demise – allowed art to be released from its anachronistic relationship to society and transformed into a utopian project. That is, by means of questioning habitual artistic practice, Duchamp, Rodchenko and Mondrian altered art from being something *retardataire* into an anticipation of societal developments. Bois was thus accurate in pointing out that the Modern movement's radicalism and aggressiveness fed upon a longing for death, and that the teleological versions of its history (ranging from Baudelaire to Greenberg) can be characterised as apocalyptic. But like every such impulse, Modernism's death wish was to have its own vicissitudes. Although the utopian project accomplished the abolition of painting from the moment of its proclamation, because from that point onwards the preceding history of art could be construed as the prehistory of an inevitable apocalypse, art never did come to an end. For it gained from the awareness of an impending and inescapable death the strength to paint on and on, in order to postpone an end it hopes will never come.

Therefore the history of painting after its deconstruction by Duchamp, Rodchenko and Mondrian cannot be understood as a straightforward death impulse, but rather as an attempt to postpone a predetermined ending by employing ruses such as doubling, reflection and recapitulation of its own history.[6] Ad Reinhardt's 'Black Paintings' can be understood as an example of this kind of cunning postponement. They present us with a black that arises not from black pigment, but from the systematic application of layers of red, yellow and blue paint, thus reflecting upon and revoking the avant-garde reduction of painting to its basic elements. In other words, at the very point one had begun to think painting had come to an end, it seemed to begin its history anew – although

[4] Yve-Alain Bois, 'Painting: The Task of Mourning', *Endgame: Reference and Simulation in Recent Painting and Sculpture*, Boston/Cambridge, Massachusetts 1986, pp.29–49.
[5] Thierry de Duve, *Nominalisme pictural, Marcel Duchamp – La peinture et la modernité*, Paris 1984.
[6] Foucault has formulated a similar explanation for 'doublings' which occur in texts; see Michel Foucault, 'Le langage à l'inifini', *Tel Quel*, vol.15, Autumn 1963, pp.44–53.
[7] This quality of historical reflection, as well as the negativity characteristic of Reinhardt's works, is missed by those – like Gottfried Boehm – who interpret the 'Black Paintings' metaphorically. According to Boehm: 'The entire visible world (which the primary colours represent basic elements of) is thus transformed into a state of suspension, concentration and intensification. It is the mature sum of everything, a concentrate, the pure essence of reality that we confront in this painting (which to someone who is not capable of perceiving but only ascertains and identifies, might have looked like a boring black-painted surface). It becomes apparent that Ad Reinhardt is working towards an altogether-mystical metaphorical system, in which a disparate reality is concentrated into a paradoxical experience by the emanation of black light. It does not have to do with nature, or figuration, or treatment. It is a matter of all these and much more: it is a metaphor for the Absolute, an optically-verifiable totality.' (Gottfried Boehm, 'Abstraktion und Realität. Zum Verhältnis von Kunst und Kunstphilosophie in der Moderne', *Philosophisches Jahrbuch*, 1990/II, p.236.)

this can only take place on an individual basis and in a purely intellectual sense.[7]

Richter's work initially stemmed from a similar desire to abolish painting. This impulse can be understood in biographical terms as a reaction against his early training in Dresden, especially against the misconception espoused by the art academy there that the various traditions of painting were unproblematically available for use. Upon arriving subsequently in West Germany, where he studied at the academy in Düsseldorf, the artist confronted circumstances in which painting was considered to have lost its social necessity. In art-historical terms, he belongs to the generation including movements (such as Fluxus) which had dedicated themselves to overcoming the autonomous artwork by means of performances and 'happenings'. Of these two possible paths, neither that indicated by the tradition of painting as well as its critique nor that of its simple transmutation into 'actionism', seemed to Richter to possess the potential for productive development.

Since the beginning of the 1960s Richter's work has therefore been characterised by a double negation, directed against both the conventions of painting and the conventionalism of those who would criticise it. This painterly critique of painting enabled him to distinguish his artistic production from both the naive notion of an 'existential painting'[8] (characterised by a belief in the possibility of a willed return to art's origins), and the avant-garde's apocalyptic vision of art's demise. In contrast to the former, Richter was convinced that contemporary artistic practice could not rely upon presupposing a diffuse *au-delà de la peinture*, but rather necessitated an evaluation of painting's position with respect to and as a reflection of the socio-economic conditions under which it is produced. And in opposition to the latter avant-garde position, Richter realised that painterly production can in fact never come to an end and leave history behind, but rather must always work with historical fragments remaining present within its forms and procedures, thereby forming an inescapable condition of any artistic project.

Consequently, Richter's painterly reflection upon painting did not begin at some fictitious historical 'point zero', but rather with the readymade – since it represented the most profound critique of preceding pictorial production and contained the potential justification for subsequent artistic endeavour. In both the conceptual and literal senses, the readymade has remained an historical point of reference for Richter's production, for each of his works adapts, alters or destroys existing pictures. In this way, Richter is not simply responding to the fact that painting always involves intervention in an existing history of painting, but acknowledging that since Duchamp it always also requires formulating an attitude toward the concept of the readymade. As Benjamin Buchloh has shown, Richter's seemingly paradoxical effort to produce readymades using pictorial means should be understood simultaneously as a criticism of painting's traditions and as a reaction against reification of the notion of the readymade.[9]

Examination of Richter's Photo Paintings can clarify Buchloh's observations. The snapshots which acted as their basis offered Richter the possibility of leaving behind traditional painterly problems such as *sujet* or composition,[10] instead defining his project as an intervention involving manipulation of amateur photography's conventions.[11] The amalgamation of such photographs into painting can be understood as relativising and subverting the category of high art, since it directs attention to questions suppressed by fine art – those

8 Mathias Bleyl, *Essentielle Malerei in Deutschland. Wege zur Kunst nach 1945*, Nuremberg 1988.

9 Benjamin H.D. Buchloh, '"Ready-made", photographie et peinture dans la peinture de Gerhard Richter', *Gerhard Richter*, Paris 1977, pp.11–58.

10 In a conversation with Irmeline Lebeer, Richter has explained his recourse to photographs thus: 'I wanted to do something that had nothing to do with art as I knew it, nothing to do with painting, composition, colour, invention, design, etc. . . . because I was surprised by photographs, something we all use so abundantly every day. I was suddenly able to see them differently, as pictures that conveyed to me another kind of seeing without all the conventional criteria I had previously associated with art. They had no style, no concept, no judgement, they liberated me from experiencing things personally, at first they had nothing at all, they were pure image. For that reason I wanted to have them, to show them, not to use them as a medium for painting, but painting as a medium for photographs.' (translated from the French, 'Gerhard Richter, ou la réalité de l'image', *Chronique de l'art vivant*, vol.36, Feb. 1973, pp.13–16.)

11 Bourdieu has discussed the socially constructed aspect of such non-professional photography, in: Pierre Bourdieu, *Un art moyen – Essais sur les usages sociaux de la photographie*, Paris 1965.

concerning the social origin of certain artistic practices and the socio-economic status of their products' recipients. The employment of amateur photography also serves to remind the viewer that the majority of images surrounding one today cannot be attributed to any particular author, but are in fact readymades – that is, the product of socially-constructed conventions. In both their subversion of 'high art' as well as their relativisation of the social significance of pictorial practice, the Photo Paintings bring the concept of the readymade up to date. But this observation captures only one facet of this group of works, for the Photo Paintings did not solely introduce certain characteristics of the readymade into the arena of painting, but also those of painting into the realm of the readymade – thereby attacking reification of that latter concept.

In the process of this double confrontation with the traditions of painting and that of the readymade, Richter defines in his oeuvre his conception of an authorial role. In the Photo Paintings but also throughout Richter's production, the author appears in a paradoxical position. Working with such pre-existing materials, the artist posits himself as neither their absolute arbiter nor the ultimate centre to which the meaning of his images might be traced. For the author's work in the Photo Paintings is confined to the selection of his sources, determining the details to be framed, and finally the blurring of the images which results from a systematic process of overpainting. In so operating, Richter's aim is not to establish a self-contained totality embodied in each work, but rather he intervenes in something already formulated – inserting himself as artist into a pre-existing context which is thereby modified in a slight yet decisive fashion.

The trace left by Richter's intervention in the appearance of a pictorial given can be defined using the term '*différance*' as coined by Jacques Derrida: it deviates from an already established meaning, while at the same time deferring the positing of a new meaning.[12] The unfocused and blurred zones in the Photo Paintings thus function strategically, annulling a given content without formulating one with which to replace it. We are consequently confronted with pictures that, awkwardly enough, can only be described in negative terms: they are neither photographs nor paintings, although possessing some of the characteristics of both. The blurred zones of the Photo Paintings direct a 'stop making sense' at the viewer, who – thwarted by the lack of authorial prescription of meaning – attempts to resolve their contradictions, in order to arrive at an unequivocal interpretation. This effort is doomed to failure, as Richter's pictures do not permit resolution of this dilemma in favour of either the signifier or the signified. Content is only arrived at by means of a negation of form, form only as negation of content: which means that the whole project of representation is called into question.

[12] Jacques Derrida, *De la Grammatologie*, Paris 1967; this concept is discussed in chapter 1, and the divergence from correct spelling of this word is intentional.

III

With his subsequent series of Townscapes, these ambivalences are further reinforced. In the powerful facture of these pictures, the painter's intervention is more palpable than in the Photo Paintings, though rather than appearing as free expressive brushwork it remains bound up with the structure of the photographic images upon which they are based. Combining painterly intervention with its restriction within the limitations imposed by the source material, the Townscapes present a more profound challenge to the beholder than the Photo Paintings. For the beholder must here perform a twofold task: standing at a distance from these Townscapes permits the *Gestalt* of the depicted Townscapes to come into focus, while moving closer to the canvases brings about the destruction of these forms and a concomitant directing of attention to the painter's brushwork. In presenting the beholder with such contradictory experiences, the Townscapes emphasise the distinction between perceiving an object and seeing a painting. Since the beholder is forced to comprehend the Townscapes in two successive stages rather than in a single perception, the process of viewing is given a temporal index. This differentiation between viewing from a distance and seeing from close up reflects the logic of the painter's approach: it fosters awareness of the difference between the process of painting and the product which results from it. The observer who is accustomed to Hegel's dialectical sublimation of opposites will be puzzled by Richter's paintings, however, for instead of disappearing into the object depicted the process of representation rather remains apprehensible within it, while conversely the figurative content constantly disturbs the self-containment of the painted work.

By contrasting two mutually exclusive modes of perception in the Townscapes, Richter makes the observer an active participant in the process of producing meaning. In their somatic form of address, Richter's pictures can be compared with strategies employed at about the same time by Minimalist artists. This is because he insists upon the beholders' active participation while simultaneously never allowing them to arrive at a conclusive and unambiguous interpretation, thereby preventing his work from being reified and invested with an aura.

The aura-abolishing impulse motivating Richter's artistic production becomes still more apparent in his Colour Charts. These consist of small colour samples laid out in a grid on white, giving them the appearance of the charts found in art-supply or paint stores. By means of employing unmodified, industrially produced colours, their arrangement within a rigid structure and the effacement of any traces of artistic labour, Richter attempted to dissociate colour from the descriptive, symbolic and expressive functions it normally has in painting. In subjecting colour to such a regimentation, the artist formulated a critique of approaches to art-making which had focused upon colour in attempting to create a metaphysical aura for their works, since it was viewed as an aspect of painting which defies rational interpretation. Richter particularly directed his critique towards such spiritualised employment of colour as is found in the work of some Abstract Expressionist artists (Barnett Newman, for example); against the fluctuation between colour's material and spiritual facets

characteristic of Yves Klein's oeuvre; and finally in contradiction of Neo-Expressionist artists in post Second World War Germany for whom colour was synonymous with painting *per se*. In spite of the disparity between these phenomena, exponents of those three tendencies had in common the belief that it was possible to employ colour without taking into account the history of its usage.

In contrast to such a belief, Richter's painting begins doubts as to even the possibility of colour. The artist had entirely refrained from using colour in his early pictures; the grey of the Photo Paintings, and the black and white of the Townscapes, can be understood as the formal equivalent of their conceptual structure. For already the very photographic material constituting the starting point of Richter's work is marked by the presence of an absence, resulting from the reference to something irrevocably past and the impossibility of making present again what it depicts. Since the colourlessness of the painted component of these two groups of pictures reinforces rather than contradicts that impression, not only the object depicted but also the means employed are characterised by the presence of an absence — for grey or black and white are precisely the absence of colour. And where colour does appear, as in the Colour Charts, it loses its immediate impact because of being serially arranged, framed within a white grid and lacking any trace of manual labour. In other words it has lost the dimension that, in the view of its previous defenders, caused it to be designated the quintessential medium of transcendental experience or means of expressing unmediated energy — in either case, those aspects resistant to apprehension by means of discursive language.

The fact that Richter's employment of colour emphasises that it is always mediated rather than 'natural', is connected with a realisation unavoidable for painters at least since the time of Seurat: namely, that colours as pigments were themselves readymades. And although in some ontological sense they had always been such, technically speaking this had been true only since the invention of paint tubes.[13] Painters — and in particular those who believed themselves to have found in colour a means to assist their medium in the competition with techniques of mechanical reproduction described above — had to ignore or suppress this awareness, since it would have made construing colour as a phenomenon involving 'pure expression' impossible.

Richter's Colour Charts restore the lost (or more accurately, suppressed) self-conscious dimension to painting, precisely because their strict ordering of colours prevents the viewer's direct perception of that element. As is apparent from the artist's remarks, his motivation in creating the Colour Charts lay not in a simple desire to abolish painting *per se* but rather in an impulse to create a new kind of painting which would overcome the dichotomy between sensuousness and intellectual reflection. To this end, Richter experimented with various organisational schemes (ranging from the numerical to the aleatory) for the colour fields composing the Colour Charts. Thus in their combination of rationally-planned and chance elements, the Colour Charts are indicative of the systemic as well as experimental nature of Richter's painterly investigation of painting; it is an endeavour which is not interested in working out of schemes formulated *a priori*, but rather in the empirical investigation of his medium's potentialities.

13 Thierry de Duve, 'The Readymade and the Tube of Paint', *Artforum*, May 1986, pp.115–16.

IV

Consideration of the Grey Paintings makes apparent that Richter's work is not defined by a simple opposition to the tradition of painting, a history which subsumes his own previous work, but is rather structured as a particular negation of certain qualities evolved by the medium in the course of its history. In these Grey Paintings the bipartite character of Richter's work, its critical as well as utopian orientation, is particularly apparent; simultaneously they are no longer paintings and yet can always be considered as such. Richter examined in them the notion of monochrome painting, an artistic strategy devised by the avant-garde to overcome the tradition of easel painting, by placing an emphasis upon either colour's materiality or its spirituality. In both cases, the reduction of painting to a single colour was teleologically motivated: it was used to indicate the existence of a reality beyond the painted canvas, which was thought to be of a political or a spiritual nature.

Richter has lost faith in the existence of such a metapictorial level of reality, one which would guarantee painting's significance and permit reductive artistic strategies to be understood as a means of connecting with that reality. His painting is consequently without 'sense'; that is, it lacks the motivation for progressing towards that essence which monochrome painters were attempting to approach in their reduction of painting to a single colour. Having lost the metaphysical point of reference towards which monochrome painting had been directed, Richter's Grey Paintings have become part of painting's ongoing engagement in self-criticism. This explains why Richter defines his project neither as a reduction of coloration nor as a demonstration of colour's symbolic potential, but rather as an effort to extinguish colour. The Grey Paintings should therefore be understood as achromatic rather than monochromatic painting. Their greyness constitutes a *différance*, for although embodying the combination of all colours and thus referring to colouration as a concept, colour is visually present in them only as an absence.

V

Since the late 1970s, Richter has abandoned both the disciplined approach characterising his Colour Charts and the achromatism of the Grey Paintings.[14] In the misleadingly titled Abstract Paintings series, colour made a vehement comeback that all the more urgently posed the question of its own significance, the less it permitted itself to be described in terms of classificatory categories traditional for the use of colour. For art theoreticians, colour had always been the *scandalon* of every interpretation, as it constitutes an irreducible quality of painting *per se* which defies discursive analysis and thus undermines any attempt at conclusive interpretation. Art theory has attempted to escape from this dilemma through either devaluing or overestimating colour: theory proclaimed on the one hand that colour was a mere deception of the eye which obstructed perception of truth, and on the other colour was conceived of as the very medium through which this essential aspect would be revealed. But regardless of whether

14 On this subject, see Ulrich Loock, 'Das Ereignis des Bildes', in: Ulrich Loock and Denys Zacharapoulos, eds. *Gehard Richter*, Munich 1985, pp.81–125.

art's most important content was located outside of or rather within colour, in both instances theoretical discourse was attempting to fend off the threat posed by colour's irreducibility and to redirect discussion of art back onto the safe path of metaphysical thought.

It is therefore possible to envision a history of art theory which would focus upon its inability to come to terms with colour, and demonstrate its consequent efforts to either marginalise and suppress, or alternatively glorify and hypostasise it. The main character in such a narrative could be the Platonist Laurenz Ehmke, a character created by Carl Einstein in his Expressionist-period novel *Bebuquin*: he is a man who only goes out at night, because then there are no colours, and who drinks only colourless spirits.[15] The twentieth century has contributed two further chapters to the ongoing history of problematic colour: one of them indicates that colour can be avoided by presenting it as the artist's 'expression', which draws attention away from the picture towards the psyche of its creator. This shift into the realm of psychology continues the tradition of devaluing colour, for, rather than seeking the motivation and meaning of colour within a given picture, it permits it validity only as psychological symptomatology. The other twentieth-century narrative continues the history of overestimating colour's significance, by construing it as the non-subjective revelation of essential truth, thereby circumventing the issue of representation and elevating the picture into a symbol of a transcendent reality.

The inadequacy of both of these interpretations becomes apparent when Richter's Abstract Paintings are confronted. These pictures can neither be described by employing psychological categories such as gesture or expression, nor characterised using theological terms like revelation or transcendence; they cannot be explained in terms of their author's subjectivity, nor by referring to the existence of a reality transcending the image. Discussion of the Abstract Paintings must instead begin with description of the artist's working method, and as is always the case with Richter, a readymade provides their point of departure. The first Abstract Paintings were created by transposing photographs of small-scale sketches onto the canvas, while the subsequent works were produced by starting from brightly coloured compositions which were subsequently painted over, effaced, and destroyed in the process of creating the new images. The idiosyncratic density of the Abstract Paintings arises from this procedure, which combines conscious artistic invention (including definition of format, establishment of the preliminary composition, and the selection and distribution of colours), with processes of destruction which negate that intervention because their outcome cannot be completely controlled by the artist's overpainting, scraping and scratching of the layered paint.

The *Gestalt* of these pictures is therefore not a product of a process of abstraction – that is, involving the reduction of a multiplicity to its basic elements – but rather results from a process of 'concretisation', in which a variety of accidental elements are caused to appear. Abstraction can be described as defined by a two-way reference; it presupposes the existence of a reality *per se*, directed away from or towards which the process of abstraction takes place. Of course, in the resulting picture that 'reality' no longer appears as a mimetic referent, but rather as a set of internal relations between hierarchically and

15 Carl Einstein, *Bebuquin oder die Dilettanten des Wunders*, Frankfurt am Main 1974 (reprint; originally published in the periodical *Die Aktion*, 1912).

syntactically ordered elements on the canvas. In contrast to abstraction, concretisation involves neither hierarchical order nor pictorial syntax, being based upon no such notion of an external reality. Instead of an ordered reduction, an irreducible variety of visual phenomena appear. By its very nature, the simultanaeity with which this excess is experienced cannot be adequately conveyed through language, which is, rather, structured sequentially. And it is not necessary to interpret these concrete pictures as being 'mystical', in order to acknowledge that this inaccessibility to language constitutes their most important characteristic.

If the abstract paintings elude anyone who attempts to describe them, they had initially in a sense already eluded the painter himself. While his preliminary decisions and interventions influence these paintings' appearance, their final form escapes his control; they are determined by the readymades forming their basis as well as by the accidents of production. Thus rather than expressing their author's original conceptions, the fashion in which these pictures come into being manifests a process in which he becomes alienated from his own intentions. This type of painting does not involve the short circuit connecting psyche and canvas called *écriture automatique*, but constitutes an infinitely mediated surface phenomenon that cannot be elucidated in terms of psycho-biography, nor as a kind of mimesis. For the Abstract Paintings are defined by the difference between experience and its representation; in other words, they are of an allegorical nature.[16]

Richter's paintings can be understood as a form of communication which is cancelled in the very act, even though the painter's desire to communicate with his viewers via his paintings persists. The melancholy character of such a production stems from a simultaneous awareness of the necessity of utopia — Richter has called painting 'the highest form of hope' — and recognition of its inaccessibility. The Abstract Painting's specific nature is therefore neither sufficiently described by Buchloh's 'rhetoric of painting' concept, nor by means of the incomparably naive notion of 'pure seeing' propagated by Konrad Fiedler and his followers. While Buchloh seems correct in emphasising the rhetorical nature of Richter's formulations, his works cannot be explained as a product of the painter's conscious decision but must rather be seen as a result of the separation between personal experience and pictorial representation taking place in the very act of painting. Whatever motivated the creation of the Abstract Paintings cannot be deduced from the finished canvas, since it is subjected to a process of revealing while concealing, which is a particular characteristic of Richter's production.

This mechanism is at work as well in the figurative pictures which were produced during the same period as the Abstract Paintings. Since the former employ iconographically conventional still-life motifs such as skulls, candles and fruit, the allegorical dimension of these figurative works is more apparent than in the abstract canvases. But this apparent decodability is an illusion, for like their abstract contemporaries, Richter's figurative works are the product of a displacement. That is, they are dealing with a psychological content that is other than what they represent; as in the Abstract Paintings, they deny access to the beholder since in a sense they conceal what motivated their creation behind the motifs they depict.

16 Paul de Man, 'The Rhetoric of Temporality', *Blindness and Insight: Essays in the Rhetoric of Contemporary Criticism*, Minneapolis 1983, pp.187–228.

VI

In retrospect, the multiplicity and richness of Richter's production becomes especially apparent. His work will be confusing only if one does not realise that a seemingly disjointed plethora is held together by one basic principle: a belief in painting's necessity born of radical doubt in its potential. This belief constitutes a *credere quia absurdum*, because it combines awareness that it is impossible to give painterly production a coherent significance, with the hope that the very consistency with which painting is carried out might ultimately evoke that coherence.

Revolution and Restoration: Conflicts in the Making of Modern Germany

NEAL ASCHERSON

There are many Germanies. They lie scattered across time, but also in many different corners of the imagination. The Germany which formed Gerhard Richter, for example, seemed to commence in 1945, but one of its roots runs back to February 1837. Two related events took place that month. On 19 February, the writer Georg Büchner died of typhoid in exile at Zurich, at the age of 23. Four days later, at Giessen in the state of Hesse, his older friend Friedrich Ludwig Weidig was found dead in his prison cell, covered with blood and surrounded by fragments of broken glass.

Both were liberal revolutionaries, intellectuals whose vision of a transfigured, unified Germany – 'true' Germany whose revolution would be both spiritual and social – led them into a hopeless conflict with authority. Büchner, in his short life, wrote dramas whose mystery and intensity can still shake the self-possession of any audience, but he also wrote the *Hessische Landbote*, the purest and wildest of all revolutionary manifestos. 'Peace to the cottages! War on the palaces!': the *Landbote* called on the Hessian peasantry to rise by describing to them in language of biblical simplicity and fury the privileges of the rich and the wickedness of class oppression. The peasants did not rise, however. Instead the Hessian police rounded up all the revolutionaries they could find, and Weidig, who helped compose the *Landbote*, was arrested and tortured by Konrad Georgi, the 'university judge' charged with repressing intellectual sedition at Giessen.

They left behind them an utterly uncompromising, incandescent vision of their country which disdained shabby political reality and soared away from any discussion of practical possibilities. They dealt with reality in the Hegelian manner. The 'real' was not what actually existed, which was a mere 'phenomenon'. It was the perfection into which each phenomenon could develop by 'self-realisation'. The flower was the 'reality' of the seed. Thus the legend of Büchner and Weidig drew force from the incompleteness of their ends. Nobody can ever know what Büchner might have done if he had lived longer, while the death of Weidig in prison – did he kill himself, or was it murder made to look like suicide? – remains a mystery which is still a touchstone of emotional allegiance rather than a subject of historical enquiry. And both men returned to haunt the German scene in the 1970s, sometimes with a presence so heavy that they seemed to be dictating the script from beyond the grave. It was Büchner in 1833, not Ulrike Meinhof or any of her comrades in the Red Army Faction (RAF), who wrote: 'They accuse young people of resorting to violence. But do we not

live in a condition of eternal institutionalised violence?' As for Weidig, the re-enactment of his death which took place in the prison at Stammheim on 18 October 1977, when Andreas Baader, Gudrun Ensslin and Jan-Carl Raspe were found dead in their cells (suicide? murder? suicide disguised as murder, or the reverse?) terrifies reason and obsesses the imagination.

The Germany which traces its ancestry back to Büchner and Weidig is manic-depressive. On the downswing, this sensibility can look like apathetic detachment when in fact it is a condition of intense disgust and suffering. On the manic upswing, it is a vision of an imminent Second Coming, the fulfilment of history. This kind of idealism came alive in the revolutionary days of 1848. The revolution led to the convocation of the 'Frankfurt Parliament', a constituent assembly which was to draw up the constitution of a modern and liberal Germany. But the revival of Germany's conservative rulers, Prussia above all, cut off the parliament in mid-course, so that it too remained a Hegelian ghost to haunt the future with dreams of what it might have been if it had been allowed its self-realisation. Even today, there are intellectuals who judge the united Germany which appeared in 1990 by that standard, asking whether this state is really the fulfilment of the undelivered promise of Frankfurt 140 years ago. But, for nationalists, Germany ceased to be an abstraction and became concrete reality when the Empire was declared in 1871. After 1918, there were many (mostly on the right) who could not recognise authenticity in the Weimar Republic; their disdain for an unglamorous bourgeois democracy helped to prepare the way for the Third Reich. The situation changed radically, however, when Hitler took power in 1933 – a development which most thinking Germans had considered too absurd to be a real possibility. From then on, there was little space for lofty meditation about the 'real' and the 'phenomenal'. The Hitler State was horribly present and urgent; the concern of most intellectuals who remained in the land was to survive (to resist was the concern of only a very few).

Then came the collapse of 1945, followed within a few years by the construction of two rival 'part-states' by the victor powers of the Second World War. There will always be people to argue that, in retrospect, the Allies could have refrained from demanding unconditional surrender and encouraged some sort of native revolution within defeated Germany. There was never any chance of that. Instead, the Federal Republic of Germany and the German Democratic Republic were designed, with very different degrees of coercion, by the West and the Soviet Union, and the inevitable question returned: was this Germany? Did either of these places represent that essential Germany glimpsed through the clouds by Büchner, and again by the delegates to the Frankfurt Parliament?

Clearly, they did not. In the Western state, there was a twilight of authenticity; in the East, a complete darkness. In the GDR, especially in the earlier decades, there were only two views. One – the official position – held that this was a totally new socialist state of the German nation which had no evolutionary relationship to any previous German state-form. The other version held that this was a totally bad and despotic state, imposed by foreign armed force, which displayed some striking similarities to its fascist predecessor. Today, meditating at the tomb of the German Democratic Republic, we can see that in a nightmarish way it managed to combine both sides of Büchner's conflict. There was certainly war on the palaces, but the peace of the cottages was

'Arrest 1' and 'Arrest 2', 1988, from '18 October 1977' series, based on the Baader-Meinhof group. These two sequential paintings are based on photographs depicting the arrest on 1 June 1972 of Holger Meins in front of a multistorey car park in Frankfurt. In the second picture the armoured police vehicle has withdrawn a few yards, while Meins undresses at the command of the police, to ensure he has no concealed weapons. The contrast between the vulnerability of the naked individual and the overwhelming power of the State is thus potently illustrated.

enforced by a secret police larger than most armies and far more effective at the repression of thought-crime than anything Konrad Georgi could command at Giessen.

It was easy to dismiss the GDR's claim to be the perfect Germany, but extremely dangerous to do so aloud. In West Germany, only the most naive citizens thought that the Bonn republic was the ultimate synthesis and climax of all German strivings, and to complain about the shams and shortcomings of the place was so safe that it became boring. Legally, the Federal Republic proclaimed itself the heir of German statehood within the frontiers of 1937, which included not only the GDR but a broad slice of postwar Poland. In practice, its claim to the loyalty and patriotism of all good Germans was regarded with mild contempt. It was not an accident that so many civil servants, government secretaries, officers and senior intelligence staff willingly provided information to the East German intelligence services during the forty years of German partition. They simply did not regard one Germany as much more 'genuine' than the other. Patriotic morality was not involved – and neither, in most cases, was any ideological preference for East over West.

After about 1948, it became obvious that the bourgeois democracy planted in the Western zones of occupied Germany was going to provide an infinitely freer and more prosperous society than the socialist autocracy in the Soviet Occupation Zone. But this did not compensate, especially among intellectuals, for a sense of cultural amputation and loss in the West. For a time, until the mid 1950s, it seemed possible that East Germany had maintained a stronger connection with the best in pre-1933 German culture than West Germany. Even when the Party's interference with the arts had made that idea untenable, there remained a vague feeling on both sides of the divide that to live in the East – perhaps because of its very difficulties and disillusions – was morally superior to life in West Germany or West Berlin. As the dissident ballad singer Wolf Biermann proclaimed in the 1960s before he was ejected from the GDR, 'I live in the better half / And suffer twice the pain.'

In both German states, there was reluctance to accept the existing social and political forms as final. Instead, there was a tendency to use those forms as a springboard to an imaginary but more authentic Germany (which might or might not be united in a single polity). The most energetic supporters of the Bonn republic, in its earlier years, were not so much pragmatists who appreciated rising wages and an opulent level of consumption as anti-Communist crusaders who wanted to use the growing strength of West Germany in order to regain German unity. In the East, dissidents dreamed of a Third Way: a democratic socialism which was somewhere between the Stalinist version of Communism imposed by Walter Ulbricht and the allegedly 'corrupt' compromise with capitalism represented by the Social Democrats (SPD) in West Germany. The Third Way vision did not evaporate until after the collapse of the Berlin Wall in 1989. It was the inspiration of the New Forum group which led the first wave of demonstrations against the régime, but the 1990 elections showed that – as far as the East German population was concerned – this middle ground between capitalism and Communism would remain waste ground.

Gerhard Richter himself was involved in private discussions of that kind, before he left for the West in 1961, and his self-criticism in retrospect is

interesting. 'I was part of a circle that claimed to have a moral concern, that wanted to be a bridge . . . between capitalism and socialism. As a result, our whole way of thinking was preoccupied with compromise. So, too, was what we sought in art. That simply wasn't radical . . . it wasn't truthful. It was full of false considerations'. (Interview with Benjamin Buchloh, in *Gerhard Richter: Paintings* 1988, p.15).

Both Germanies, then, denied sections of their cultural past. In the East, Richter grew up unfamiliar with the work not only of the first avant-garde generation, but of most of the Modern movement in Germany. As late as the 1960s, Expressionist paintings could only be exhibited if accompanied by a Marxist text dissecting their reactionary and progressive elements (rather in the manner of the texts which accompanied the same paintings in the *Entartete Kunst* exhibition in 1937). In the West, while it was easy enough to see the classic works of the Secession, Die Brücke, Der Blaue Reiter and so on, the avant-garde tradition was at first almost as inaccessible as in the GDR. Schwitters was actually better known in Britain in the 1960s than in West Germany; Heartfield had 'gone East' and was therefore unacceptable for most established West German galleries; the German part of Dadaism remained stranded on various shores of exile and obscurity. On top of this came the long and almost entirely destructive row between figurative and non-figurative art: a row conducted in political terms which reduced abstraction to 'the art of freedom' because it could not be perverted to serve totalitarian ends, while figurative, representational painting and sculpture came to be associated (in those simple, fevered minds which abounded in the world of West German art patronage during the 1950s) with Communism. So it came about – a sourly comic conclusion – that German artists like Richter broke away into really radical experiment in the late 1960s after their encounter with French and American new painting, scarcely aware that these models were themselves the product of encounters some years earlier with exiled survivors of the German avant-garde.

When Gerhard Richter crossed to the West, two months before the Wall was built in August 1961, Konrad Adenauer was still Chancellor of the Federal Republic. Liberal-minded West Germans liked to speak of his regime as a 'restoration', as a revival of the conservative part of pre-Nazi Germany: pious, provincial, repressive. That was only part of the truth, for with the conservative values went an economic dynamism and growth rate which amazed the world and soon transformed the remnants of traditional Germany. But the cultural climate of the Adenauer years was certainly oppressive. The ruling political elites (including the right wing of the SPD) were suspicious of intellectuals, while Axel Springer's press empire, strongly pro-Adenauer and hostile to socialism and social democracy in any form, maintained a raucous harassment of political or cultural dissidents. No doubt the chances of rallying artists and intellectuals to love the Federal Republic were always modest. But the primitive anti-Communism of the first 20 years ensured that those groups would remain instinctively in opposition. Petty incidents, like Chancellor Erhard's dismissal of politically critical writers as 'Pinscher' (yapping terriers), were taken with exaggerated seriousness and even compared to Nazi attitudes towards non-conformist culture.

In those years – and this was the period of Richter's formation as a painter – it

was fashionable to say: 'I do not feel that I am German: I feel that I am European'. This was evidence of the extent to which roots in national tradition and culture seemed to have been severed. But, of course, it was also a conscious denial of the Germany that actually existed in the form of the Federal Republic. For some, this denial was a liberation, a release of the imagination like a balloon whose string is cut. But for those like Gerhard Richter, who were not in their first youth (he was born in 1932) and who had already consciously experienced three Germanies (the Third Reich, the German Democratic Republic, the Federal Republic), liberation seemed less a matter of soaring upwards than of digging downwards. Politics and revolutionary messianism never took possession of Richter, not even in 1968. In his interview with Buchloh, he remarks that he thinks highly of psychoanalysis 'because it removes prejudices and makes us mature, independent, so that we can act more truly, more humanly, without God, without ideology.' For many young West Germans and West Berliners, the revolutionary movement of 1968 performed this function of rendering them mature and independent precisely because its ideology had many roots in psychoanalysis of a heterodox kind and in a Marxism adapted into a liberation cult of the individual will. Richter, with his own experiences which were hard to communicate to Westerners in their twenties, did not need revolution. He had already conducted his own emancipation in his own way, although his work at the time was attacked by radical critics as 'escapist'.

In 1968, which is the only really important date in the history of West Germany between its foundation in 1949 and its final transfiguration in 1990, the latent Büchnerism of the German intellectuals began once again to erupt. It had become fashionable to rebuke the younger generation for apathy, indifference to the nation, allergy to ideas, empty consumerism. But this impression turned out to be highly misleading. Discredited systems of ideas had been successively abandoned by the postwar young: fascism initially, then Stalinist and post-Stalinist versions of socialism, and finally – for a brief but intense interlude – the ideology of the Western world in the 1960s which was referred to as 'late capitalism'. As the student unrest began to spread through the universities of West Berlin and then the Federal Republic in the course of 1967 it became apparent that indifference to actually existing Germany in no way implied a lack of faith in a dazzling Germany of the mind's eye. In both Paris and Berlin, the rhetoric rapidly took a turn which had little to do with American liberal values and everything to do with old Hegelian arguments about what was real and what was not. The 'real world' became the vision of a republic of workers' councils without structures or authority. The 'phenomenal world' was the 'Spectacle', the stage-set of government and institutions which began visibly to wobble as the uproar continued.

After 1968, West German society and culture changed greatly. The 'restoration' engineered by Adenauer went on to the defensive. The state culture of anti-Communism slowly dissolved; the stiff hierarchies in universities, arts colleges, schools and most of the professions (including the law) were dismantled or modified. No revolution had taken place. Instead, within a few years, advocates of revolution found themselves in well-paid posts supervising the reform of existing institutions, both in their structure and in their style. This was no small achievement, even if it was unintended. It has been suggested that 1968

'Confrontation 1', 'Confrontation 2' and 'Confrontation 3', 1988, from '18 October 1977' series. These three sequential paintings are based on photographs of Gudrun Ensslin. Hung side by side, they seem like freeze frames in a cinematic sequence of images.

[37]

represented an attempt to complete 1848: in other words, to finish the interrupted effort of the Frankfurt Parliament to construct an authentic German democracy which owed its genesis not to an emperor or dictator or foreign occupying power, but to spontaneous popular will. This was certainly not how the student revolutionaries understood their purpose, but it is a convincing analysis.

There followed the episode of the Red Army Faction, the doomed resort by a group of young intellectuals to armed struggle, which was to reach its hideous, Büchnerian climax in Stammheim prison, on 18 October 1977. Ten years later, Gerhard Richter began work on a cycle of fifteen oil paintings, transformed photographs of that scene. A contemporary letter of Richter's to Stefan Germer is revealing, not only about his own emotions, but about the feelings of many intelligent Germans towards their own society and culture. He begins by denying any sympathy for the aims and methods of the RAF; his years in East Germany had taught him that all states were harsh and many were harsher than the Federal Republic. Yet 'the death of the terrorists and all the connected events before and afterwards amounted to a monstrosity which made an impact on me and which has preoccupied me ever since, even when I repress it, like a piece of unfinished business'. The Stammheim tragedy has a sinister resonance, a lingering echo of ambiguity which is not so much about the facts of what happened that night as about the divisions in German minds.

The aftermath of the 1968 events might have convinced the intellectuals that they had done well out of West German society, and were even taking it over to some extent. But the RAF's campaigns brought about a fresh crisis of conscience, and of confidence in authority. It was not that there was significant support for the bombings and assassinations of the RAF, which appalled almost the entire radical left. It was, rather, the repression which the campaigns provoked: tougher police powers, a sense of insecurity stimulated by police raiding and searching and occasionally shooting, the purge of public services – education, especially – carried out by means of a compulsory oath of loyalty. Resistance to this 'State counter-terrorism' ensured that a widespread subculture alienated from existing political institutions would survive into the 1990s.

All that is long ago now. Yet even the unification of Germany in 1990 has so far failed to convince a large part of the creative intelligentsia that this is *the* Germany, the essence of German possibility, the real thing entitled to their loyalty. Many opposed the manner of unification, feeling that it amounted to a mere extension of the Bonn state rather than the creation of a new and better one. Others, haunted by history, said flatly that Germany was safer if it remained divided. The resurgence of German national self-assertion, though still pretty modest by the standards of patriotic bombast in other European nations, has been seized upon as confirmation of those doubts.

Richter's sensibility, although it is in many ways carefully unpolitical, is a product of this endlessly idealistic, endlessly disillusioned Germany. His protean range of manner, the impression his work conveys of an impassive versatility, has been taken as the symptom of inner coldness and indifference. But that is a fundamental misunderstanding. His long pursuit of 'radicalism' in art, through the rejection of attachments and compromises, has left him rather defencelessly exposed to all the malignant radiation of life. It is not a cold man

'Hanged Person', 1988, from '18 October 1977' series. The hanged figure, scarcely recognisable in the painting, is based on photographs taken in Gudrun Ensslin's prison cell on 18 October 1977. During the previous night, according to the State Prosecutor, she hanged herself using electric cable from her speakers, fastened to the bars of her cell window.

who writes in his diary that 'the crime which fills the world is so absolute that we can lose our senses out of sheer despair. Not only in torture systems and concentration camps, but also in civilised countries it goes on persistently, differing only in quantity (every day people are mistreated, raped, beaten, humiliated, tormented and murdered – cruel, inhuman, incomprehensible)'. Elsewhere, he writes that all beauty is a mere projection which we can shut off at will, leaving only the reality of nature's inhuman ugliness. And yet he does not 'lose his senses', but through art, through the constant choices implicit in making art, behaves as if utter chaos must have utter harmony as its twin. Büchner said, during his last illness: 'We do not have too much pain but too little, because through pain we enter God's presence. We are death, dust, ash: how should we complain?'

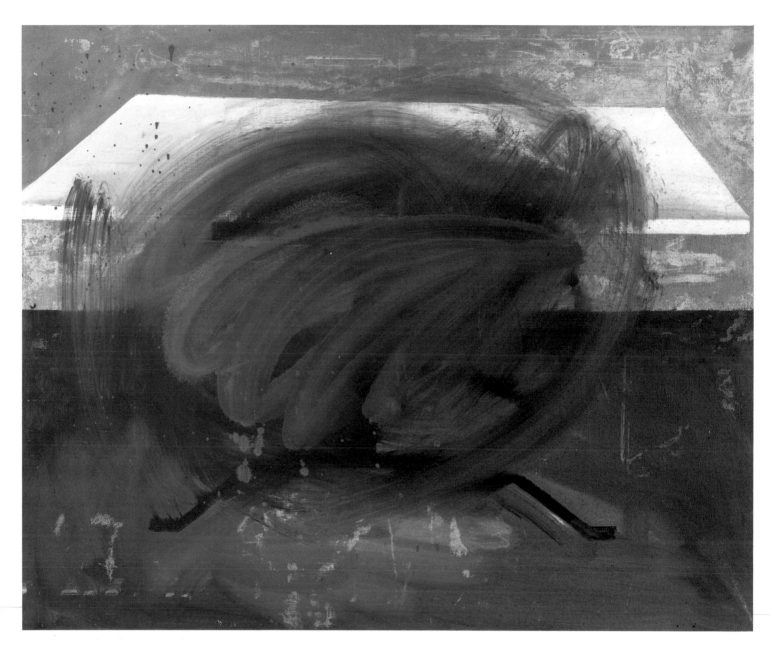

1 Table [1] 1962

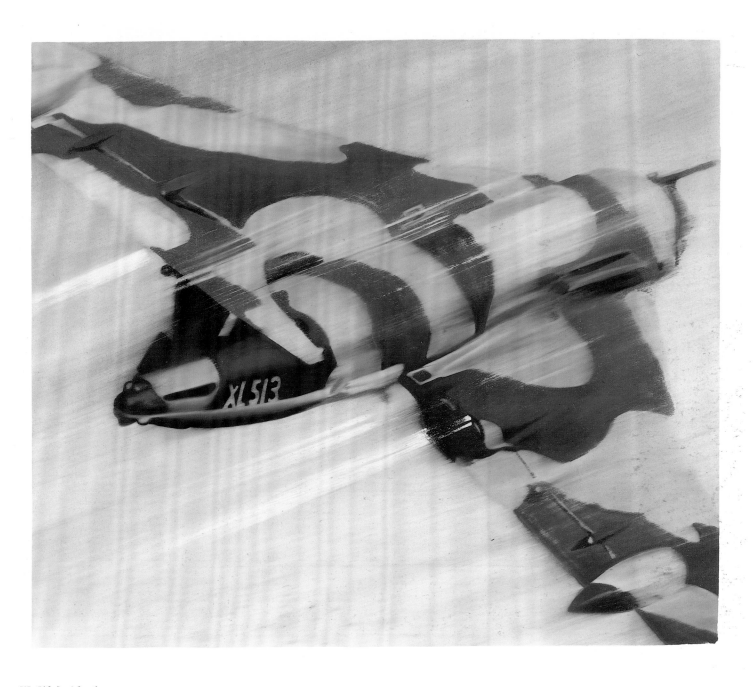

2 XL 513 [20/1] 1964

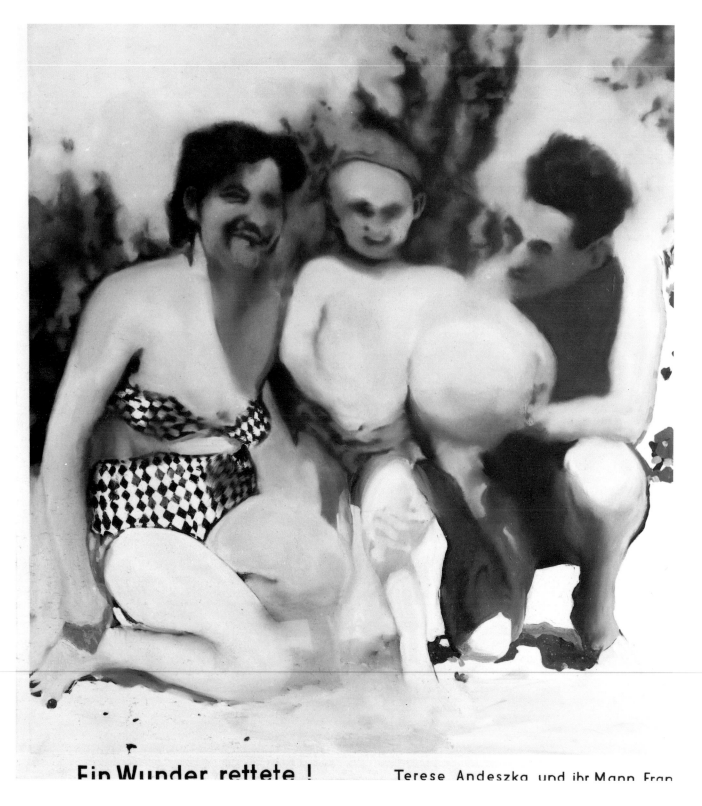

Ein Wunder rettete ! Terese Andeszka und ihr Mann Fran

3 Terese Andeszka [23] 1964

4 Woman with Umbrella [29] 1964

5 Administrative Building [39] 1964

Die Sphinx von Gise (Sphinx des Königs Chephren).
Im Hintergrunde die Pyramide des Königs Cheops. 4. Dyn. (um 2600 v. Chr.)

6 Great Sphinx of Giza [46] 1964

7 Flemish Crown [77] 1965

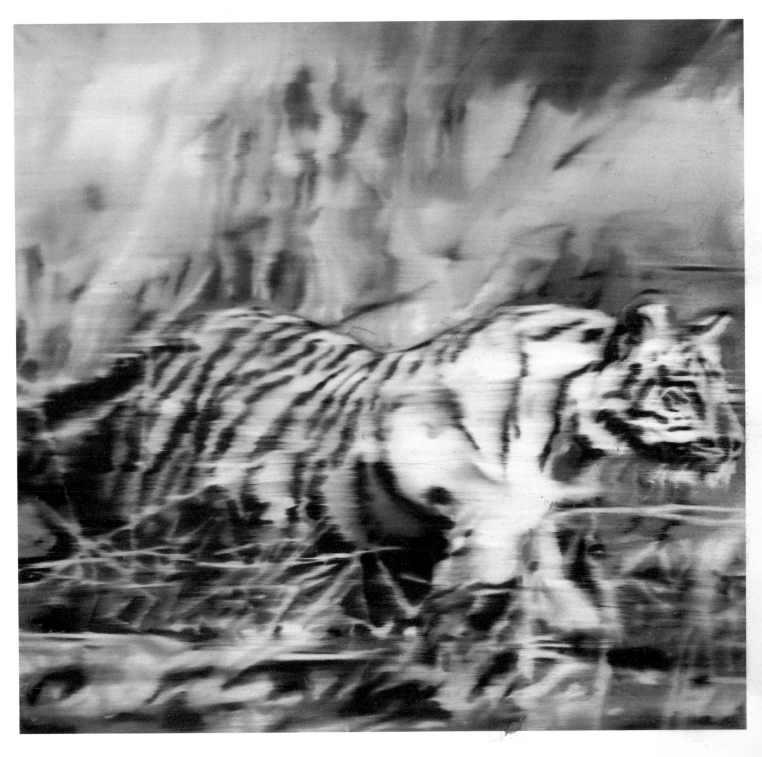

8 Tiger [78] 1965

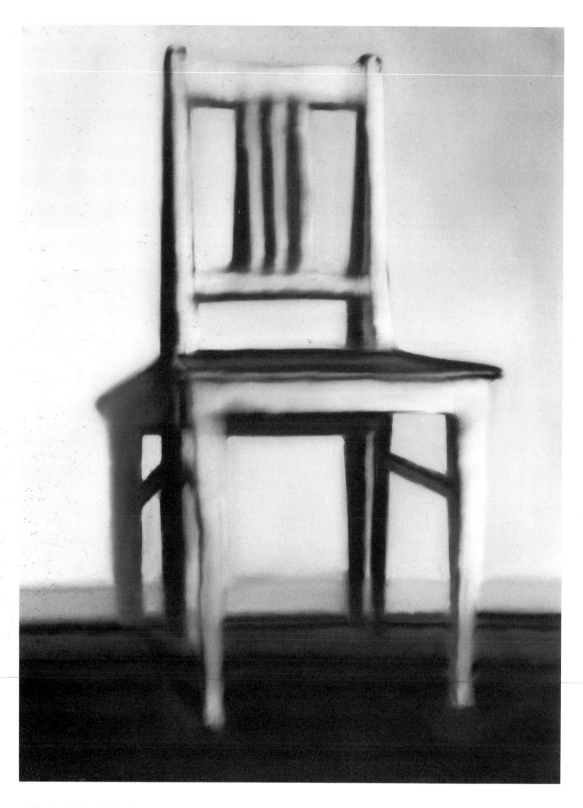

9 **Kitchen Chair** [97] 1965

10 Townscape M 2 [170/2] 1968

11 Townscape Paris [175] 1968

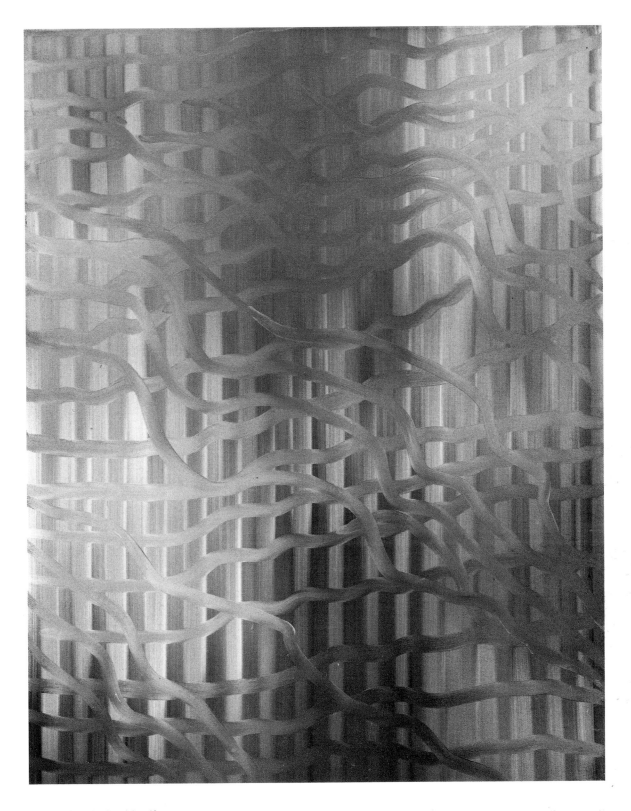

12 Grid Streaks [194/5] 1968

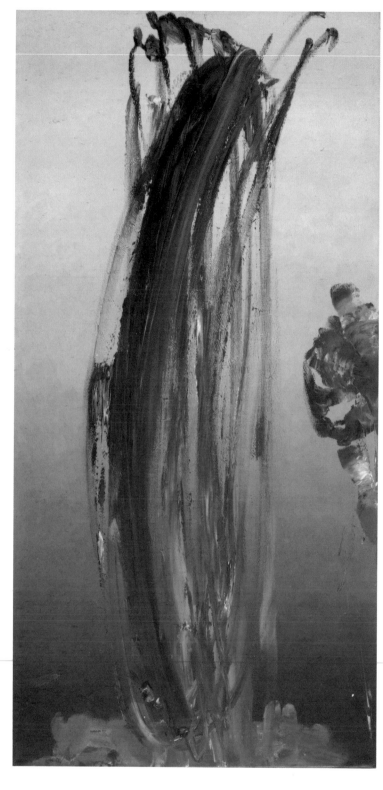

13 Untitled [194/9] 1968

14 Townscape TR [217/1–3] 1969

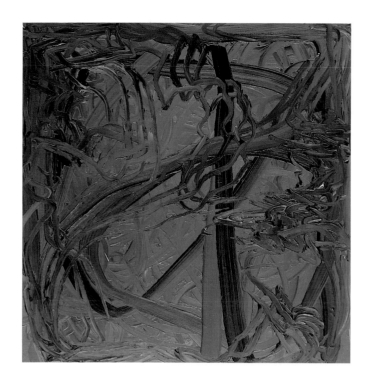

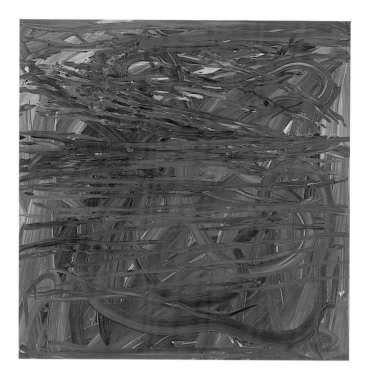

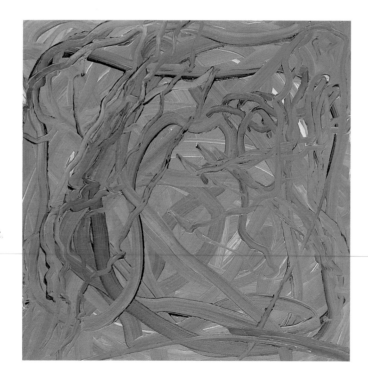

15 Star Picture [224/13–15] 1969

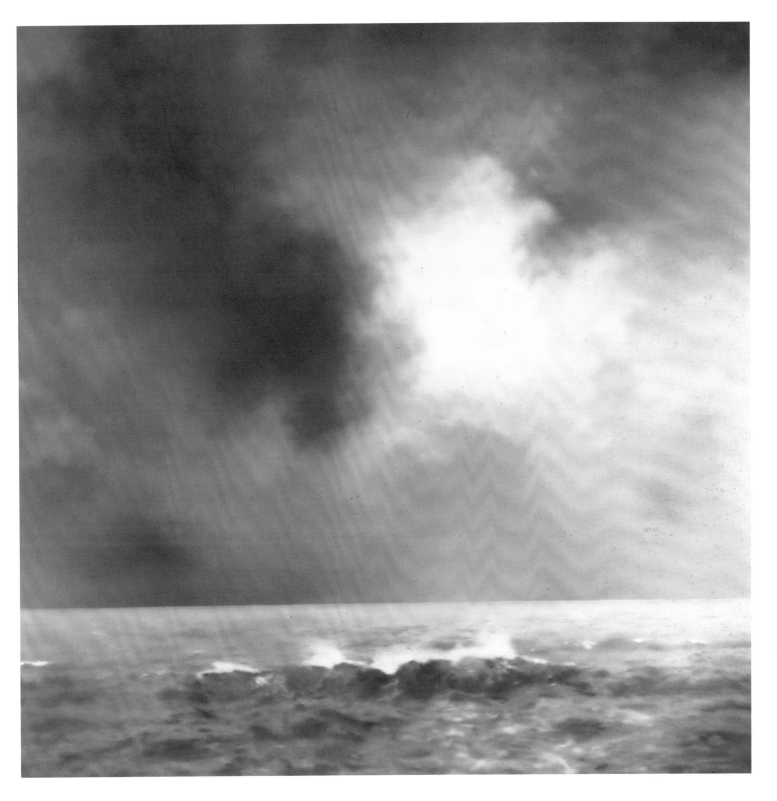

16 Sea Piece (Wave) [234] 1969

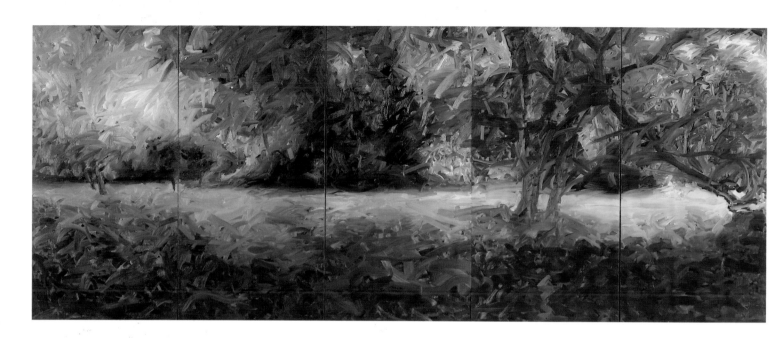

17 **Park Piece** [311] 1971

Herbert George Wells 1866–1946

Alfredo Casella 1883–1947

Gustav Mahler 1866–1911

Mihail Sadoveanu 1880–1961

José Ortega y Gasset 1883–1955

Otto Schmeil 1860–1943

Arrigo Boito 1842–1918

Frederic Joliot 1900–1958

James Chadwick 1891–1974

Igor Stravinsky 1882–1971

Jean Sibelius 1865–1957

Hans Pfitzner 1869–1949

William James 1842–1910

Peter Tschaikovsky 1840–1893

Max Planck 1858–1947

Manuel de Falla 1876–1946

James Franck 1882–1964

Thomas Mann 1875–1955

Paul Valéry 1871–1945

Paul Claudel 1868–1955

Nicolai Hartmann 1882–1950

Enrico Fermi 1901–1954

Paul Adrien Maurice Dirac 1902–1984

Alfred Mombert 1872–1942

Franz Kafka 1883–1924

Albert Einstein 1879–1955

Rainer Maria Rilke 1875–1926

Patrick Maynard Stuart
Blackett 1897–1974

Louis Victor de Broglie 1892–1987

François Mauriac 1885–1970

John Dos Passos 1896–1970

Alfred Adler 1870–1937

Björnstjerne Björnson 1832–1910

Isidor Isaac Rabi 1898–1988

Oscar Wilde 1856–1900

Paul Hindemith 1895–1963

Saint-John Perse 1887–1975

Giacomo Puccini 1885–1924

Hugo von Hofmannsthal 1874–1929

William Somerset Maugham 1874–1965

Graham Greene 1904–1991

Rudolf Borchardt 1877–1945

André Gide 1869–1951

Anton Webern 1883–1945

Karl Manne Siegbahn 1886–1978

Emile Verhaeren 1855–1916

Wilhelm Dilthey 1833–1911

Anton Bruckner 1824–1896

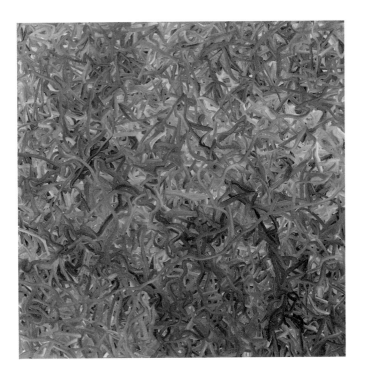

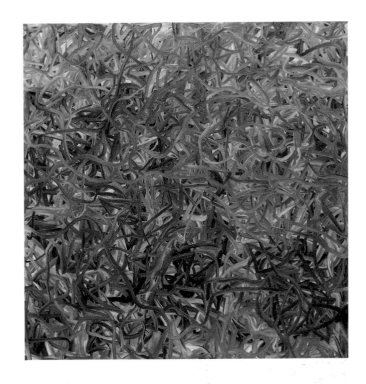

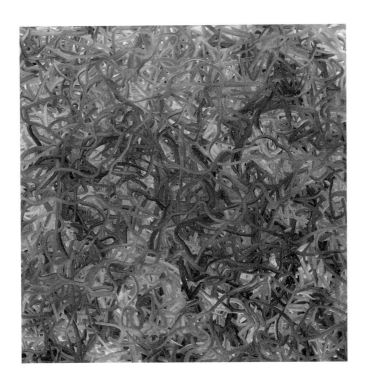

19 Inpainting (Grey) [326/1–3] 1972

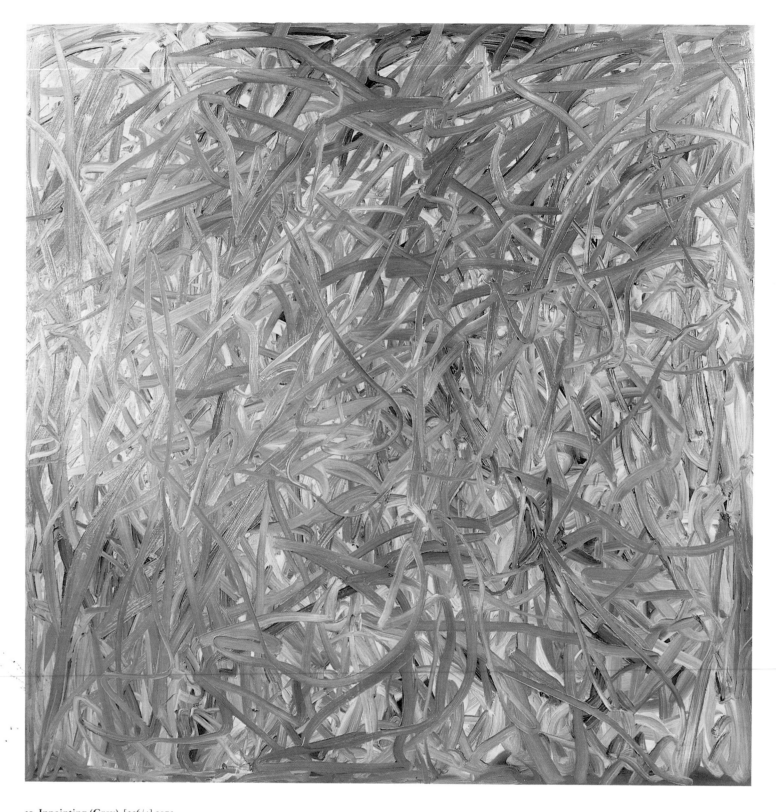

20 Inpainting (Grey) [326/4] 1972

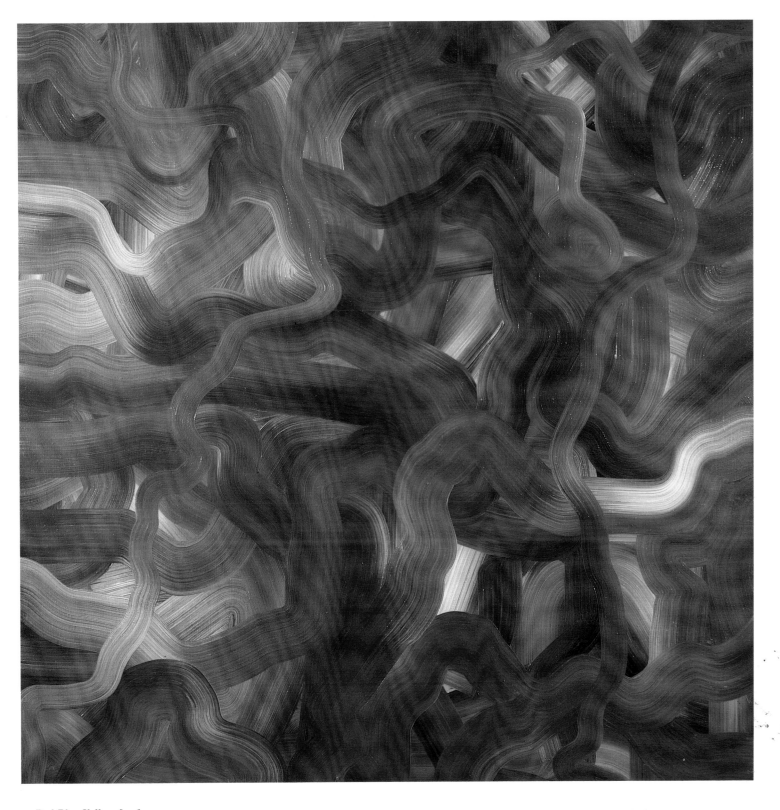

21 **Red-Blue-Yellow** [330] 1972

22 **Grey** [334/3] 1973

27 Grey [348/7] 1973

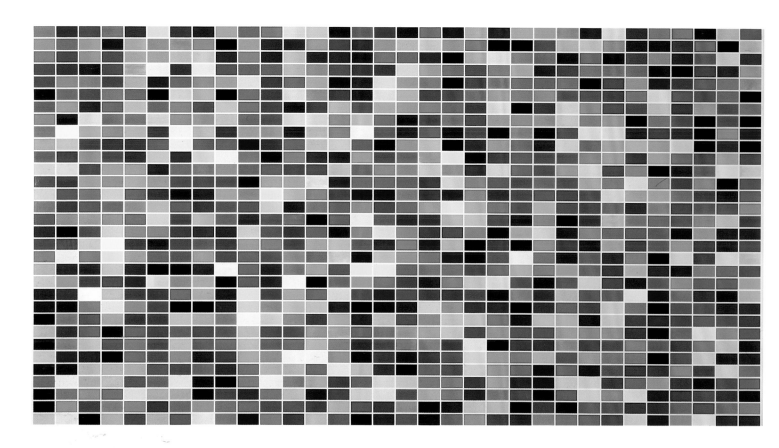

28 1024 Colours [350/4] 1973

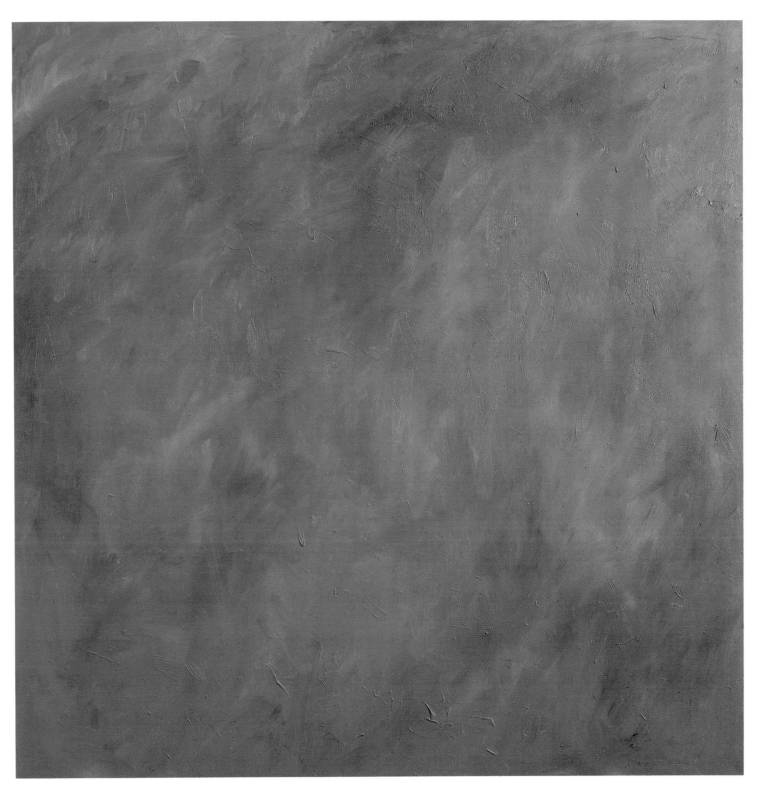

29 **Tourist (Grey)** [368] 1975

30 Tourist (with 2 Lions) [369] 1975

31 Tourist (with 1 Lion) [370] 1975

32 Tourist (with 1 Lion) [370/1] 1975

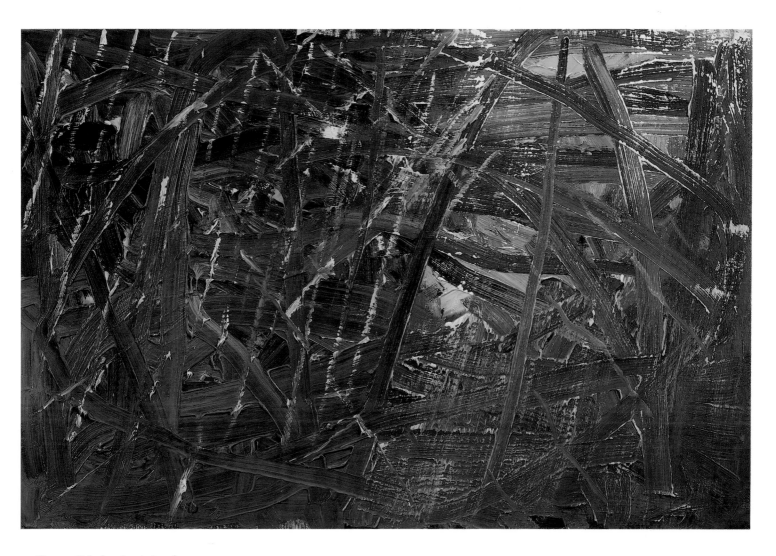

33 **Abstract Painting** [432/11] 1978

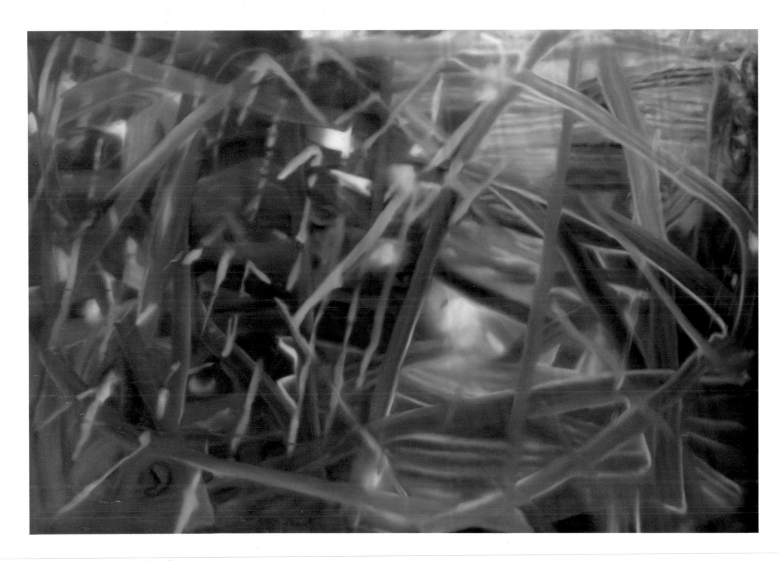

34 Abstract Painting [439] 1978

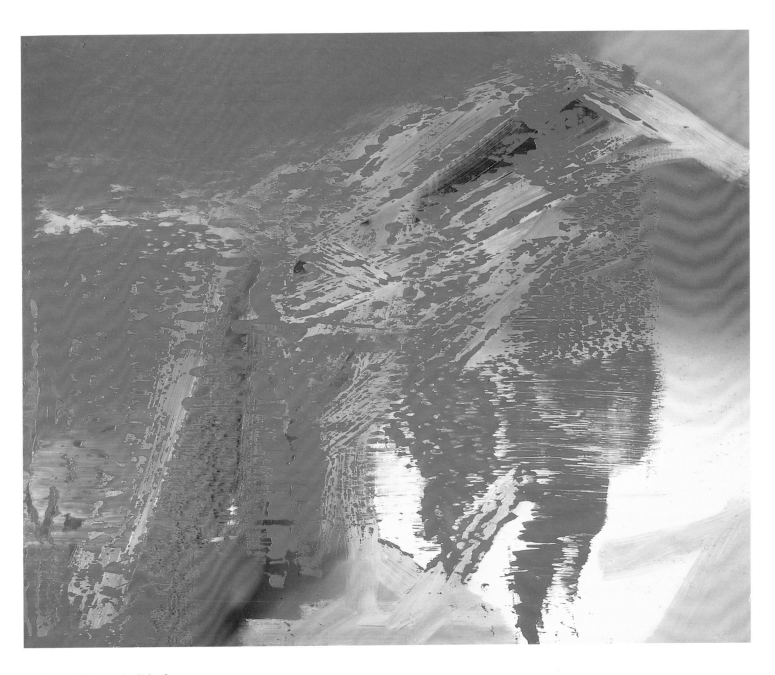

35 **Abstract Painting** [456/2] 1980

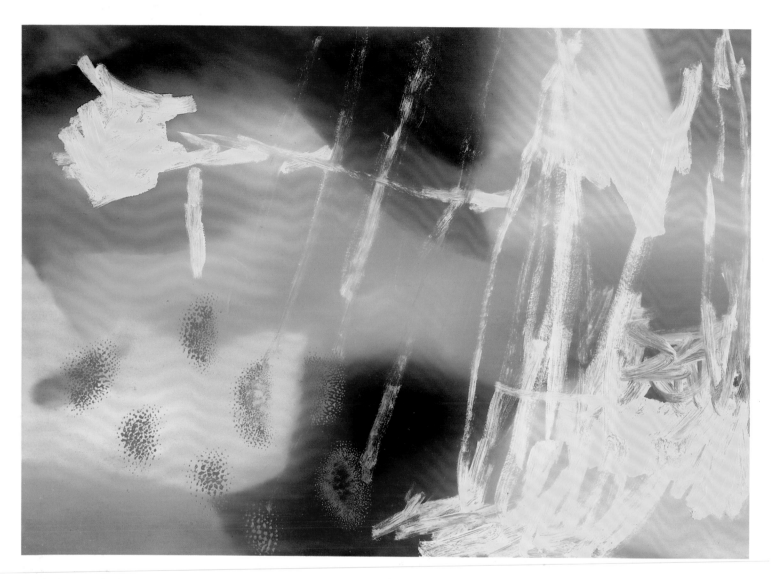

36 **Abstract Sketch** [457/5] 1980

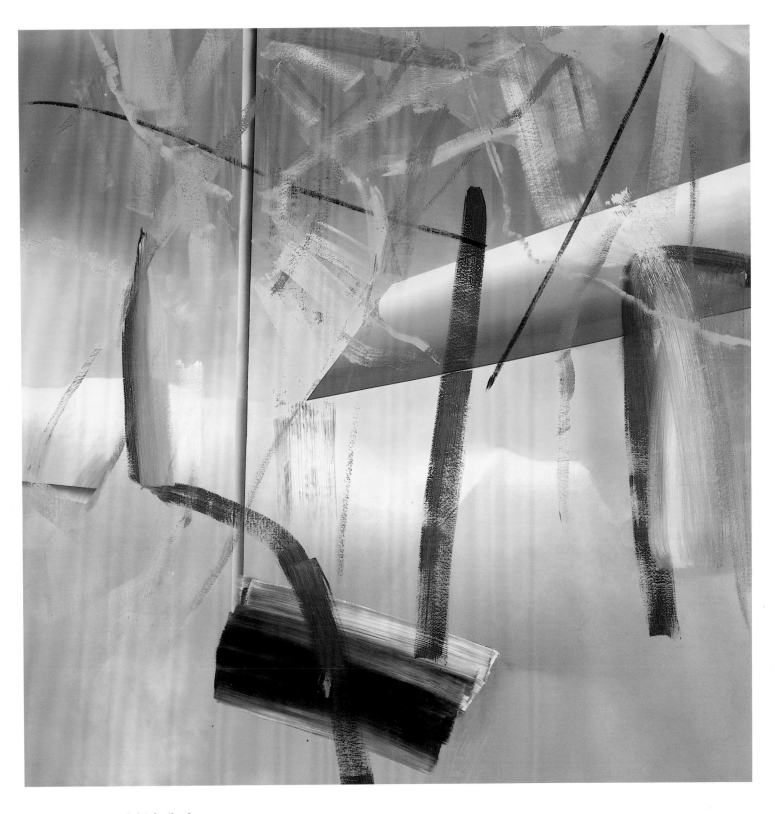

37 **Abstract Painting (July)** [526] 1983

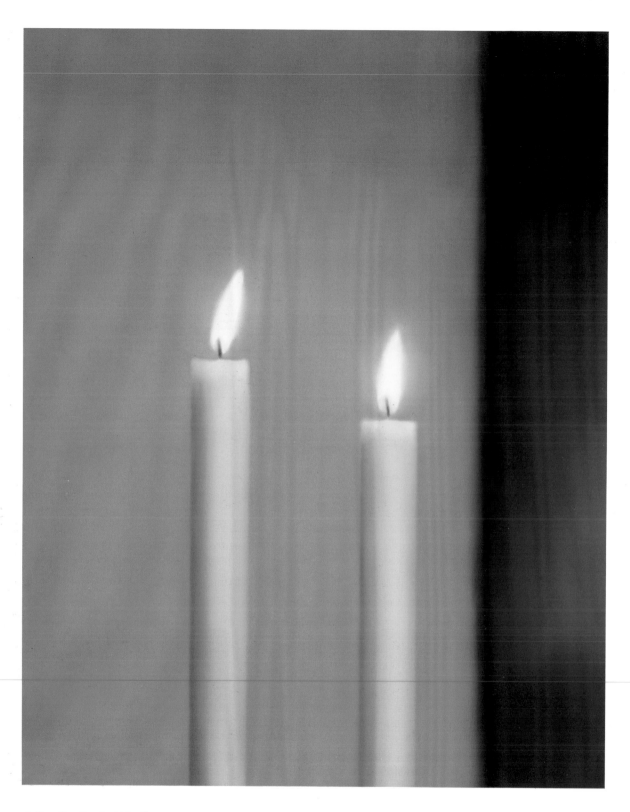

38 Two Candles [546/1] 1983

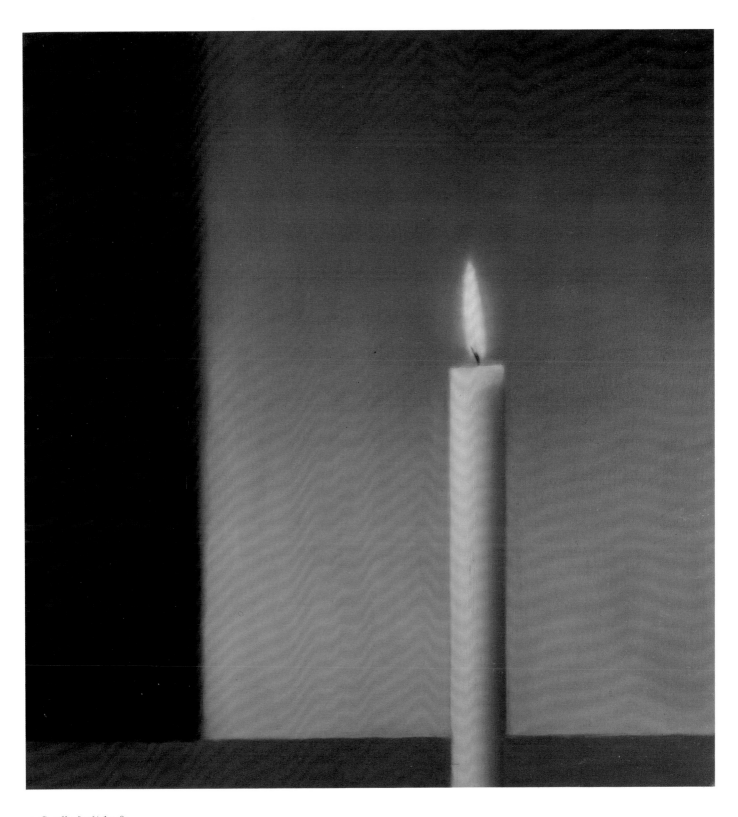

39 Candle [546/2] 1983

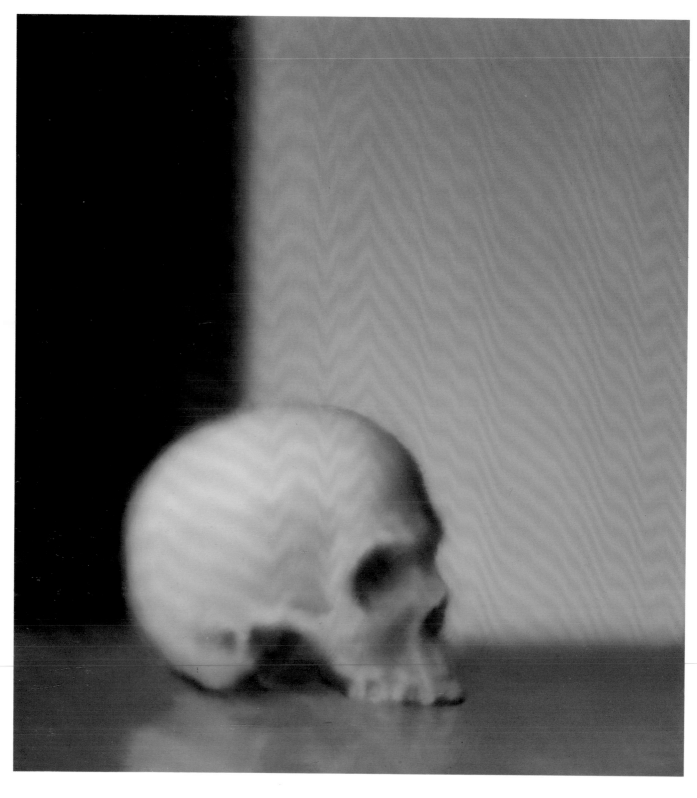

40 Skull [548/1] 1983

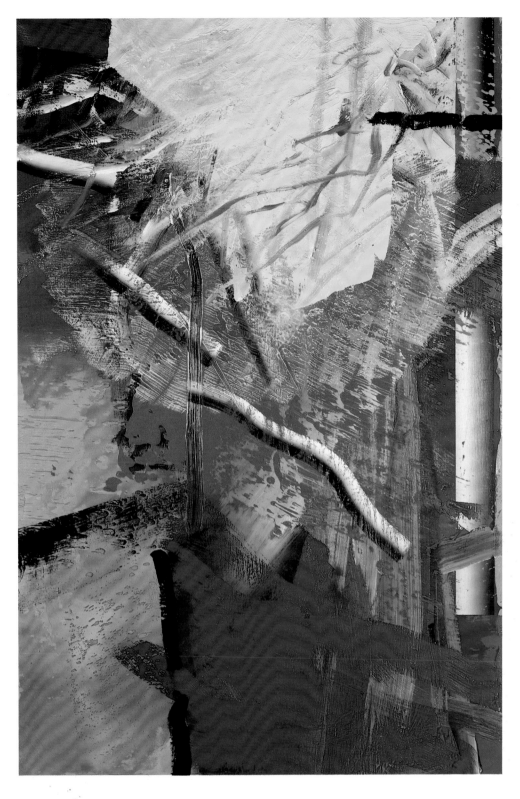

41 **Abstract Painting** [576/3] 1985

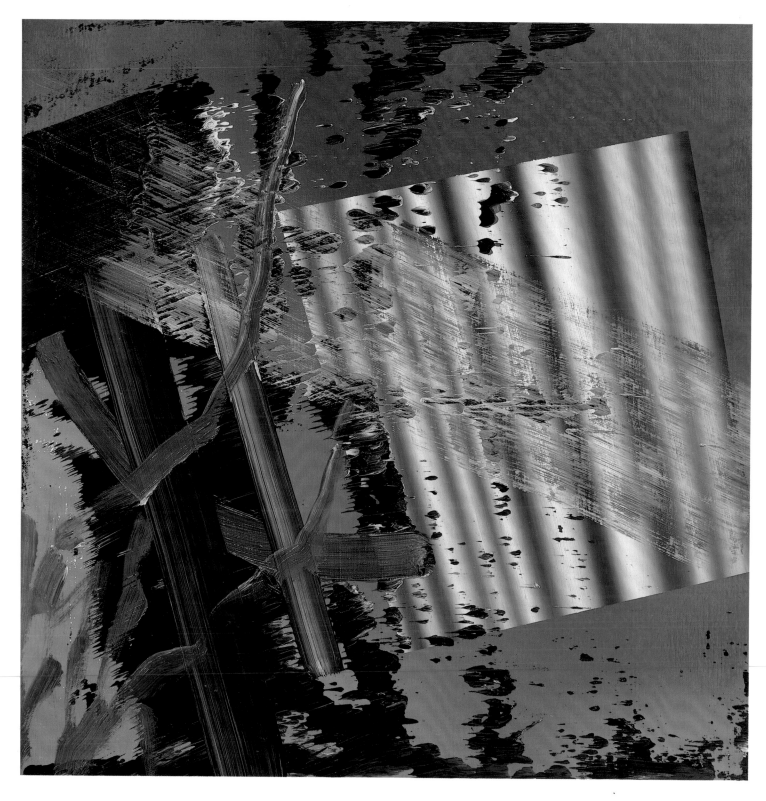

42 Abstract Painting [581/6] 1985

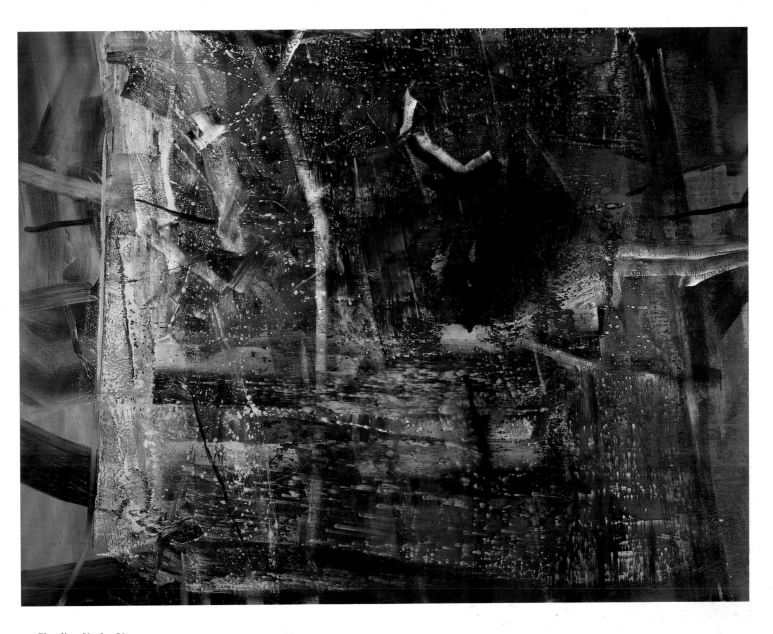

43 Claudius [603] 1986

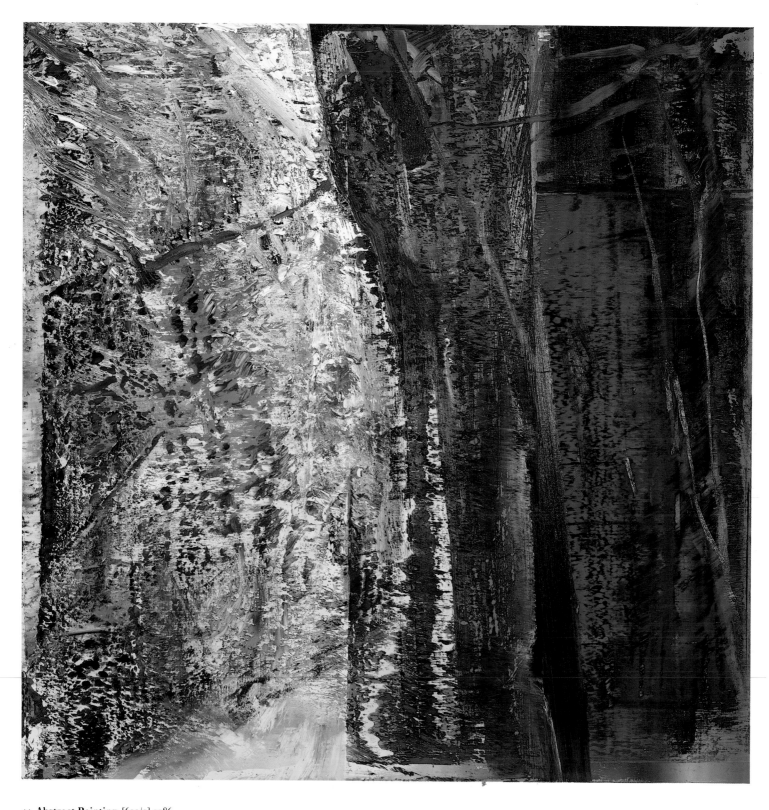

44 **Abstract Painting** [610/3] 1986

45 Cathedral Corner [629/1] 1987

46 Marcay [642/1] 1987

47 Fortress at Königstein [651/2] 1987

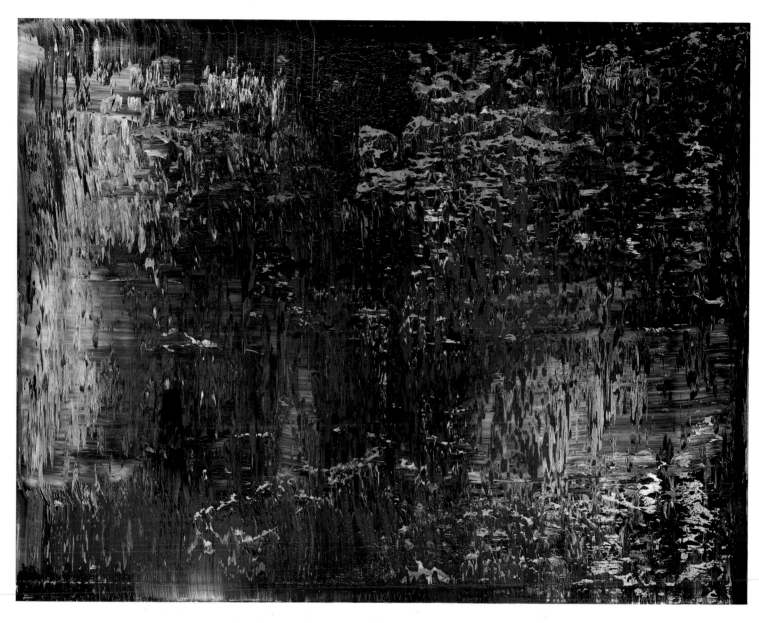

48 St John [653/4] 1988

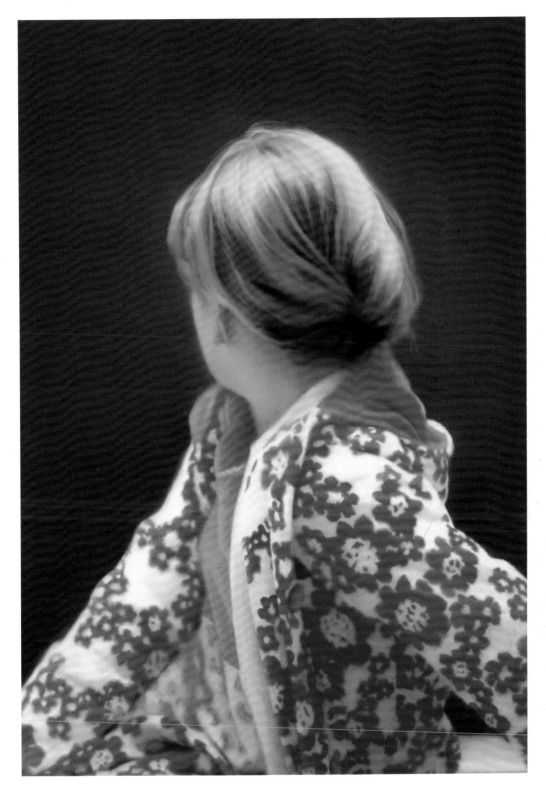

49 Betty [663/5] 1988

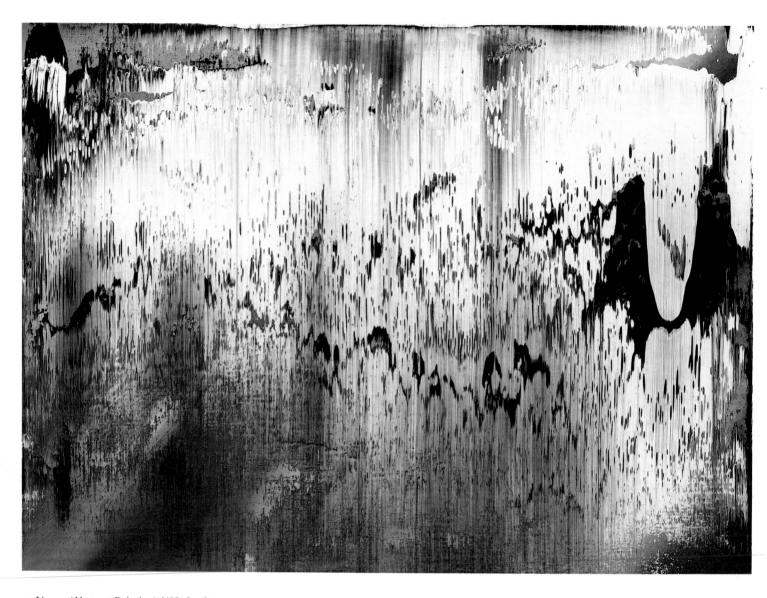

50 Uran 1 (Abstract Painting) [688/1] 1989

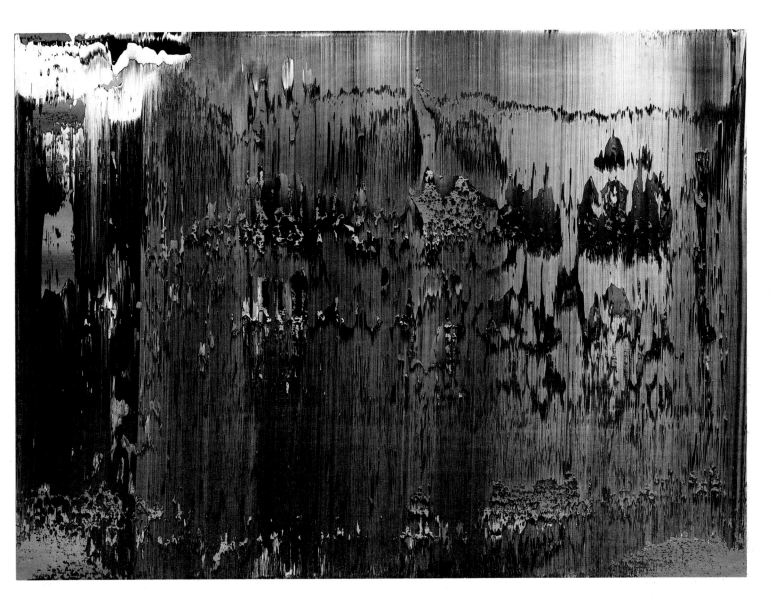

51 Uran 2 (Abstract Painting) [688/2] 1989

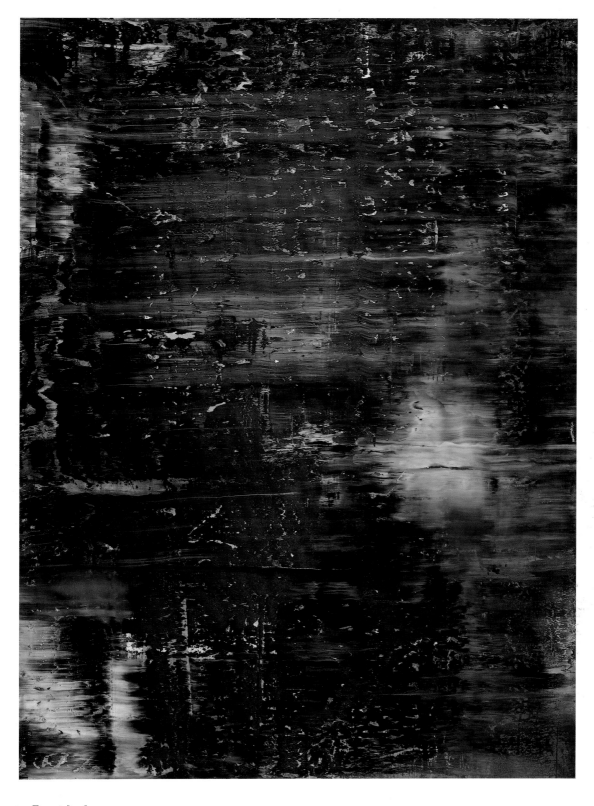

54 **Forest** [731] 1990

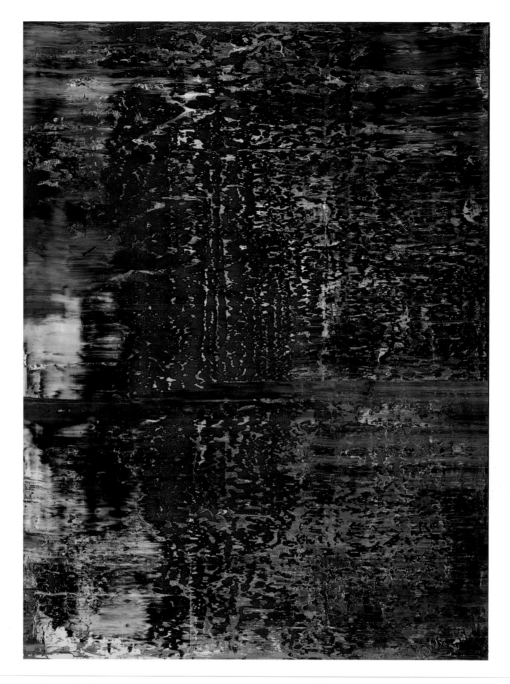

55 **Forest** [732] 1990

Studio photograph. Work in progress
on 'Forest' [732] 1990

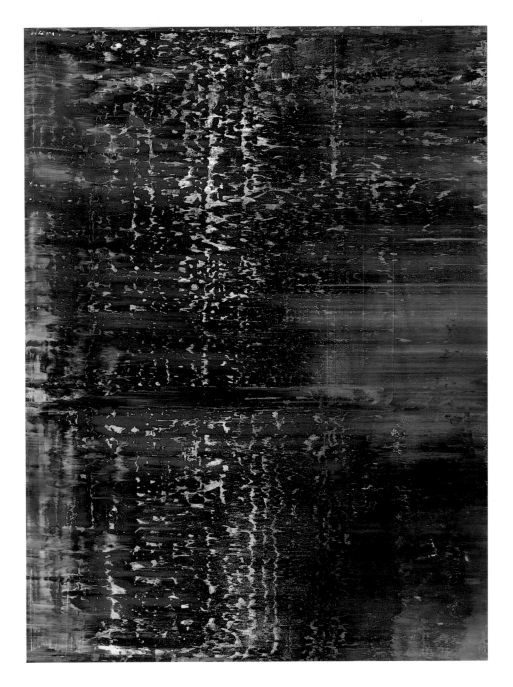

56 Forest [733] 1990

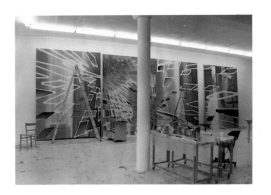

Studio photograph. Work in progress
on 'Forest' series [731–4] 1990

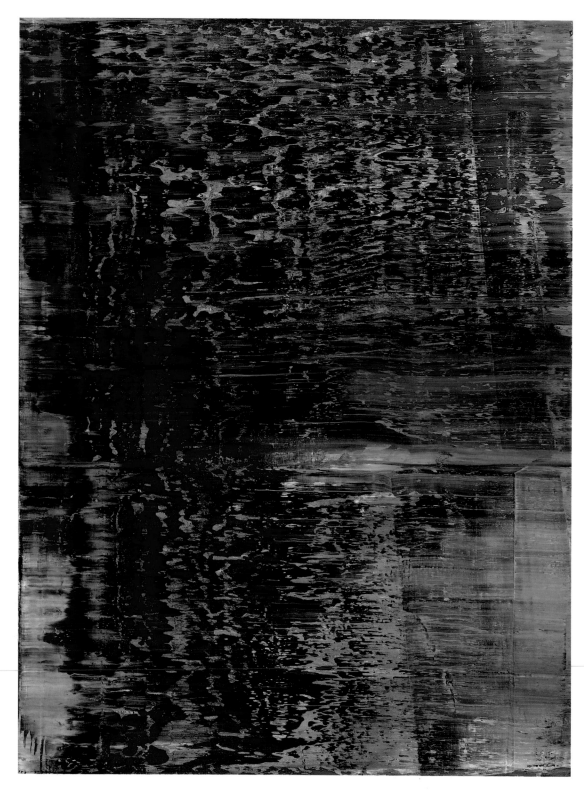

57 Forest [734] 1990

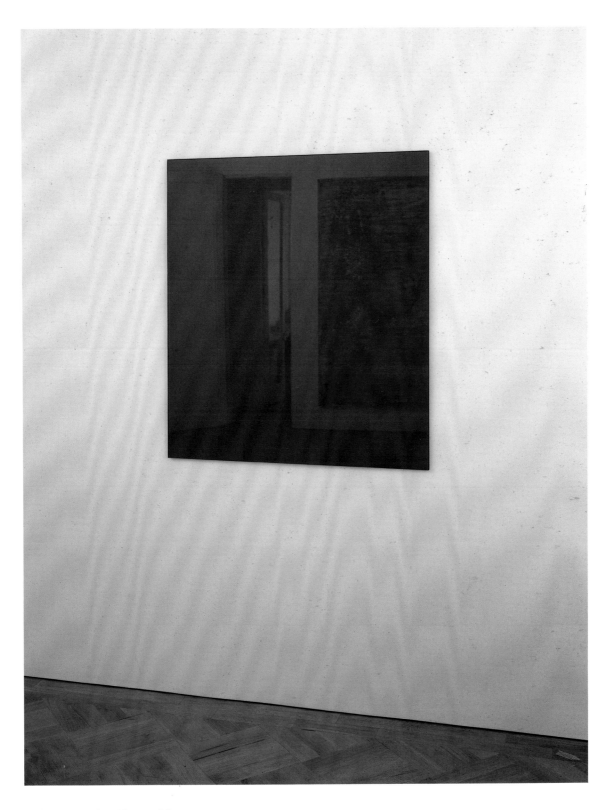

58 Mirror Painting [Grey 739/2] 1991

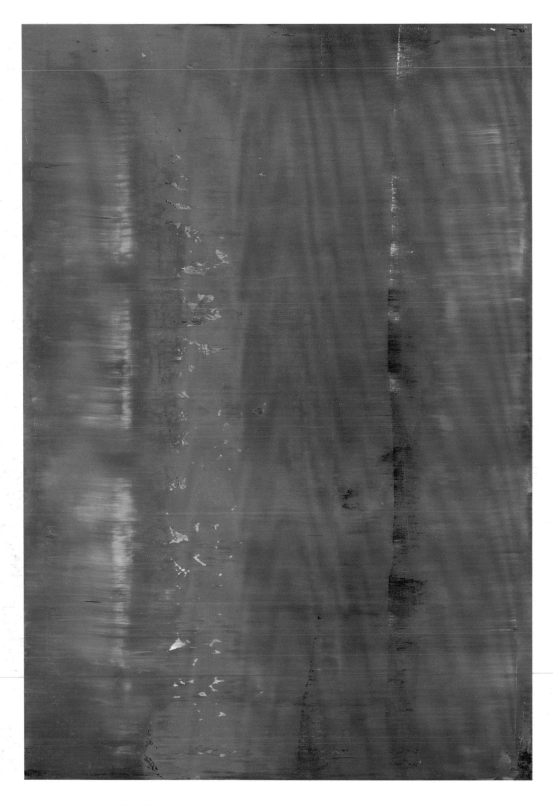

59 Abstract Painting [743/3] 1991

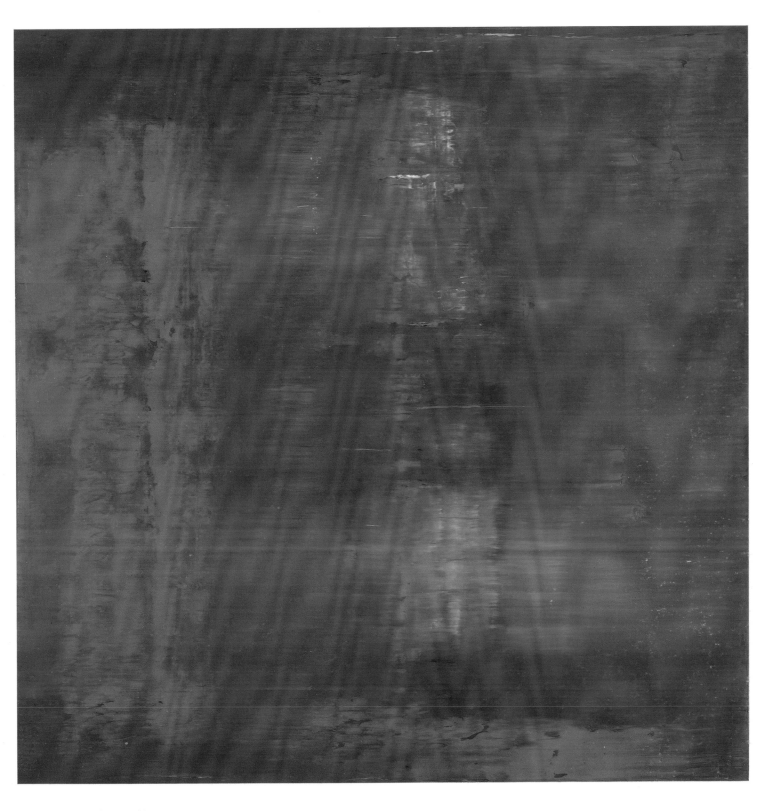

60 Abstract Painting [747/1] 1991

Gerhard Richter:
Notes 1966–1990

Although Richter has emphasised that he is foremost a painter and has never been a theorist, he has, throughout his career, produced a wide variety of writings. For this catalogue, he has agreed to publish a range of texts, many translated for the first time. This group of texts come from all periods of Richter's career, beginning with a previously unpublished text of 1966, and contains both public statements on particular groups of work and his private commentaries on his artistic and philosophical outlook. While his short, explanatory statements on the 'Greys' and 'Colour Charts' have been previously translated, his text for inclusion in the catalogue for Documenta 7 is given in its original form, as a letter to the then Director of the Stedelijk Museum, Amsterdam. In a previously unpublished letter, to Jean-Christophe Ammann, also from the 1970s, Richter discusses many of the current intentions in his works of that period. The main body of writings included here are from the artist's private journals and are translated for the first time. The selection of notebook entries up until 1986 originally appeared in their complete form in an exhibition of Richter's works on paper at the Museum Overholland in Amsterdam. In edited form, they are now augmented by his journal entries from the late 1980s, which the artist has generously agreed to publish, thus bringing up to date the journal Richter has maintained over the past decade. To accompany the texts, we have included a selection of studio photographs taken over the past twenty-five years, many showing work in progress, including some of works in this exhibition.

1966

I do not pursue any particular intentions, system, or direction. I do not have a programme, a style, a course to follow. I have brought not being interested in specialist problems, working themes, in variations towards mastery. I shy away from all restrictions, I do not know what I want, I am inconsistent, indifferent, passive; I like things that are indeterminate and boundless, and I like persistent uncertainty. Other qualities promote achievement, acquisition, success, but they are as superseded as ideologies, views, concepts and names for things.

Now that we do not have priests and philosophers any more, artists are the most important people in the world. That is the only thing that interests me.

1966

Ich verfolge keine Absichten, kein System, keine Richtung. Ich habe kein Programm, keinen Stil, kein Anliegen. Ich halte nichts von fachlichen Problemen, von Arbeitsthemen, von Variationen bis zur Meisterschaft. Ich fliehe jede Festlegung, ich weiß nicht was ich will, ich bin inkonsequent, gleichgültig, passiv; ich mag das Unbestimmte und Uferlose und die fortwährende Unsicherheit. Andere Eigenschaften dienen der Leistung, der Werbung, dem Erfolg, sie sind in jedem Fall überholt wie Ideologien, Ansichten, Begriffe und Namen für etwas.

Nachden es keine Priester und Philosophen mehr gibt, sind die Künstler die wichtigsten Leute auf der Welt. Das ist das Einzige was mich interessiert.

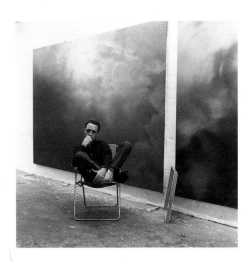

left
Studio photograph, *c.*1965 (with 'Mother and Daughter (B)', 1965)
right
Studio photograph, *c.*1970 (with 'Clouds', 1970)

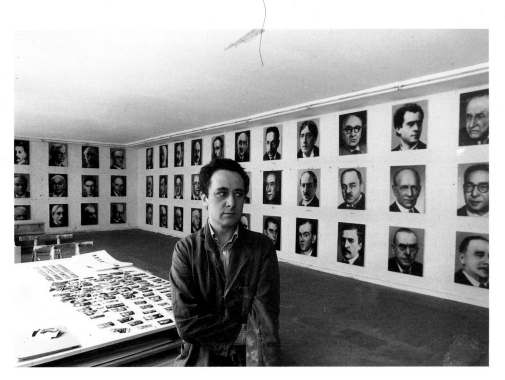

Studio photograph, *c.*1972 (with '48 Portraits', 1972)

1973

(from a letter to Jean-Christophe Ammann, 24.2.73)

The pictures are an idea made visible, or depicted, and the idea should also be readable, both in the individual image and in the context, which of course requires that linguistic information is available about ideas and context. However, this does not mean that the pictures function as illustrations of an idea: ultimately they are the idea itself; also the linguistic formulation of the idea is not a translation of the pictorial, but simply has a certain similarity with the meaning of the idea, is an interpretation, literally an afterthought. So what I intend is the picture, the individual, constructed picture, completed, even if I perhaps doubt that completedness in the very next sentence.

The pictures are related to the more recent Colour Charts, above all to the ones in preparation, where a few examples of an infinite variety of mixtures and possible arrangements represent the infinite number of never-to-be-realised possibilities, the boundlessness and utter and complete meaninglessness that I consider hopeful, not as a slogan: 'everything is nonsense', not as an ideology, for that they are not suited (just as little as style), not even as freedom or truth or even interpretation of meaning – I am convinced that the future needs neither ideology, nor truth, nor freedom; now the question about the meaning of life is ridiculous and ascription of meaning inhuman – I realise that I cannot explain it after all. But from that point of view a picture by Mondrian is not constructivist, but political (still at the moment, and only of necessity for an immediate reason) and after that —

Thus, in the Photo Paintings for example, I tried to grasp this beautiful lack of meaning from the point of view of the *sujet* (choicelessness of the choice, large/small, neither/nor, precise/imprecise – indifference) while the colour panels and abstract pictures offer the possibility of perhaps making that clearer from the making, an analogy with motor activity, which causes something to come into being blindly and by chance. (Certainly that is not blind and by chance, for I am part of the greater whole and can do nothing other than act precisely as rightly as the greater whole does, even if I do not get it myself.)

Incidentally 'jungle', i.e. the real one, seems a suitable example. There everything grows as it grows, not planned, not meaningful, not asked for or necessary but because certain conditions, space, nutrition, etc. are there by chance, therefore neither good nor bad, nor free, nor intended for a particular end or purpose.

The 'Jungle' pictures in the [Venice] Biennale use nature's colours; I took a long time to consider my materials, with which I can manufacture everything, red–blue–yellow (and light = white), pictures that emerge from a process. Three primary colours as a starting point for an endless chain of colour tones; either tone by tone systematically multiplied and exactly represented (colour panels) or in this artificial jungle, the colour shades and shapes emerge in the course of constant mixture by brushstrokes, form illusionistic three-dimensionality, without my needing to invent forms or signs: the

1973

(Auszüge aus einem Brief an Jean-Christophe Ammann 24.2.73)

Die Bilder sind zwar veranschaulichte Idee, oder bildgewordene, und die Idee soll auch ablesbar sein, sowohl im Einzelbild wie im Zusammenhang, was natürlich voraussetzt, daß über Idee und Kontext sprachlich informiert wird. Das heißt aber nicht, daß sie als Illustration einer Idee fungieren, sondern die Bilder sind letztlich die Idee selbst; die sprachliche Formulierung der Idee ist auch keine Übersetzung vom Bildnerischen, sondern hat lediglich eine gewisse Ähnlichkeit mit der Meinung der Idee, ist Interpretation, wörtlich genommen Nachdenken. Ich will also das Bild, das einzelne in sich abgeschlossene Gebilde, auch wenn ich es im nächsten Satz vielleicht bezweifle, das Abgeschlossensein.

Die Bilder sind den neueren, vor allem den geplanten Farbtafeln verwandt, wo einige wenige Beispiele von unendlich vielen Mischungen und möglichen Anordnungen für die unendlichen nie zu verwirklichenden Möglichkeiten stehen, für das Uferlose, ganz und gar Sinnlose, das ich für so hoffnungsvoll halte, nicht als Parole 'alles ist Quatsch', nicht als Ideologie, denn dafür eignet es sich nicht (ebenso wenig als Stil), nicht einmal als Freiheit oder Wahrheit oder gar Sinngebung –, ich bin überzeugt, daß die Zukunft weder Ideologie, noch Wahrheit, noch Freiheit braucht; schon jetzt ist die Frage nach dem Sinn des Lebens lächerlich, und Sinngebung unmenschlich – ich merke, daß ich es doch nicht erklären kann. Aber von daher ist auch ein Bild von Mondrian nicht konstruktivistisch, sondern politisch (im Moment noch, und nur gezwungenermaßen aus aktuellem Anlaß) und danach —

Also, in den Fotobildern z.B. versuchte ich diese schöne Sinnlosigkeit vom Sujet her zu begreifen (Wahllosigkeit der Auswahl, groß/klein, weder/noch, genau/ungenau, – Indifferenz), während die Farbtafeln und die abstrakten Bilder die Möglichkeit bieten, das vielleicht deutlicher aus dem Machen heraus zu machen, eine Analogie der Motorik, die blind und zufällig was entstehen läßt. (Sicher ist das nicht blind und zufällig, denn ich bin ja Teil vom Großen Ganzen und kann also gar nicht anders als genau so richtig handeln wie es das Große Ganze tut, auch wenn ich es selbst nicht kapiere.)

Übrigens 'Dschungel', d.h. der wirkliche kommt mir als Beispiel gelegen. Da wächst alles wie es wächst, nicht geplant, nicht sinnvoll, nicht gefragt oder notwendig, sondern weil bestimmte Bedingungen, Raum, Nahrung etc., zufällig da sind oder nicht da sind. Also weder gut noch böse, noch frei, noch zu einem Ziel oder Zweck hin.

Die 'Dschungelbilder' der Biennale haben die Farben von der Natur; es hat lange gedauert, bis ich mich auf mein Werkzeug besinnen konnte, mit dem ich alles herstellen kann, Rot-Blau-Gelb (und Licht = Weiß), Bilder die aus dem Prozeß entstehen. Drei Grundfarben als Ausgang für unendliche Ketten von Farbtönen; entweder Ton für Ton systematisch multipliziert und exakt dargestellt (Farbtafeln), oder dieser künstliche Dschungel, die Farbtöne und Formen entstehen im Verlauf

paintbrush moves in the given path from patch of colour to patch of colour, first mediating, then more or less destroying, mixing up until there is no space left untouched, everything almost a mush, the coequal of form, shape and colour. Pictures that emerge, grow from the making, not creations, not creative in the sense of this mendacious word (I mention that because I loathe the word so much) – but certainly creaturely. In order to illustrate the fascination that jungle-like intertwining forms have on me: as I child, after I had eaten all my food and while my supper plate was slightly greasy, I daubed loops with my finger, curves that constantly cut across each other and produced fantastic spatial structures that changed according to the light, that could be reshaped endlessly. I find this changing and allowing to flow, relativising, more attractive than fixed form, than set signs. This all has something to do with the 'informel', which suits me very well, because it is the opposite of death, which anyway does not exist, because it is uninteresting.

As I now see it, all my pictures are actually 'informel' (the glasses anyway, unfortunately I have not got any further with that) – with the possible exception of the landscapes. A picture by Caspar David Friedrich is not a thing of the past, the only thing of the past are some of the circumstances that caused it to come into being, e.g. certain ideologies; over and above this, if it is 'good' it affects us, beyond ideologies, as art, which we go to some lengths to defend (perceive, exhibit, make). Thus one can paint like C.D. Friedrich 'today'.

1974

1024 Colours in 4 Permutations
(1973, gloss on canvas, each 254 × 478 cm)

In order to represent all shades of colour that occur in one picture I developed a system that – starting on the basis of the three primary colours and grey – proceeded in stages that were always equal and made possible an ever-increasing degree of differentiation. $4 \times 4 = 16 \times 4 = 64 \times 4 = 256 \times 4 = 1024$. The number 4 was necessary as a multiplier because I wanted to keep picture size, field size and number of fields in constant proportion. It seemed pointless to me to use more than 1024 colour shades (e.g. 4096) because then it would not have been possible to see the distinction between one shade of colour and the next.

The colours were arranged randomly in the fields in order to achieve a diffuse, indifferent overall effect, with the possibility of exciting detail. The rigid grid prevents the emergence of figurations, although these can be seen with an effort. This kind of artificial naturalism is an aspect that fascinates me, in the same way as the fact that if I had painted all possible permutations, it would need over 400 billion light years to pass from the first to the last picture. I wanted to paint four large coloured pictures.

der ständigen Vermischung durch Pinselbahnen, bilden illusionistische Räumlichkeit, ohne daß ich Formen oder Zeichen erfinden müßte: der Pinsel zieht den gegebenen Weg von Farbfleck zu Farbfleck, erst vermittelnd, dann mehr oder weniger zerstörend, vermischend bis es keine unberührte Stelle mehr gibt, alles fast ein Brei, gleichrangige Verflechtung von Formen, Raum und Farbe. Bilder die sich ergeben, aus dem Machen entstehen, keine Kreationen, nicht kreativ, im Sinne dieses verlogenen Wortes (ich erwähne das, weil ich das Wort so verabscheue) – sicher aber kreatürlich. Um die Faszination, die die dschungelartigen Formverflechtungen auf mich ausüben, zu illustrieren: als Kind schmierte ich mit dem Finger auf dem leergegessenen leicht fettigen Abendbrotteller Schleifen, Kurven, die sich immer wieder überschneiden und phantastische räumliche Gebilde ergeben, die sich je nach Beleuchtung ändern, die man endlos weiterformen kann. Das finde [ich] reizvoller als die feste Form, als das gesetzte Zeichen, wechseln und fließen lassen, relativieren, das hat schon was mit Informel zu tun, was mir sehr paßt, weil es das Gegenteil von Tod ist, den es ja auch gar nicht gibt, weil er uninteressant ist.

Wie ich es jetzt sehe, sind eigentlich alle meine Bilder informel (die Gläser sowieso, leider bin ich damit noch nicht weitergekommen) – bis auf die Landschaften vielleicht.

Ein Bild von C.D. Friedrich ist nicht vorbei, vorbei sind nur einige Umstände die es entstehen ließen, z.B. bestimmte Ideologien; darüber hinaus, wenn es 'gut' ist, betrifft es uns, überideologisch, als Kunst, die wir mit einigem Aufwand verteidigen (wahrnehemen, ausstellen, machen). Man kann also 'heute' wie C.D. Friedrich malen.

1974

1024 Farben in 4 Permutationen
(1973, Lack auf Leinwand, je 254 × 478 cm)

Um alle vorkommenden Farbtöne auf einem Bild darstellen zu können, entwickelte ich ein System, das – ausgehend von den 3 Grundfarben + Grau – in stets gleichmäßigen Sprüngen eine immer weitgehendere Aufspaltung (Differenzierung) ermöglichte. $4 \times 4 = 16 \times 4 = 64 \times 4 = 256 \times 4 = 1024$. Die Zahl '4' als Multiplikator war notwendig weil ich eine gleichbleibende Proportion von Bildgröße, Feldgröße und Felderanzahl erhalten wollte. Die Verwendung von mehr als 1024 Farbtönen (z.B. 4096) erschien mir sinnlos, da dann die Unterschiede von einer Farbstufe zur nächsten nicht mehr sichtbar wären.

Die Anordnung der Farbtöne auf den Feldern erfolgte per Zufall, um eine diffuse, gleichgültige Gesamtwirkung zu erzielen, während das Detail aufregend sein kann. Das starre Raster verhindert die Entstehung von Figurationen, obwohl diese mit Anstrengung sichtbar werden können. Diese Art von künstlichem Naturalismus ist ein Aspekt, der mich fasziniert wie die Tatsache, daß, wenn ich alle möglichen Permutationen gemalt hätte, das Licht über 400 Billionen Jahre brauchte, um vom ersten bis zum letzten Bild zu kommen. Ich wollte vier große bunte Bilder malen.

1975

(from a letter to E. de Wilde, 23.2.75)

At first (about eight years ago) when I painted a few canvases grey I did so because I did not know what I should paint or what there might be to paint, and it was clear to me when I did this that such a wretched starting point could only lead to nonsensical results. But in time I noticed differences in quality between the grey surfaces and also that these did not not reveal anything of the destructive motivation. The pictures started to instruct me. By generalising the personal dilemma they removed it; misery became a constructive statement, became relative perfection and beauty, in other words became painting.

Grey. Grey is the epitome of non-statement, it does not trigger off feelings or associations, it is actually neither visible nor invisible. Its inconspicuousness makes it suitable for mediation, for illustration, and in that way virtually as an illusion, like a photograph. And like no other colour it is suitable for illustrating 'nothing'.

For me grey is the welcome and only possible equivalent for indifference, for the refusal to make a statement, for lack of opinion, lack of form. But because grey, just like shapelessness, etc. can only be notionally real, I can only produce a shade of colour that means grey but is not grey. The picture is then a mixture of grey as fiction and grey as a visible, proportioned colour surface.

In conclusion: I am fascinated by this kind of reduced painting in general because it attempts scrupulously and with great care to achieve correctness or better commitment, because it strives to attain a quality that tends towards validity and generalisation. This seems important to me when faced with mindlessly proliferating productivity that is becoming ever less committed.

1982

(first published in exhibition catalogue *Documenta 7*, 1982)

When we describe a process, draw up an invoice or take a photograph of a tree we are creating models; without these we would know nothing of reality, we would be animals. Abstract pictures are fictitious models because they illustrate a reality that we can neither see nor describe, but whose existence we can infer. These we describe with negative concepts: un-known, in-conceivable, in-finite, and for millennia we portrayed them in surrogate pictures as heaven, hell, gods and devils.

With abstract painting we created for ourselves a better possibility of approaching what is non-visual and incomprehensible, because it portrays 'nothing' directly visually, with all the means available to art. Used to

1975

(Auszuge aus einem Brief an E. de Wilde, 23.2.75)

Als ich anfangs (vor ungefähr 8 Jahren) einige Leinwände grau zustrich, tat ich das weil ich nicht wußte was ich malen sollte oder was zu malen wäre, und es war mir dabei klar, daß so ein erbärmlicher Anlaß auch nur unsinnige Resultate zur Folge haben konnte. Mit der Zeit jedoch bemerkte ich Qualitätsunterschiede zwischen den Grauflächen und auch daß diese nichts von der destruktiven Motivation zeigten. Die Bilder fingen an, mich zu belehren. Indem sie das persönliche Dilemma verallgemeinerten, hoben sie es auf; das Elend geriet zu konstruktiver Aussage, relativer Vollkommenheit und Schönheit, also zu Malerei.

Grau. Es hat schlechthin keine Aussage, es löst weder Gefühle noch Assoziationen aus, es ist eigentlich weder sichtbar noch unsichtbar. Die Unscheinbarkeit macht es so geeignet zu vermitteln, zu veranschaulichen, und zwar in geradezu illusionistischer Weise gleich einem Foto. Und es ist wie keine andere Farbe geeignet, 'nichts' zu veranschaulichen.

Grau ist für mich die willkommene und einzig mögliche Entsprechung zu Indifferenz, Aussageverweigerung, Meinungslosigkeit, Gestaltlosigkeit. Weil aber Grau, genau wie Gestaltlosigkeit usf., nur als Idee wirklich sein kann, kann ich auch nur einen Farbton herstellen, der Grau meint aber nicht ist. Das Bild ist dann die Mischung von Grau als Fiktion und Grau als sichtbarer proportionierter Farbfläche.

Abschließend noch: mich fasziniert diese Art reduzierter Malerei ganz allgemein; weil ich glaube, daß sie voller Skrupel, und mit großer Vorsicht eine Richtigkeit oder besser Verbindlichkeit von Malerei versucht, daß sie eine Qualität anstrebt, die zum Gültigen und Allgemeinen tendiert. Das scheint mir wichtig, angesichts einer bedenkenlosen wuchernden Produktivität, die immer unverbindlicher wird.

1982

[Erstveröffentlichung im Katalog *Documenta 7*, 1982]

Wenn wir einen Vorgang beschreiben, eine Rechnung aufstellen oder einen Baum fotografieren, schaffen wir Modelle; ohne sie wüssten wir nichts von Wirklichkeit und wären Tiere.

Abstrakte Bilder sind fiktive Modelle, weil sie eine Wirklichkeit veranschaulichen, die wir weder sehen noch beschreiben können, auf deren Existenz wir aber schliessen können. Diese bezeichnen wir mit Negativbegriffen: das Nicht-Bekannte, Un-Begreifliche, Un-Endliche, und sie schilderten wir seit Jahrtausenden in Ersatzbildern mit Himmel, Hölle, Göttern und Teufeln.

Mit der abstrakten Malerei schufen wir uns eine bessere Möglichkeit, das Unanschauliche, Unverständliche anzugehen, weil sie in direktester Anschaulichkeit, also mit allen Mitteln der Kunst

recognising something real in pictures, we rightly refuse to regard only colour (in all its multiplicity) as what has been made visible and instead involve ourselves in seeing the non-visual, that which hitherto had never been seen and that is not visible. This is not an artful game, but necessity; because everything that is unknown makes us anxious and at the same time puts us in a hopeful mood, we take the pictures as a possibility of making the inexplicable perhaps somewhat more explicable, but in any case more accessible. Of course, figurative pictures have this transcendental side as well; because every object also embodies this as part of a world that is ultimately, primarily, fundamentally incomprehensible, it shows that mysteriousness all the more vividly when represented in a picture the less 'function' the representation has. This explains the ever-increasing fascination of, for example, so many old and beautiful portraits. Thus paintings are all the better, the more beautiful, intelligent, crazy and extreme, the more clearly perceptible and the less decipherable metaphors they are for this incomprehensible reality.

Art is the highest form of hope.

1983

27.1.83

Traditional, so-called old works of art are not old, but up to date. For as long as we 'have' them, in the broadest sense, they will never be superseded. We are not putting anything of the same calibre alongside them, nor will we equal or exceed their quality. Their permanent presence makes that other work that we produce today necessary, and it is neither better nor worse, but has to be different, because we painted the Isenheim altarpiece yesterday.

This does not mean that it would be useless to produce something similar to what has come down to us. But the more precisely we know what has been handed down, and therefore ourselves, the more responsibly we handle it, the better things we do similarly and things we do differently will be.

For this reason it is correct that the academies no longer offer traditional training and in this sense produce only people who are self-taught. Training in traditional skills would be against the academies' tradition of continually being up to date.

Essentially art always had to do with need, despair and helplessness (I am thinking of Crucifixion stories from the Middle Ages to Grünewald, but also of Renaissance portraits, of Mondrian and Rembrandt or Donatello and Pollock), and we often neglect this content by making the formal, aesthetic side too important in isolation. Then we no longer see content in form, but form as the thing that contains content (like beauty and skill slapped on top), something additional, something that rewards examination. And yet content has no form (like a dress that you can change), but is itself form (that cannot be changed).

'nichts' schildert. Gewohnt, etwas Reales auf Bildern zu erkennen, weigern wir uns mit Recht, nur Farbe (in aller Mannigfaltigkeit) als das Veranschaulichte anzusehen und lassen uns statt dessen darauf ein, das Unanschauliche zu sehen, das was vordem nie gesehen wurde und was nicht sichtbar ist. Das ist kein kunstvolles Spiel sondern Notwendigkeit; weil alles Unbekannte uns ängstigt und gleichzeitig hoffnungsvoll stimmt, nehmen wir die Bilder als Möglichkeit, das Unerklärliche vielleicht etwas erklärlicher, auf jeden Fall aber umgänglicher zu machen. – Natürlich haben auch gegenständliche Bilder diese transzendentale Seite; weil jeder Gegenstand als Teil einer im Letzten, Ersten, Grundsätzlichen unverständlichen Welt diese auch verkörpert, zeigt er im Bilde dargestellt um so eindringlicher alle Rätselhaftigkeit je weniger 'Funktion' die Darstellung hat. Daher kommt die immer stärker werdende Faszination z.B. so vieler alter schöner Bildnisse. – So sind Bilder um so besser, je schöner, klüger, irrsinniger und extremer, je anschaulicher und unverständlicher sie im Gleichnis diese unbegreifliche Wirklichkeit schildern.

Die Kunst ist die höchste Form von Hoffnung.

1983

27.1.83

Überlieferte, sogenannte alte Kunstwerke sind nicht alt, sondern aktuell. Sie werden, solange wir sie im weitesten Sinne 'haben', nie überholt sein, und wir stellen ihnen weder etwas Gleichrangiges zur Seite, noch werden wir ihre Qualität erreichen oder überragen. Ihre permanente Gegenwart macht das Andere erforderlich, das wir heute herstellen, das weder besser noch schlechter ist, sondern deshalb anders sein muß, weil wir gestern den Isenheimer Altar gemalt haben.

Das heißt nicht, daß es unnütz wäre, etwas dem Überlieferten ähnliches herzustellen. Aber je genauer wir das Überlieferte, also uns, kennen, je verantwortungsvoller wir damit umgehen, desto besser wird das sein, was wir ähnlich und das, was wir anders machen.

Deshalb ist es richtig, daß die Akademien keine traditionelle Ausbildung mehr bieten und in diesem Sinne nur noch Autodidakten hervorbringen. Denn die Ausbildung in traditionellen Fertigkeiten wäre gegen die Tradition der Akademien, fortwährend Gegenwart sein zu können.

Kunst hatte immer im wesentlichen mit Not, Verzweiflung und Ohnmacht zu tun (ich denke an die Kreuzigungsgeschichten vom Mittelalter bis zu Grünewald, aber auch an Renaissance-Bildnisse, an Mondrian und Rembrandt oder Donatello und Pollock), und diesen Inhalt vernachlässigen wir oft, indem wir die formale, ästhetische Seite zu isoliert wichtig nehmen. Dann sehen wir in der Form nicht mehr den Inhalt, sondern die Form als das den Inhalt Fassende und (wie übergestülpte Schönheit und Kunstfertigkeit) Zusätzliche, was sich lohnt zu untersuchen. Dabei hat der Inhalt keine Form (wie ein Kleid, das man wechseln kann), sondern ist Form (die nicht wechselbar ist).

13.5.83

I have always had a resigned insight that we can do nothing, that utopia is meaningless, if not criminal. The photopaintings, colour charts and Grey paintings were all produced with this 'structure'. In all these cases I kept in the back of my mind the belief that utopia, meaning, future, hope may appear, as we work, so to speak, as something that happens to us because nature is (therefore we are) infinitely better, cleverer, richer than anything we can think out for ourselves with our brief, limited, narrow understanding.

1984

15.4.84

All assertions about the future, about things that we don't know, all assumptions, ideologies, speculations, constructions, all acts of faith, all propagated certainties are nothing but superstition and only prove that we have fantasy, that is to say the ability to imagine. We should not use this ability in order to deceive ourselves.

23.4.84

I have let myself in for thinking and acting without the assistance of an ideology; I have nothing to help me, no idea that I serve and in return am told what is to be done, no rules to determine 'how' things be done, no faith that points me in a particular direction, no picture of the future, no construction that gives higher meaning. I recognise only what is and accordingly consider senseless any description and depiction of things that we do not know. Ideologies seduce and always exploit ignorance, legitimise war.

15.6.84

Lack of education, directness, spontaneity, authenticity(!): that is reductive art, art that avoids all artificiality, that does not want to fool us any more, that weeds out all skill and complexity of references as disturbing.

21.9.84

Certainly Piloty, Makart and all the other salon artists were much more influential and crucial in their time than Manet, Mondrian and the like, i.e. they were even more important for society and not only in the negative sense that they supported the reactionary status quo; they also supported a social order that was no longer tenable but nevertheless one that functioned fundamentally socially, in fact just as every social order has functioned for thousands of years, namely as necessary as it was and is and will be; more or less unjust, antisocial or criminal. There is no way out of this, but there is utopia, that more or less woolly, unconcrete hope. But I intended to say

13.5.83

Die resignierende Einsicht, daß wir nichts machen können, daß Utopie sinnlos, wenn nicht verbrecherisch ist, hatte ich immer. Mit dieser 'Struktur' entstanden die Fotobilder, die Farbfelder, die Grauen Bilder. Bei all dem behielt ich im Hinterkopf den Glauben, daß sich Utopie, Sinn, Zukunft, Hoffnung einstellen mögen, sozusagen unter der Hand als etwas, das einem unterläuft, weil die Natur also wir, unendlich besser, klüger, reicher ist als das, was wir mit unserem kurzen, begrenzten, engen Verstand uns ausdenken können.

1984

15.4.84

Alle Behauptungen über Künftiges, über das, was wir nicht wissen, alle Annahmen, Ideologien, Spekulationen, Konstruktionen, alle Glaubensakte, alle propagierten Gewißheiten sind nichts als Aberglaube und beweisen nur, daß wir Phantasie, also Vorstellungsvermögen besitzen. Wir sollten dieses Vermögen nicht benutzen, um uns zu betrügen.

23.4.84

Ich habe mich darauf eingelassen, zu denken und zu handeln ohne die Hilfe einer Ideologie; ich habe nichts was mir hilft, keine Idee, der ich diene und dafür gesagt bekomme, was zu tun sei, kein Reglement, das das Wie Bestimmt, keinen Glauben, der mir die Richtung zeigt, kein Bild der Zukunft, keine Konstruktion, die übergeordneten Sinn gibt.

Ich erkenne nur an was ist und halte dementsprechend jede Beschreibung und Verbildlichung von dem, was wir nicht wissen für unsinnig. Ideologien verführen und beuten immer die Unwissenheit aus, legitimieren den Krieg.

15.6.84

Unbildung, Direktheit, Unmittelbarkeit, Spontanität, Authentizität(!): reduzierte Kunst ist das, Kunst, die alle Künstlichkeit vermeidet, die uns nichts mehr vormachen will, die alle Kunstfertigkeit, Komplexität der Bezüge als störend ausmerzt.

21.9.84

Sicher sind Piloty, Makart und wie die Salonkünstler alle hießen, in ihrer Zeit viel einflußreicher, entscheidender gewesen als Manet, Mondrian und dergleichen, d.h. sie sind sogar wichtiger gewesen für die Gesellschaft und zwar nicht nur im dem negativen Sinn, daß sie das reaktionär Bestehende unterstützten; sie unterstützten ja auch eine soziale Ordnung, die zwar nicht mehr haltbar, aber immerhin grundsätzlich sozial funktionierte, nämlich genauso wie jede gesellschaftliche Ordnung schon Jahrtausende funktionierte, also so notwendig wie mehr oder weniger ungerecht, a-sozial oder verbrecherisch war, und ist und sein wird. Es gibt da gar keinen Ausweg, aber doch die Utopie, die mehr oder weniger verschwommene unkonkrete Hoffnung. Aber ich wollte etwas anderes sagen, nämlich, daß diese Salonkünstler, die

something else, namely that we are not really aware of these Salon artists any more now as unimportant, stupid, inflated and silly as they are, but that it was precisely these artists who actually made the intellectual and spiritual life of their times. I can hardly believe this myself, but have to accept it, not just because the importance of these so-called artists can be checked from old magazines, but because we are experiencing the same thing today: what distinguishes our age and actually keeps it alive is precisely this Salon rubbish: we use it, produce it in enormous masses, discuss it, comment upon it, document it in exhibitions, essays and films; it is the intellectual and spiritual life of our times, our 'Zeitgeist'. And an exceptional phenomenon, like the period we had with Minimal and Concept art as an elitist movement, seems only to prove that it can only work like this and in no other way.

This did not last for long, then came the punishment: tons and square kilometres of rubbish painting, rubbish sculpture, eagerly accepted by a voracious society. Art in the actual sense exists nevertheless, but it is hardly recognisable, or anyway not with certainty, has always existed, continues to be effective as the highest longing for truth and happiness and love or whatever one wants to call it; is actually the most perfect form of our humanity.

19.10.84

Glenn Gould, Goldberg Variations. I have listened to almost nothing else for one, even two years. A drug. What is beginning to annoy me is the perfection of it. This completely absurd, malevolent perfection. No wonder he died young.

wir heute kaum mehr kennen, so unwichtig, blödsinnig, aufgebläht und albern wie sie sind, daß also genau diese Salonkünstler das geistige Leben ihrer Zeit ausmachten. Ich kann das selbst kaum glauben, muß es aber annehmen, nicht nur, weil die Wichtigkeit dieser sogenannten Künstler in den alten Zeitschriften nachprüfbar ist, sondern weil wir heute das gleiche erleben: was unsere Zeit ausmacht und tatsächlich lebendig erhält, ist genau dieser Salonmüll, den wir brauchen, in ungeheuerlichen Massen produzieren, den wir diskutieren, kommentieren, in Ausstellungen, Texten, Filmen dokumentieren, der das geistige Leben unserer Zeit ist, 'Zeitgeist' ist. Und wie zum Beweis, daß es nur so und nicht anders geht, scheint mir so eine Ausnahme-Zeiterscheinung zu sein, die wir als elitäre Bewegung mit Minimal und Konzeptkunst kurzfristig hatten.

Sie endete rasch, danach kam die Bestrafung: tonnenweise, quadratkilometerweise Müllmalerei, Müllskulptur, gierig aufgenommen von einer gefräßigen Gesellschaft. Kunst im eigentlichen Sinne existiert trotzdem, ist kaum oder jedenfalls nicht mit Sicherheit erkennbar, hat immer existiert, wirkt weiterhin als die nächste Sehnsucht nach Wahrheit und Glück und Liebe oder wie man das alles auch immer nennen mag; sie ist tatsächlich unsere vollkommenste Form unserer Menschlichkeit.

19.10.84

Glenn Gould, Goldbergvariationen. Seit einem, seit zwei Jahren höre ich fast nichts anderes. Eine Droge. Was mich zu ärgern anfängt, ist die Vollkommenheit. Diese völlig absurde, langweilige, bösartige Vollkommenheit. Kein Wunder, daß er früh gestorben ist.

Studio photograph, 1985 (with 'Atelier', 1985)

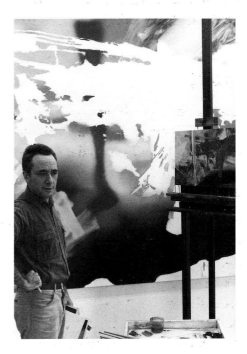

Studio photograph, c.1980 (with 'Abstract Painting', 1980, now destroyed, on the easel and part of 'Faust', 1980, as work-in-progress in the background)

1985

20.2.85

It is true that I am constantly in despair about my inability to finish anything, the impossibility of being able to finish anything, of painting a valid, correct picture, above all of knowing how such a picture would have to look; but at the same time I still live in hope that that is the very thing that might succeed, that will emerge from this continuing, and this hope is indeed often nourished by the fact that partially, tentatively, things can in fact come into being that are reminiscent of what is longed for, or give a presentiment of it, although I have often enough simply been fooled, when what I saw in it for a moment disappeared, leaving nothing but the usual behind.

I have no motif, only motivation. I believe that motivation is the essential, the natural thing, and that the motif is something old-fashioned, indeed reactionary (as silly as questions about the meaning of life).

28.2.85

Causing something to come into being, rather than creating; thus no assertions, constructions, provisions, inventions, ideologies – in order to attain essential, richer, more alive things beyond my understanding.

Tolstoy's *War and Peace*: it doesn't matter how right my memory is, the only thing I retained that struck me at the time, is Kutusov's way of not intervening, never planning anything, but observing how things run, in order to force self-produced movement. Passivity was this General's genius.

18.5.85

One cannot really paint in the way in which I paint, because the essential prerequisite is missing: the certainty of what is to be painted, the 'subject' in other words. If I were to name Raphael or Newman, or less complicated people like Rothko or Lichtenstein, or all the others, right down to the last provincial painter – all of them have a subject that they follow, a 'picture' to which they are always aspiring. If I paint an abstract picture (the problems are not dissimilar with the other works) I neither know in advance what it is supposed to look like, nor where I intend to go while I am painting, what could be done, to what end. For this reason the painting is a quasi blind, desperate effort, like that made by someone who has been cast out into a completely incomprehensible environment with no means of support – by someone who has a reasonable range of tools, materials and abilities and the urgent desire to build something meaningful and useful, but it cannot be a house or a chair or anything else that can be named, and he therefore just starts building in the vague hope that his correct, expert activity will finally produce something correct and meaningful.

13.11.85

'I have nothing to say and I am saying it', Cage.

1985

20.2.85

Ich habe zwar die ständige Verzweiflung über mein Unvermögen, die Unmöglichkeit, etwas vollbringen zu können, ein gültiges, richtiges Bild zu malen, vor allem zu wissen, wie so ein Bild auszusehen hätte; aber ich habe gleichzeitig immer die Hoffnung, daß genau das gelingen könnte, daß sich das aus diesem Weitermachen einmal ergibt, und diese Hoffnung wird ja auch oft genährt, indem stellenweise, ansatzweise, tatsächlich etwas entsteht, was an das Ersehnte erinnert oder es ahnen läßt, wenngleich ich ja oft genug nur genarrt wurde, also daß das, was ich momenthaft darin sah, verschwand und nichts übrigließ als das Übliche.

Ich habe kein Motiv, nur Motivation. Ich glaube, daß die Motivation das Eigentliche, Naturgemäße ist, daß das Motiv altmodisch, ja reaktionär ist (dumm wie die Frage nach dem Sinn des Lebens).

28.2.85

Etwas entstehen lassen, anstatt kreieren; also keine Behauptungen, Konstruktionen, Erstellungen, Erfindungen, Ideologien, – um so an das Eigentliche, Reichere, Lebendigere heranzukommen, an das, was über meinem Verstand ist.

Tolstois Krieg und Frieden. Egal wie richtig meine Erinnerung ist, das einzige was ich behielt, was mich damals traf, die Art Kutusows nicht einzugreifen, nichts zu planen, sondern zu beobachten wie die Dinge laufen, um im richtigen Moment die sich von selbst ergebende Bewegung zu forcieren. Die Passivität war die Genialität dieses Generals.

18.5.85

So wie ich male, kann man eigentlich nicht malen, denn es fehlt die wesentliche Voraussetzung: die Gewißheit, was zu malen ist, also das 'Thema'. Ob ich Raffael nenne oder Newman oder schlichtere wie Rothko oder Lichtenstein, oder alle anderen bis hin zum letzten Provinzkünstler, – alle haben ein Thema, das sie verfolgen, ein 'Bild' das sie immer wieder anstreben.

Wenn ich ein Abstraktes Bild (bei den anderen ist die Problematik nicht unähnlich) male, weiß ich weder vorher wie es aussehen soll, noch während des Malens wohin ich will, was wofür zu tun wäre. Deshalb ist das Malen ein quasi blindes, verzweifeltes Bemühen, wie das eines mittellosen, in völlig unverständlicher Umgebung Ausgesetzten, – wie das von einem, der ein bestimmtes Sortiment von Werkzeugen, Materialien und Fähigkeiten besitzt und den dringenden Wunsch hat, etwas Sinnvolles, Brauchbares zu bauen, das aber weder ein Haus noch ein Stuhl noch sonst irgendwas Benennbares sein darf, der also drauflosbaut in der vagen Hoffnung, daß sein richtiges, fachgerechtes Tun letztlich etwas Richtiges, Sinnvolles zustande kommen läßt.

13.11.85

'Ich habe nichts zu sagen und das sage ich', Cage.

27.12.85

(The advantage of my Grey Paintings is that they seem to unmask all other approaches, figurative or abstract, and show them to be substitutes, arbitrary. But in the nature of things they are the same approach.)

The abstract pictures are no less arbitrary than all figurative representations (based on any random motif intended to become a picture), they are distinctive only to the extent that their 'motif' is only developed during painting. They therefore require that I do not know what I intend to represent, how I should begin and that I have only very unclear and always false notions of the motif to be depicted – that I, therefore, motivated only by ignorance and frivolity, am in a position to begin. (The 'only' stands for life!)

1986

18.2.86

My landscapes are not just beautiful, or seemingly nostalgic, romantic and as classical as lost paradises; they are above all 'mendacious' (even if I did not always find a way of showing precisely that) and when I say 'mendacious' I mean the ecstasy with which we look at nature; but nature that is against us in all its forms because it knows neither sense nor mercy nor sympathy, because it knows nothing, is absolutely without mind or spirit, is the total opposite to ourselves, is absolutely inhuman.

Any beauty that we see in landscape, any enchanting colouration, peace or violence of mood, gentle lines, magnificent space and goodness knows what else is a projection of ours, something that we can switch off, then be able to see at the very same moment only the terrifying hideousness and ugliness of it all.

Nature is so inhuman that it is not even criminal. It is nature that we must essentially overcome, reject – because with all the overwhelming frightfulness, cruelty, wretchedness that we ourselves have we are still in a position to produce a spark of hope, a spark that came into being with us, that we can also call love (that has nothing to do with unconscious, brutish mammal nurturing reflex) – nature has nothing of this, its stupidity is absolute.

18.3.86

Formalism means something negative, contrived stuff, playing with colour and form, empty aesthetics. When I say I make form my starting point I mean I should like content to develop from form (and, not conversely, form to be found for a literary idea), then this corresponds to my conviction that form, that is to say the correlation of formal elements, that is to say the structure of the image of material (= form), that all this produces a content

27.12.85

(Der Vorzug meiner Grauen Bilder ist, daß sie alle übrigen Setzungen, gegenständliche oder abstrakte, als Ersetzungen und als beliebige zu entlarven scheinen. Aber naturgemäß sind sie die gleichen Setzungen).

Die Abstrakten Bilder sind nicht weniger beliebig als alle gegenständlichen Darstellungen (die auf einem x-beliebigen Motiv beruhen, das Bild werden soll), sie unterscheiden sich nur insofern als ihr 'Motiv' erst während des Malens entwickelt wird. Sie setzen also voraus, daß ich nicht weiß, was ich darstellen will, wie ich beginnen sollte und daß ich nur sehr unklare und stets falsche Vorstellungen von dem zu verbildlichenden Motiv habe, – daß ich also, nur von Ignoranz und Leichtsinn motiviert, anzufangen in der Lage bin. (Das 'nur' steht für Leben!)

1986

18.2.86

Meine Landschaften sind ja nicht nur schön oder nostalgisch, romantisch und klassisch anmutend wie verlorene Paradiese, sondern vor allem 'verlogen' (auch wenn ich nicht immer die Mittel fand, gerade das zu zeigen), und mit 'verlogen' meine ich die Verklärung mit der wir die Natur ansehen, die Natur, die in all ihren Formen stets gegen uns ist, weil sie nicht Sinn, noch Gnade, noch Mitgefühl kennt, weil sie nichts kennt, absolut geistlos, das totale Gegenteil von uns ist, absolut unmenschlich ist.

Jede Schönheit, die wir in der Landschaft sehen, jede bezaubernde Farbigkeit, Friedlichkeit oder Gewalt einer Stimmung, sanfte Linienführung, großartige Räumlichkeit und was weiß ich, ist unsere Projektion, die wir auch abschalten können, um im selben Moment nur noch die erschreckende Gräßlichkeit und Häßlichkeit zu sehen.

Die Natur ist so unmenschlich, daß sie nicht einmal verbrecherisch ist. Sie ist das, was wir wesentlich überwinden, ablehnen müssen, – denn bei aller übermächtigen Entsetzlichkeit, Grausamkeit, Erbärmlichkeit, die uns zu eigen ist, sind wir doch noch in der Lage, einen Funken Hoffnung zu produzieren, der mit uns entstanden ist, den wir auch Liebe nennen können (die nichts mit dem bewußtlosen, animalischen Säugetier-Pflegeverhalten zu tun hat). – die Natur hat nichts davon, ihre Blödheit ist absolut.

18.3.86

Formalismus bezeichnet etwas Negatives, ausgedachtes Zeug, Farb-und Formspielereien, leere Ästhetik. Wenn ich sage, ich gehe von der Form aus und ich möchte, daß sich der Inhalt aus der Form entwickelt (und nicht umgekehrt für eine literarische Idee eine Form gefunden wird), dann entspricht das meiner Überzeugung, daß die Form, also der Zusammenhang von Formelementen, also die Struktur des Erscheinungsbildes von Materie (= Form), daß das einen Inhalt erzeugt und daß

and that I can control the emergence of the image in order to obtain one content or another by this means.

I need only act in the sense of the legalities, the conditions of form, in order to produce correct materialisation.

On the one hand I am supported in this effort by music (Schönberg and any other pure music develops from its own autonomy and not from an effort to find a form for a particular statement) and on the other hand I find an essential confirmation in nature, which produces material changes without any purpose in terms of content (or cause), but takes on one form or another based on its own conditions and the more complicatedly it does this, the more useful are its 'contents', its qualities, its abilities.

28.3.86

Fundamentally I am a materialist. Spirit, soul, wanting, feeling, sensing, etc. have material causes (mechanical, chemical, electronic, etc.) and are extinguished with their physical basis like work done on a computer when it is destroyed, switched off.

Art is based on these material conditions. It is a particular mode of our daily dealings with appearance, in which we recognise ourselves and everything that surrounds us. Thus, art is the desire in the manufacture of appearances that are comparable with those of reality, because they are more or less similar to them. Thus, art is a possibility of thinking about everything differently, of recognising appearance as fundamentally inadequate; thus, it is an instrument, a method of approaching things closed and inaccessible to us (banal future as well as things fundamentally unrecognisable, metaphysical). Because of that, art has an educative and therapeutic, comforting and enlightening, exploratory and speculative function, thus, it is not just existential pleasure, but utopia.

12.10.86

What should I paint, how should I paint.

The 'what' is the most difficult, as it is the most essential. By comparison, the 'how' is simple. Beginning with the 'how' is frivolous, but legitimate. To apply the 'how', namely the conditions of technique, of the material, as with those of the physical possibilities – in relation to the intention. The intention: no invention, no idea, no composition, no object, no form – and to retain everything: composition object, form, idea, image. In my youth, when I adopted 'themes' with a certain naivety, I already sensed this problem of having no subject. Of course, I seized on certain motifs and depicted them, but frequently with the feeling that these were not essential, but rather imposed, artificial, worn out. The question as to what I should paint showed me my impotence, and I was often envious (and still am) of those average painters, for their 'preoccupation', which was depicted with stamina, in an average manner (fundamentally, I despise them for this).

ich die Entstehung des Erscheinungsbildes steuern kann, um damit diesen oder jenen Inhalt zu erhalten.

Ich muß nur im Sinne der Gesetzlichkeiten, Bedingungen, der Form handeln, um eine richtige Materialisation zu erzeugen. Zum einen werde ich bei diesem Bemühen von der Musik unterstützt (Schönberg und jede andere reine Musik entwickelt sich aus ihren Eigengesetzlichkeiten und nicht aus dem Bemühen, für eine bestimmte Aussage eine Form zu finden), und zum anderen finde ich die wesentliche Bestätigung in der Natur, die materielle Veränderungen hervorbringt ohne inhaltliche Absicht (oder Ursache), sondern aus den eigenen Bedingungen heraus diese oder jene Gestalt annimmt und, je komplizierter sie das tut, desto brauchbarer sind ihre 'Inhalte', sind ihre Eigenschaften, ihre Fähigkeiten.

28.3.86

Grundsätzlich bin ich Materialist. Geist, Seele, Wollen, Fühlen, Ahnen etc. haben materielle Ursachen (mechanische, chemische, elektronische etc.) und verlöschen mit ihrer physischen Grundlage wie die Leistungen eines Computers, wenn er zerstört, ausgeschaltet wird.

Kunst basiert auf diesen materiellen Bedingungen. Sie ist eine besondere Weise unseres täglichen Umgangs mit Erscheinung, in der wir uns und alles uns Umgebende erkennen. Kunst ist also die Lust an der Herstellung von Erscheinungen, die mit denen der Wirklichkeit vergleichbar sind, weil sie mit ihnen mehr oder weniger Ähnlichkeit haben. Damit ist die Kunst eine Möglichkeit, alles anders zu denken, die Erscheinung als grundsätzlich unzulänglich zu erkennen, damit ist sie ein Instrument, eine Methode, das uns Verschlossene, Unzugängliche (banale Zukunft genauso wie das grundsätzlich Unerkennbare, Metaphysische) anzugehen, damit hat die Kunst bildende und therapeutische, tröstende und aufklärende, forschende und spekulierende Funktion, damit ist sie nicht nur existenzielle Lust, sondern Utopie.

12.10.86

Was soll ich malen, wie soll ich malen.

Das Was ist das Schwierigste, denn es ist das Eigentliche. Das Wie ist vergleichsweise leicht. Mit dem Wie'beginnen ist leichtsinnig aber legitim. Das Wie anwenden, also die Bedingungen der Technik, des Materials, wie die der physischen Möglichkeiten – im Hinblick auf die Absicht nutzen. Die Absicht: nichts erfinden, keine Idee, keine Komposition, keinen Gegenstand, keine Form, – und alles erhalten: Komposition, Gegenstand, Form, Idee, Bild. Bereits in meiner Jugend, wo ich mit einer gewissen Naivität 'Themen' hatte (Landschaften, Selbstportraits), spürte ich sehr bald dieses Problem, kein Sujet zu haben. Natürlich griff ich Motive auf und stellte sie dar, aber meistens mit dem Gefühl, daß das nicht die eigentlichen, sondern aufgesetzte, abgegriffene, künstliche seien. Die Frage, was soll ich malen, zeigte mir meine Ohnmacht und oft beneidete ich (beneide bis heute) die mittelmäßigsten Maler um ihr 'Anliegen', das sie mit Ausdauer mittelmäßig darstellen (im Grunde verachte ich sie dafür).

In 1962 I found the first outlet; by painting from photos I was relieved of the obligation to choose and construct a subject. Admittedly, I had to choose the photographs, but I was able to do this in a manner which avoided acknowledgment of the subject, namely through motifs which were less eye-catching and not 'of their time'. This seizing on photographs, painting them without modification, without transformation into a modern form (like Warhol and others) was already basically avoiding the subject. I have maintained this principle with few exceptions (the doors, windows, shadows, all of which I dislike) until today. Grey pictures, Colour Charts, Inpaintings, small abstracts (so full of planned wilfulness, that they too were equally unassertive) 'soft' abstracts, that adopted the lack of subject of the small abstracts and through blurring and augmentation were a varient of this 'non-showing'. It is exactly the same with the large abstracts; and with them the paradox of seeming gratuitously general, better, less consumible and more generally relevant. Of course, it is not truth that I compose uninterruptedly and, above all, extinguish, thereby limiting myself to a very small repertoire, i.e. behaving in an entirely intentional manner: then the connections with music, the ceaselessly attempted beginnings, to create a musically perceived structure and a differentiated instrumentation. With these many failures, I should be amazed that the pictures occasionally show something imposing (fine-looking), as at root, they are all pitiable proofs of inability and failure (during the attempt to overcome this inability). But it is also untrue to say that I did not want something specific – it is like with my landscapes: I see innumerable landscapes, photograph scarcely one in a hundred thousand, paint scarcely one of a hundred photographs – thus I look for something quite specific; I can conclude from that, that I know what I want.

1962 fand ich den ersten Ausweg; indem ich Fotos abmalte, war ich enthoben mir das Sujet zu wählen, zu konstruieren. Zwar mußte ich die Fotos auswählen, aber das konnte ich in einer Weise tun, die das Bekenntnis zum Sujet vermied, also mit Motiven, die wenig Image hatten oder unzeitgemäß waren. Also das Aufgreifen des Fotos, das Abmalen ohne Veränderung, ohne Übersetzung in eine moderne Form (wie Warhol u.a.) war ja schon grundsätzlich sujetvermeidend. Dieses Prinzip hielt ich bis auf wenige Ausnahmen (Türen, Fenster, Schatten, die ich alle nicht mag) bis heute durch. Graue Bilder, Farbtafeln, Vermalungen, kleine Abstrakte (so voller geplanter Willkür, daß sie also genauso aussagelos waren), 'weiche' Abstrakte, die das Nicht-Sujet von den kleinen Abstrakten übernahmen und durch Unschärfe und Vergrößerung eine Variante des Nichts-Zeigens waren. Bei den großen Abstrakten ist es genauso; und dazu im Widerspruch stehend stets die Absicht, die Hoffnung, ein Sujet quasi geschenkt zu erhalten, eines, das ich nicht erfunden habe und das dafür allgemeiner, besser, weniger verbrauchbar, allgemeingültiger sein mußte. Natürlich ist das nicht die Wahrheit, da ich ununterbrochen komponiere und vor allem auslösche, also vermeide und mich nur auf ein sehr kleines Repertoire beschränke, d.h. ganz absichtsvoll mich verhalte; dann der Bezug zur Musik, diese immer wieder probierten Ansätze, eine musikalisch verstandene Struktur und differenzierte Instrumentierung zu schaffen. Diese vielen Mißerfolge, ich muß mich wundern, daß die Bilder ab und zu überhaupt etwas Ansehnliches aufweisen, denn im Grunde sind sie alle klägliche Beweise des Unvermögens und des Scheiterns (bei dem Versuch, dieses Unvermögen zu überwinden). Aber es ist auch nicht wahr, daß ich nichts Bestimmtes wollte, – es ist wie bei meinen Landschaften: ich sehe unzählige Landschaften, fotografiere kaum eine von 100,000, male kaum eine von 100 fotografierten, – ich suche also etwas ganz Bestimmtes; ich kann daraus schließen, daß ich weiß was ich will.

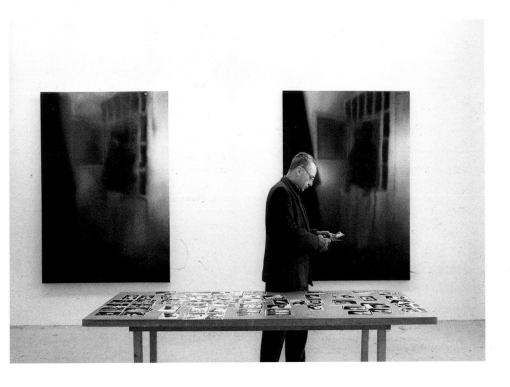

Studio photograph, 1988 (with two versions of 'Hanged Person', 1988, from '18 October 1977' series. The right-hand picture was later destroyed by the artist)

1988

3.1.88

Art is the pure realisation of religiosity, of the ability to believe, longing for 'God'.

All other realisations of this most considerable quality of man are an abuse to the extent that they exploit this quality, in other words make it serve an ideology. Art too becomes 'applied art' when it gives up its freedom of purpose, when it wants to communicate something; for it is only in an absolute refusal to make any statement at all that it is human.

The ability to believe is our most considerable quality, and it is only appropriately realised through art. If, on the other hand, we use an ideology to quench our need for belief, we can only do damage.

7.1.88

My deep-rooted aversion to assertions, claims to truth, ideologies that I have often expressed earlier with varying degrees of skill (which showed itself in my pictures, in my way of working, in my entire attitude to such an extent that I continually projected this aversion onto a fundamental lack of constructive ability or of courage, strength, desire to shape, potency and creativity and had to suffer from this) – this aversion is now confirmed by people like the physicist Dürr, evolutionary researchers Riedl and Konrad Lorenz, who see the only hope for our survival in 'the spread of human self-doubt', with awareness of our limitations. Because of that I hope that my 'inability', my scepticism that replaces 'ability', can be a quite important 'modern' strategy for a human being. And because of that more than previously I can see the ridiculousness (and inhumanity) of any ideology as obvious (and propagate it if possible).

13.1.88

Art is wretched, cynical, stupid, helpless, confusing – a mirror of our spiritual poverty, our abandonment, forlorness. We have lost big ideas, utopias, any sense of faith, anything that endows meaning.

Incapable of faith, hopeless to the highest degree, we are wandering around a poisonous rubbish tip, extremely endangered; every one of these incomprehensible broken pieces, pieces of rubbish, pieces of junk threatens us, hurts us, cripples us continually, kills us, ultimately, sooner or later inevitably. Worse than madness.

Consolations are for sale, and so are superstitions of all varieties, all shades, little overblown ideologies, the most stupid lies.

1988

3.1.88

Die Kunst ist die reine Verwirklichung der Religiosität, der Glaubensfähigkeit, Sehnsucht nach 'Gott'.

Alle anderen Verwirklichungen dieser erheblichsten Eigenschaft des Menschen sind Mißbrauch insofern, daß sie diese Eigenschaft ausbeuten, also in den Dienst einer Ideologie stellen. Auch Kunst wird zur 'angewandten Kunst' wenn sie ihre Zweckfreiheit aufgibt, wenn sie etwas mitteilen will; denn nur in absoluter Verweigerung jeder Aussage ist sie menschlich.

Die Fähigkeit zu glauben ist unsere erheblichste Eigenschaft, und sie wird nur durch die Kunst angemessen verwirklicht. Wenn wir dagegen unser Glaubensbedürfnis in einer Ideologie stillen, richten wir nur Unheil an.

7.1.88

Meine tiefeingewurzelte Abneigung gegenüber Behauptungen, Wahrheitsansprüchen. Ideologien, die ich früher oft mehr oder weniger geschickt äußerte (die sich in meinen Bildern, in der Arbeitsweise, in der Gesamthaltung so sehr zeigte, daß ich immerwährend diese Abneigung auch auf einen grundsätzlichen Mangel an konstruktiver Fähigkeit oder an Mut, Stärke, Gestaltungswillen, Potenz und Kreativität schob und darunter leiden mußte), – die Abneigung erfährt jetzt Bestätigung durch Leute wie den Physiker Dürr, den Evolutionsforscher Riedl und Konrad Lorenz, die die einzige Hoffnung für unser Überleben in dem 'Umsichgreifen des humanen Selbstzweifels', in der Bewußtheit unserer Beschränktheit sehen. So hoffe ich, daß meine 'Unfähigkeit', also meine die 'Fähigkeit' ersetzende Skepsis, doch eine ganz wichtige, 'moderne' Strategie des Menschen sein kann. Und so kann ich mehr als zuvor die Lächerlichkeit (und Unmenschlichkeit) jeder Ideologie als gegeben ansehen (und wenn möglich propagieren).

13.1.88

Die Kunst ist elend, zynisch, dumm, hilflos, verwirrend, – ein Spiegel unserer geistigen Armut, unserer Verlassenheit, Verlorenheit. Verloren haben wir die großen Ideen, die Utopien, jeden Glauben, alles Sinnstiftende.

Glaubensunfähig, hoffnungslos in höchstem Maße, irren wir auf einer giftigen Müllkippe, äußerst gefährdet; jedes dieser unverständlichen Scherbenstücke, Abfallstücke, Gerümpelstücke bedroht uns, schmerzt uns, verkrüppelt uns fortwährend, tötet uns, letztlich früher oder später unausweichlich. Schlimmer als Wahnsinn.

Tröstungen werden verkauft, Aberglauben in allen Schattierungen, kleine aufgebauschte Ideologien, die dümmsten Lügen.

12.3.88

Most artists are smitten with extraordinary stupidity, and that makes them more desperate than necessary, so they make themselves out to be more stupid than they actually are, and so they can make themselves artistically impotent – for by becoming (consciously or unconsciously) frightened of their nonsense they lose all self-esteem and can produce nothing at all any more, or only the most unspeakably stupid things.

1989

14.3.89

'Bürgerlich', bourgeois, middle-class, formerly a distinction, now used perjoratively in a variety of ways, always imprecisely and polemically, meaninglessly and inaccurately. 'Bürgerlich' suggests tidy, educated, taking a positive view of the state rather than being freaky, colourfully dressed, demonstrably nonconformist (e.g Thomas Mann rather than Bertolt Brecht, Weizsäcker rather than Joschka Fischer).

Conformity is by no means identical with security, in that it describes adjustment to the prevailing fashion, the prevailing climate or system as a result of stupidity, cowardice, laziness and despicableness; nonconformity is not necessarily the opposite of this, but often results from a kind of courage that induces stupidity and blindness; this slack nonconformist behaviour derives from the limited, disabled structure of the primitive.

21.7.89

Nature/structure. There is no more to be said, that is what I reduce things to in the pictures, though 'reduce' is the wrong word, for it is not a matter of simplifications. I cannot verbalise what I am working on there, what I see as fundamental, multi-layered, as important and more true.

(Everything that one can think out for oneself in this way, all this idiocy, these foolish things, cheap constructions and speculations, amazing inventions, harsh, surprising juxtapositions, which one is of course also forced to see a million times day in and day out, this mentally deficient misery, the whole stupidly bold botch) —

All this I paint away, clear out of my head when I start a picture, that is my ground, which I deal with in the first few layers, which I destroy layer by layer, until all the frivolous rubbish is destroyed. Thus what I ultimately have is a work of destruction. It goes without saying that I cannot do without these detours, thus that I cannot begin with the final state.

12.3.88

Die meisten Künstler sind doch alle mit außergewöhnlicher Dummheit geschlagen, und das macht sie noch verzweifelter als es notwendig ist, und damit machen sie sich noch dümmer als sie es eigentlich sind, und damit machen sie sich sogar künstlerisch impotent, – denn indem sie (bewußt oder unbewußt) über ihren Unsinn erschrecken, verlieren sie jede Selbstachtung und können gar nichts mehr oder nur noch das unsäglich Dümmste produzieren.

1989

14.3.89

'Bürgerlich', ehemals eine Auszeichnung, heute negativ besetzt, vielseitig gebraucht, immer ungenau polemisch, nichtssagend und unzutreffend. 'Bürgerlich' – gleich ordentlich, gebildet, staatsbejahend im Gegensatz zu ausgeflippt, munter gekleidet, demonstrativ nonkonform, – (z.B. Thomas Mann zu Bertolt Brecht, Weizsäcker zu Joschka Fischer).

So wenig identisch Konformismus mit Sicherheit ist, indem er die aus Dummheit, Feigheit, Faulheit und Niedertracht resultierende Anpassung an die herrschende Moden, an das herrschende Klima oder System bezeichnet, so ist der Nonkonformismus nicht unbedingt das Gegenteil davon, sondern resultiert sehr oft aus einem Mut, den die Dummheit und Blindheit entstehen läßt; wo diese Lockerheit des nonkonformen Verhaltens der limitierten, behinderten Struktur des Primitiven entspringt.

21.7.89

Natur/Struktur. Mehr ist nicht zu sagen, darauf reduziere ich in den Bildern, wobei 'Reduzieren' das falsche Wort ist, denn es handelt sich nicht um Vereinfachungen. Ich kann es nicht verbalisieren, woran ich da arbeite, was ich als grundsätzlich, vielschichtig ansehe, als das Wichtigere, Wahrere.

(Alles was man sich so ausdenken kann, all diesen Schwachsinn, diese Dummheiten, die billigen Konstruktionen und Spekulationen, die verblüffenden Erfindungen, grellen, überraschenden Zusammenstellungen (was man ja auch millionenfach tagtäglich sehen muß, dieses minderbemittelte Elend, das ganze dummdreiste Gebastel) —

Das alles male ich mir vom Leibe, aus dem Kopf, wenn ich mit einem Bild beginne, das ist mein Untergrund, den erledige ich mit den ersten paar Schichten, die ich Schicht für Schicht zerstöre, bis all der leichtfertige Schwachsinn zerstört ist. Am Ende habe ich also ein Zerstörungswerk. Es versteht sich von selbst, daß ich nicht auf diese Umwege verzichten kann, daß ich also nicht mit dem Endzustand beginnen kann.

23.7.89

However clumsily, desperately clumsily I may behave, my will, striving, effort, in other words what drives me, is the search for enlightenment (recognition of the 'truth', of coherence, the search for approximation to meaning – thus all pessimistic, nihilistic behaviour and assertion is only intended to create or to discover hope).

25.7.89

My condemnation of ideology: I do not have the means to investigate that. There is no doubt that ideologies are always harmful, and therefore that we should take them very seriously: as a way of behaving and not in terms of content (in terms of content they are all equally wrong).

Ideology is the rationalisation of faith, the 'material' that tangibly verbalises devoutness and makes it capable of communication. Faith, I repeat, is awareness of the future, is also like hope, like illusion, is therefore absolutely human (it is incomprehensible to me how animals survive without this awareness), because without this notion of 'tomorrow' we are incapable of living.

3.11.89

Chance as subject and method

Method, in order to allow something objective to come into being, subject, in order to create a simile (image) for our survival strategy.

1) Method of the living, that not only processes allotted conditions, qualities and events, but only exists as 'processing', unstatically, nothing different and only in this way —
2) Ideologically: denial of the plan, the opinion, the view of the world that creates social designs and consequently the 'great pictures'.

And so the thing I often saw as my shortcoming, the fact that I was not in a position to 'make a picture' is not inability, but an instinctive concern for a modern truth that we are already living (life is not what is said, but the saying, not the picture, but the depiction).

4.11.89

Andy Warhol is less an artist than a symptom of a cultural situation that created and used this symptom as a substitute for an artist. His merit is that he did not make 'art', in other words did not tackle all the methods and subjects that traditionally place other artists under an obligation (thus sparing us the high level of 'artistic' nonsense that we see in other pictures). And to the extent that his avoidance of nonsense was active he was an artist, but to the extent that it was passive and naive he was not an artist, no more than are the mentally disturbed, whose 'works' are collected and used. The situation is tricky. Probably the fact is that – although some of his works are among the most impressive produced in the last thirty years, and although

23.7.89

So ungeschickt, verzweifelt ungeschickt, ich mich auch anstelle, mein Wille, Streben, Bemühen, also das was mich treibt, ist die Suche nach Aufklärung (Erkenntnis der 'Wahrheit', der Zusammenhänge, nach Annäherung an einen Sinn, – also alles pessimistische, nihilistische Verhalten und Behaupten hat doch nur den Zweck, Hoffnung zu erschaffen bzw. zu entdecken).

25.7.89

Meine Ideologie-Verurteilung: mir fehlen die Mittel, das zu untersuchen. Kein Zweifel, daß Ideologien nur schädlich sind, daß wir sie also sehr wichtig nehmen müssen: als Verhaltensweise und nicht inhaltlich (inhaltlich sind alle gleich falsch).

Ideologie ist die Rationalisierung des Glaubens, der 'Stoff', der die Gläubigkeit greifbar verbalisiert und kommunikationsfähig macht. Glaube, ich wiederhole mich, ist das Bewußtsein des Künftigen, ist also gleich Hoffnung, gleich Illusion, ist also absolut menschlich (wie die Tiere ohne dieses Bewußtsein auskommen, ist mir unverständlich), denn ohne diese Vorstellung vom 'Morgen' sind wir lebensunfähig.

3.11.89

Zufall als Thema und Methode
Methode, um etwas Objektives entstehen zu lassen, Thema, um ein Gleichnis (Bild) zu schaffen für unsere Überlebensstrategie:
1) Methode des Lebendigen, das die zugefallenen Bedingungen, Eigenschaften und Ereignisse nicht nur verarbeitet, sondern nur als 'Verarbeitung' existiert, unstatisch, nichts anderes und nur auf diese Weise, —
2) ideologisch: Verneinung des Plans, der Meinung, der Weltanschauung, die die gesellschaftlichen Entwürfe schafft, und in der Folge die 'großen Bilder'.

Also das, was ich oft als mein Manko ansah, daß ich nicht in der Lage war ein 'Bild zu schaffen', ist nicht Unfähigkeit, sondern instinktives Bemühen um eine modernere Wahrheit, die wir bereits leben (Leben ist nicht das Gesagte, sondern das Sagen, nicht das Bild, sondern das Bilden).

4.11.89

Andy Warhol ist weniger ein Künstler als ein Symptom für eine kulturelle Situation, die es schuf und benutzte als Ersatz für einen Künstler. Sein Verdienst ist es, daß er keine 'Kunst' machte, also all die Methoden und Themen, die andere Künstler traditionell verpflichten, nicht anfaßte (dadurch ersparte er uns den vielen 'künstlerischen' Unsinn, den wir auf anderen Bildern sehen). Und insofern seine Vermeidung des Unsinns eine aktive war, war er Künstler, insofern sie aber passiv und naiv war, war er kein Künstler, sowenig wie ein Geisteskranker, dessen 'Werke' gesammelt und benutzt werden. Die Sachlage ist verzwickt. Wahrscheinlich ist es so, daß – obwohl einige seiner Werke zu den eindruckvollsten der letzten 30 Jahre gehören, und obwohl sein Gesamtwerk für unsere Epoche von entscheidender

his entire oeuvre is of crucial and paramount importance for our epoch – he was nevertheless only a mediocre artist. To give a rash example: we do not know who the Pilotys and Makarts and Lenbachs of our time are, but we also do not know whether our age has comparable official salon art of the kind they had at that time anyway, art that will later be judged so differently.

20.11.89

Illusion – or better appearance, light (*Schein* = light, appearance) – is my life subject (it could be the subject for a speech welcoming beginners at the academy). Everything there is, appears, shines and is visible for us because we perceive the light that it reflects, nothing else is visible.

Painting concerns itself exclusively with light, with appearance more than any other art form. I naturally include photography in the same category.

The painter sees the appearance of things and repeats this, i.e. without producing the things themselves he produces only their appearance, and if that is no longer reminiscent of any object, this artificially produced appearance only functions because it is scanned for similarities with a familiar, i.e. object-related appearance. This happens even when experience or agreement conspire to prevent this comparative scanning: one does not compare a white painted picture by Robert Ryman with a white painted wall, but with intellectual experience of the history of monochromy and other artistic and technical problems – even then things fundamentally still function in this way: we do compare the picture with snow, flour, toothpaste and goodness knows what else.

1990

12.2.90

Accept that I can plan nothing.

Any consideration that I make about the 'construction' of a picture is false and if the execution is successful then it is only because I partially destroy it or because it works anyway, because it is not disturbing and looks as though it is not planned.

Accepting this is often intolerable and also impossible, because as a thinking, planning human being it humiliates me to find that I am powerless to that extent, making me doubt my competence and any constructive ability. The only consolation is that I can tell myself that despite all this I *made* the pictures even when they take the law into their own hands, do what they like with me although I don't want them to, and simply come into being somehow. Because anyway I am the one who has to decide what they should ultimately look like (the making of pictures consists of a large number of yes and no decisions and a yes decision at the end). Seen like this the whole thing seems quite natural to me though, or better nature-like, living, in comparison with the social sphere as well.

und überragender Bedeutung ist – er trotzdem nur ein mittelmäßiger Künstler war. – Um ein vorschnelles Beispiel zu nennen: wir wissen nicht wer die Pilotys und Makarts und Lenbachs unserer Zeit sind, wir wissen aber auch nicht, ob unsere Zeit überhaupt eine vergleichbare offizielle Salonkunst wie damals hat, die später einmal so anders beurteilt werden wird.

20.11.89

Illusion – besser Anschein, Schein ist mein Lebensthema (könnte Thema für Anfängerbegrüßungsrede an der Akademie sein). Alles was ist, scheint, und ist für uns sichtbar, weil wir den Schein, den es reflektiert, wahrnehmen, nichts anderes ist sichtbar.

Die Malerei beschäftigt sich wie keine andere Kunstart ausschließlich mit dem Schein. Die Fotografie rechne ich selbstverständlich dazu.

Der Maler sieht den Schein der Dinge und wiederholt ihn, d.h. ohne die Dinge selbst herzustellen, stellt er nur ihren Schein her, und wenn das an keinen Gegenstand mehr erinnert, funktioniert dieser künstlich hergestellte Schein nur, weil er nach Ähnlichkeiten mit einem vertrauten, d.h. gegenstandsbezogenen Schein abgesucht wird. Selbst wenn Erfahrung oder Übereinkunft dieses vergleichende Absuchen quasi verbieten: man vergleicht ein weiß angestrichenes Bild von Robert Ryman nicht mit einer weiß angestrichenen Mauer, sondern mit den intellektuellen Erfahrungen der Geschichte der Monochromie und anderen kunsttheoretischen Problemen – selbst dann funktioniert es fundamental noch immer in dieser Weise: wir vergleichen es doch mit Schnee, Mehl, Zahnpasta und wer weiß was noch.

1990

12.2.90

Akzeptieren, daß ich nichts planen kann.

Jede Überlegung, die ich zum 'Bau' eines Bildes anstelle, ist falsch, und wenn die Ausführung gelingt, dann nur deshalb weil ich sie teilweise zerstöre oder weil sie trotzdem funktioniert indem sie nicht stört und wie nicht geplant aussieht.

Das zu akzeptieren ist oft unerträglich und auch unmöglich, denn als denkender, planender Mensch, demütigt es mich zu erfahren, daß ich da derart machtlos bin, läßt mich an meiner Kompetenz und an jeglicher konstruktiven Fähigkeit zweifeln. Der einzige Trost ist, daß ich mir sagen kann, daß ich die Bilder trotzdem gemacht habe, auch wenn sie wie in Eigengesetzlichkeit gegen meinen Willen mit mir machen was sie wollen und irgendwie entstehen. Denn immerhin muß ich ja entscheiden, welches Aussehen sie dann letztlich haben dürfen (das Machen von Bildern besteht in einer Vielzahl von Ja- und Nein-Entscheidungen und einer Ja-Entscheidung am Ende). So gesehen kommt mir das Ganze wiederum doch sehr natürlich vor, oder besser naturhaft, lebendig, auch im Vergleich zum gesellschaftlichen Bereich.

30.5.90

The invention of the readymade seems to me to be the invention of reality, in other words the radical discovery that reality in contrast with the view of the world image is the only important thing. Since then painting no longer represents reality but is itself reality (produced by itself). And sometime or other it will again be a question of denying the value of this reality in order to produce pictures of a better world (as before).

4.9.90

The 'dictatorship of the proletariat' has long since become reality, especially here in the Western democracies, and here in the most tolerable way. Mass society is the better term, as the masses don't have a class enemy any more and dictatorship transformed itself into material constraints. By its presence, and by being as they are, the masses create a quasi-natural structure of conditions and happenings that runs with very little planning, often chaotically and potentially catastrophically. Hierarchical systems, including socialism, are being superseded by a self-organising 'liveliness' (without a plan, without an ideology, without all the world designs and world pictures that never work).

24.10.90

It does not seem useful that we become fewer and fewer and come to an end when we have learned so much. Over and over again, later generations have to strive for decades to regain a standard of experience long since reached before.

The much despised 'artistic scene of today' is quite harmless and friendly when we do not compare it with false claims: it has nothing to do with traditional values that we uphold (or which elevate us), it has virtually nothing at all to do with art. Thus the 'art scene' is not despicable, cynical or without spirit but as a temporarily blossoming, busily proliferating scene it is only a variation on a perpetual social game that fulfils needs for communication, in the same way as sport, stamp collecting or breeding cats. Art happens despite this, rarely and always unexpectedly, never because we make it happen.

30.5.90

Die Erfindung des readymade scheint mir die Erfindung der Realität zu sein, also die einschneidende Entdeckung, daß die Realität im Gegensatz zum Weltbild das einzig erhebliche ist. Seit da stellt Malerei nicht mehr die Realität dar, sondern ist sie selbst (die sich selber herstellt). Und irgendwann wird es wieder darum gehen, dieser Realität den Wert abzusprechen, um Bilder einer besseren Welt (wie gehabt) aufzustellen.

4.9.90

Die 'Diktatur des Proletariats' ist längst Wirklichkeit geworden, vor allem hier in den westlichen Demokratien, und hier in der erträglichsten Weise. Massengesellschaft ist der bessere Begriff, denn die Masse hat keinen Klassenfeind mehr und die Diktatur verwandelte sich in die Sachzwänge. Die Masse schafft durch ihr Vorhandensein und Sosein eine quasi natürliche Gestaltung der Verhältnisse und Geschehnisse, die relativ planlos abläuft, oft chaotisch und potentiell katastrophisch. Die hierarchischen Systeme, incl. Sozialismus, werden abgelöst von einer sich ständig sich selbst organisierenden 'Lebendigkeit' (ohne Plan, ohne Ideologie, ohne all die nie funktionierenden Weltentwürfe und Weltbilder).

24.10.90

Nicht sehr zweckmäßig scheint es, daß wir dann weniger und weniger werden und enden, wenn wir so viel gelernt haben. Und immer wieder müssen die Nachgeborenen über Jahrzehnte sich mühen, diesen längst erreichten Standard an Erfahrung wiederzuerlangen.

Die vielgeschmähte 'Kunstszene heute' ist dann ganz harmlos und freundlich wenn wir sie nicht mit falschen Ansprüchen vergleichen; sie hat mit den traditionellen Werten, die wir hochhalten (oder die uns erheben) nichts zu tun, sie hat nahezu überhaupt nichts mit Kunst zu tun. Deshalb ist die 'Kunstszene' weder niederträchtig, zynisch, oder geistlos, sondern sie ist als zeitweilig blühende, geschäftig wuchernde Szene nur die Variation eines immerwährenden Gesellschaftsspiels, das den Bedürfnissen nach Kommunikation entspricht, wie Sport, Mode, Briefmarkensammeln oder Katzenzüchten. Kunst entsteht trotzdem, selten und immer unerwartet, nie machbar.

Catalogue List

All works included are listed in chronological order of the artist's worklist numbering system, which is indicated by the number in square brackets following the title. Some works are composite pieces; cat.15 (in 3 parts) has been hung both vertically and horizontally.

Unless otherwise indicated all quotations are from a conversation with the selector. Measurements are given in centimetres, followed by inches in brackets, height before width.

1 Table [1] 1962
Tisch
Oil on canvas 90 × 113 ($35\frac{1}{2}$ × $44\frac{1}{2}$)
Private Collection, Frankfurt
Illustrated page 40

'The photo for "Table" came, I think, from an Italian design magazine called *Domus*. I painted it, but was dissatisfied with the result and pasted parts of it over with newspaper. One can still see by the imprint where the newspaper was stuck to the freshly painted canvas. I was dissatisfied because there was too much paint on the canvas and became less happy with it, so I overpainted it. Then suddenly it acquired a quality which appealed to me and I felt it should be left that way, without knowing why. I destroyed or overpainted many pictures during this time. This became the first painting in my worklist; I wanted to make a new start after my work in East Germany, but also after the many pictures I had painted in the West, among which were a number of photopaintings. I wanted to draw a line, indicating that these paintings were in the past, and so set "Table" at the top of my worklist. My earlier photopaintings were not taken from magazines like *Domus*. There is an illustration of an early one, "Firing Squad", in one of my catalogues, which contains a partially obscured SS man. It is the sort of image that I used later on when I contrasted pornographic photographs with images from the concentration camps. I had known these pictures for a long time – I had probably come across them when I was twenty. Below the shooting scene are rows of identically painted faces along the underside of the canvas. It was very fashionable at the time to make this sort of image with its links to Pop Art. Without too much reflection, I can say that these two things, love and death – sex and crime – are two of the things that touch us most.'

2 XL 513 [20/1] 1964
Oil on canvas 110 × 130 ($43\frac{1}{4}$ × $51\frac{1}{4}$)
Private Collection Frieder Burda, Baden-Baden
Illustrated page 41

'I find this image very brutal, rather like a poster. The angle of the aeroplane flying swiftly past was an image I found very interesting and something not to be found in art history, with the exception, perhaps, of Lichtenstein. There is a contrast between this picture and my other paintings of military aeroplanes. The Stuka picture [18/1] is much more decorative, while the statement in this work is that this is purely a machine of destruction. The decorative margins, or edges, in the Stuka picture, transform the gruesome quality of the image into something rather cute.'

3 Terese Andeszka [23] 1964
Synthetic resin on muslin
170 × 150 (67 × 59)
City of Wiesbaden
Illustrated page 42

'A student researching into my work has actually traced the newspapers and magazines where I found these images and has found out that many of them illustrate a collection of gruesome stories, murders and suicides which contrast with the images used. There is a contrast between the message carried by the text and that suppressed by the illustration.'

4 Woman with Umbrella [29] 1964
Frau mit Schirm
Oil on canvas 160 × 95 (63 × $37\frac{3}{8}$)
Barbara Nüsse Collection
Illustrated page 43

'It was not a sudden break from my earlier work, when I began introducing colour or painting from colour photographs. Adding colour to this work was one attempt to get more out of the picture and to add more to the painting. I tried this with several other paintings at the time – adding colour glazes to works such as the "Red Bathers", the green "Diana" painting and "XL 513". With this painting, I gave it a large margin: Warhol's paintings treated the image in a way that you could imagine the image continuing indefinitely either side of the canvas. With my picture the large printed margin separates the image within the painting from surrounding reality. I gave it a deliberately anonymous, neutral title, because I did not want people simply to look at it and instantly recognise Jackie Kennedy. I was very apprehensive about that sort of reaction. With a title like 'Woman with Umbrella', it doesn't reveal anything or tell any particular story. Only later, did I not mind it so much if the people were recognised. With my portrait of Elizabeth II, it does not matter that she is recognised, as the title already acknowledges this. It focuses on the image of her in the tabloid press. With "Woman with Umbrella", I was very moved by her fate expressed through gesture. It was not in any way an ironic response to what happened or meant to be funny in the way that "Elizabeth II" was. There was another painting where I wanted particularly to conceal the identity of the depicted. It was a picture of Brigitte Bardot and her mother and I had to find a way of calling the painting "Mother and Daughter". I wanted on no account that the identity of the pair be recognised – although now I do not care less. It was not the personality of the people that I was looking for, more a case of opening the newspaper and magazines and seeing a photograph that appealed to me as a photograph. Those were the only photos to which one gained access.

Only seldom could one find private images from magazines like *Quick* and *Stern*. In those days people looked down their noses at those magazines. I used them because they published such very beautiful photographs. I did not use photos in the East, but later I was not getting anywhere and then came their use in Fluxus and Pop Art. It was the Nouveau Realists who were the first to introduce reality in that form. After that I started working in a very small way, affixing shells – or a pistol – then using photos.'

5 Administrative Building [39] 1964
Verwaltungsgebäude
Oil on canvas 98 × 150 (38½ × 59)
Private Collection, Courtesy Anthony d'Offay Gallery, London
Illustrated page 44

'This is a very banal object. Looking back on it now, it does remind you in a certain way of the type of buildings in the German Democratic Republic put up by the Party.'

6 Great Sphinx of Giza [46] 1964
Große Sphinx von Gise
Oil on canvas 150 × 170 (59 × 67)
Massimo Martino S.A.
Illustrated page 45

'This is the sort of image well known from art history, but at the time I was not conscious of the fact that it was a grave. I was made aware of the intimate connection with death rather later on. I think it is justified to interpret this connection with death in a psychoanalytical way when looking back to this image, because it shows that I was really interested in these things at the time.'

7 Flemish Crown [77] 1965
Flämische Krone
Oil on canvas 90 × 110 (35½ × 43¼)
Private Collection, Essen, Germany
Illustrated page 46

'It looks like something from a picture by Frans Hals. In fact, it was a very cheap chandelier, the sort you could buy in department stores. I actually photographed it at my father-in-law's home and made the painting from my photograph. Most of the photopaintings were based on found photographs, but I always took photographs myself and used them for pictures.'

8 Tiger [78] 1965
Oil on canvas 140 × 150 (55⅛ × 59)
Städt. Museum Leverkusen, Schloß Morsbroich
Illustrated page 47

9 Kitchen Chair [97] 1965
Küchenstuhl
Oil on canvas 100 × 80 (39⅜ × 31½)
Kunsthalle Recklinghausen
Illustrated page 48

'This was a chair I owned and photographed. It was part of my search for banal objects; the chair itself, the table, the toilet roll. Although the great majority of the photopaintings are based on photos which came from outside sources, this was one I took myself. I had always taken photographs and used several for pictures during the sixties, although I began using my own much more in the late sixties. I mainly photographed objects, rarely taking portrait shots. The portraits I painted at this time were based on passport photographs, which I received then turned into paintings. I began painting pictures of people with the painting "Ema (Nude Descending a Staircase)". The photographs I used mainly came from illustrated magazines and that was the simple reason why most of the pictures were black and white.'

10 Townscape M 2 [170/2] 1968
Stadtbild M 2
Oil on canvas 85 × 90 (33½ × 35½)
Städelsches Kunstinstitut Frankfurt am Main, on loan from the Stadtsparkasse Frankfurt am Main
Illustrated page 49

'This originally was part of a larger picture, which I cut up and made into several smaller pictures. It was an attempt to arrive at a new painting, when I considered the larger work to be unsuccessful. One part of this larger painting was then overpainted grey, rather like one of the Tourist paintings, painted from a photograph, then later overpainted with grey.'

11 Townscape Paris [175] 1968
Stadtbild Paris
Oil on canvas 200 × 200 (78¾ × 78¾)
Crex Collection, Hallen für neue Kunst, Schaffhausen
Illustrated page 50

'When I look back on the townscapes now, they do seem to me to recall certain images of the destruction of Dresden during the war.'

12 Grid Streaks [194/5] 1968
Gitterschlieren
Oil on canvas 65 × 50 (25⅝ × 19⅝)
Wiesbaden Museum
Illustrated page 51

'This is one of the pictures belonging to a group that were, in the main, despairing attempts at making paintings. I did not destroy them because they had something about them, some truth about them, which was taken up in later works. Making different attempts, trying different methods is something I have always done.'

13 Untitled [194/9] 1968
Oil on canvas 80 × 40 (31½ × 15¾)
Private Collection
Illustrated page 52

14 Townscape TR [217/1–3] 1969
Stadtbild TR
Oil on canvas, 3 parts, overall size 174 × 372 (68½ × 146¼)
Private Collection Frieder Burda, Baden-Baden
Illustrated page 53

'This came from an architectural magazine – the same sort of magazine I got the aerial views of townscapes – except these views did not appear destroyed at all, like the "Townscape Paris". They were also minimalist in a certain way. In this painting the model does not fit together – there is a sense of discontinuity about the image. I think very few of the paintings after architectural models are successful, with the exception of this one. I was able in this painting to achieve a sense of presence. I put the paint on very thickly in black and white, creating with the two a grey. It was quite musical, almost like a fugue.'

15 Star Picture [224/13–15] 1969
Sternbild
Oil on canvas, 3 parts, each 70 × 70
(27½ × 27½)
Albert Eickhoff, Düsseldorf
Illustrated page 54

'We were talking about the overpainted grey pictures in the Tourist and Townscape series. It has always fascinated me to look at scientific journals and see an almost blank illustration with perhaps four or five dots on it. They then have a caption saying that this is such and such a galaxy 80,000 light years away, approximately such and such a size, while the illustration appears to show nothing. The pictures were begun with this sort of idea in mind – the dichotomy between the image and the descriptive title which seems to have nothing to do with the image and yet be crucial to it. I was playing with this idea and might otherwise have destroyed these paintings. I was also interested in the idea that sometimes a painter can paint a picture and give it an interesting title which is so deliberate, like this one, although the painting itself is not interesting.'

16 Sea Piece (Wave) [234] 1969
Seestück (Welle)
Oil on canvas 200 × 200 (78¾ × 78¾)
Massimo Martino S.A.
Illustrated page 55

'I did not have the same sort of problem that I was having with the series of detail paintings, which I was painting at the same time and which appeared endlessly repeatable and without end. I could not judge in the end which were good and which bad. Just about all the seascapes (many of which were included in "Atlas") depict collaged motifs. The sea and cloud sections came from different photographs then collaged together in a single image. The successful paintings were dependent on finding exactly the right mood between the combined images. There were also a couple of paintings, for example, where I used two halves of the same image of the sea. Although I had a rather bad feeling about them, I was visited by George Maciunas, who thought they were absolutely wonderful and for that reason I allowed them to survive, despite feeling they were very decorative.'

17 Park Piece [311] 1971
Parkstück
Oil on canvas, 5 parts, overall size
250 × 626 (98½ × 246½)
Museum Moderner Kunst, Vienna, on loan to the Ludwig Collection, Aachen
Illustrated page 56

'This is based on a photograph of a park in Düsseldorf, where I was living at the time. At that time, I remember, it was quite fashionable to paint very large pictures. Purely on account of its size, a picture of these dimensions has an enormous presence when on display. It preceeded the Inpaintings and was an excuse to introduce gesture into paintings. With this painting, I just mixed up about twelve colours in large quantities and used those because it was a lot faster to paint that way. It was a commissioned work and after I had finished it, I still had quite a lot of paint left and made other paintings using whatever colours I had left. I made a three part, green Inpainting shortly after this, which I found interesting to make, using colour from somewhere else and applying it in this automatous fashion.'

18 48 Portraits [324a] 1972
Photographs, each 70 × 55 (27½ × 25⅝)
Stadt Aachen, Ludwig Forum
Illustrated pages 57–62

'Richter's last prints, the "48 Portraits" and the colour charts, push his earlier work in the print medium to a logical extreme, which may explain why he stopped making prints after 1974. The portraits (writers, composers, scientists, critics) are simply photographs after Richter's oil paintings shown at the Venice Biennale in 1972; they are not mediated by any other printing process, the photograph itself finally taking its place in Richter's work after ten years of being the visual provocation for paintings and prints. It should be pointed out that the sources for these portraits are encyclopedia and dictionary illustrations, photographic sources Richter rephotographed to use for his paintings, which he then photographed, the *ur*-photograph in this case becoming clearer rather than more blurred as the process continued. The "48 Portraits" thus reverse the situation described by Richter's early prints.' (Paoletti 1988, p.4)

19 Inpainting (Grey) [326/1–3] 1972
Vermalung (Grau)
Oil on canvas, 3 parts, each
250 × 250 (98½ × 98½)
Hessisches Landesmuseum, Darmstadt
Illustrated on page 63

'I applied the paint in evenly spaced patches, or blobs, on the canvas. Not following any system at all, there were black and white blobs of paint, which I joined up with a brush until there was no bare canvas left uncovered and all the colour patches were joined up and merged into grey. I just stopped when this was done.'

20 Inpainting (Grey) [326/4] 1972
Vermalung (Grau)
Oil on canvas 200 × 200
Jung Collection, Aachen
Illustrated page 64

see cat.19

21 Red-Blue-Yellow [330] 1972
Rot-Blau-Gelb
Oil on canvas 150 × 150 (59 × 59)
Di Bennardo Collection
Illustrated page 65

22 Grey [334/3] 1973
Grau
Oil on canvas 250 × 200 (98½ × 78¾)
Crex Collection, Hallen für neue Kunst, Schaffhausen
Illustrated page 66

see Richter's letter to E. de Wilde, p.112

'The paint for the Grey Paintings was mixed beforehand and then applied with different implements – sometimes a roller, sometimes with a brush. It was only after painting them that I sometimes felt that the grey was not yet satisfactory and that another layer of paint was needed.'

23 Annunciation after Titian [344/1] 1973
Verkündigung nach Tizian
Oil on canvas 150 × 250 (59 × 98½)
Crex Collection, Hallen für neue Kunst, Schaffhausen
Illustrated page 67

'This is one of the few occasions where I painted a series of paintings all relating to a single theme. My initial intention was to paint a copy of this beautiful Titian, which I saw in Venice, for myself, but I did not succeed. It developed into a series of works, because I was unable to copy the painting after several attempts, which were then destroyed through overpainting. The whole process probably lasted about two weeks. I was drawn to the theme of the Annunciation by the feeling that if anything could be intimated to me, it would be absolutely fantastic.'

24 Annunciation after Titian [344/2] 1973
Verkündigung nach Tizian
Oil on canvas 150 × 250 (59 × 98½)
Crex Collection, Hallen für neue Kunst, Schaffhausen
Illustrated page 68

see cat.23

25 Annunciation after Titian [344/3] 1973
Verkündigung nach Tizian
Oil on canvas 150 × 250 (59 × 98½)
Crex Collection, Hallen für neue Kunst, Schaffhausen
Illustrated page 69

see cat.23

26 Grey [348/3] 1973
Grau
Oil on canvas 250 × 200 (98½ × 78¾)
Private Collection
Illustrated page 70

see cat.22

27 Grey [348/7] 1973
Grau
Oil on canvas 90 × 65 (35½ × 25½)
Private Collection, on loan to the Kaiser Wilhelm Museum, Krefeld
Illustrated page 71

see cat.22

28 1024 Colours [350/4] 1973
1024 Farben
Gloss on canvas 254 × 478 (100 × 188¼)
Crex Collection, Hallen für neue Kunst, Schaffhausen
Illustrated page 72

'I painted these series of Colour Charts in the hope that they might be exhibited, which did not happen at the time. The size of the canvases, the design of the grids, as well as the size of the individual boxes were subjective decisions. I was helped while painting them by students who did much of the actual work applying the paint to the canvas. I had made smaller Colour Charts during the 1960s, which I did not feel were as successful as the later series, which are so strong and suggestive that it makes it difficult for them to be shown alongside other paintings. I made one painting with over four thousand colour boxes, directly abutting one another in quite an impressionistic way, but with each colour repeated four times. I hoped with my Colour Charts to retain a picture which stood up on its own.'

See Richter's text of 1974 on this series of Colour Charts, p.111 above.

29 Tourist (Grey) [368] 1975
Tourist (Grau)
Oil on canvas 200 × 200 (78¾ × 78¾)
Private Collection
Illustrated page 73

This series is based on photographs the artist found in *Stern* magazine. They depicted stills from an amateur video taken of an accident in a French safari park. A visitor to the park got out of his car and was subsequently mauled to death by the lions.

30 Tourist (with 2 Lions) [369] 1975
Tourist (mit 2 Löwen)
Oil on canvas 190 × 230 (74¾ × 90½)
Private Collection
Illustrated page 74

see cat.29

31 Tourist (with 1 Lion) [370] 1975
Tourist (mit 1 Löwe)
Oil on canvas 190 × 230 (74¾ × 90½)
Private Collection
Illustrated page 75

see cat.29

32 Tourist (with 1 Lion) [370/1] 1975
Tourist (mit 1 Löwe)
Oil on canvas 170 × 200 (67 × 78¾)
Private Collection
Illustrated page 76

see cat.29

33 Abstract Painting [432/11] 1978
Abstraktes Bild (Ölskizze)
Oil on canvas 52 × 78 (20½ × 30¾)
Tate Gallery, purchased 1979
Illustrated page 77

Richter characterised the importance of his small-scale sketches for the development of his Abstract Paintings in conversation with Sabine Schütz, saying the abstract works started 'in 1976 with small abstract paintings which allowed me to do all that which I had forbidden myself before: to put something down at random, and then to realise that it can never be random. This happened to open a door for me. If I don't know what is emerging, that is, if I don't have a fixed image, like with the photographs which I paint from, then randomness and chance play an important role.' (Interview with Sabine Schütz 1990, p.43)

34 Abstract Painting [439] 1978
Abstraktes Bild
Oil on canvas 200 × 300 (78¾ × 118)
Tate Gallery, purchased 1979
Illustrated page 78

35 Abstract Painting [456/2] 1980
Abstraktes Bild
Oil on canvas 65 × 80 (25⅝ × 31½)
Dieter Giesing
Illustrated page 79

This belongs to the first group of small-scale paintings where Richter began using spatulas to distribute colours. This has since become his most common technique.

36 Abstract Sketch [457/5] 1980
Abstrakte Skizze
Oil on wood 60 × 85 (25⅝ × 33½)
Private Collection
Illustrated page 80

In the mid 1970s Richter began making abstract paintings, which now comprise the most numerous body of work in his output. His uncertainty, following the extreme position of the Greys and other groups of work from the early 1970s, led him to make small-scale sketches, many subsequently destroyed, which served as models for larger paintings. When asked about the role of sketches and how he developed the possibilities offered by works in progress, he replied that he frequently returned to his paintings 'to look, until one suddenly knows what the painting needs. The sketches are important too; it is a maturation process. That is why each series (beginning with a studio full of empty canvases) takes such a long time – half a year.' (interview with Dorothea Dietrich, 1985, p.128)

37 Abstract Painting (July) [526] 1983
Abstraktes Bild (Juli)
Oil on canvas 250 × 250 (98½ × 98½)
Private Collection, Essen, Germany
Illustrated page 81

'The title was not given because it was painted during July. Rather, it was because it was first exhibited that month. It seemed to me that certain aspects connected with the colour and the forms within the painting reminded me of feelings connected with July, so I gave it that title. There are also other paintings which I called after the months, one called "June" and the more recent diptychs "November", "December" and "January". In the main, the reasons for giving them these titles are personal.'

38 Two Candles [546/1] 1983
Zwei Kerzen
Oil on canvas 125 × 100 (49¼ × 39⅜)
Private Collection, London
Illustrated page 82

39 Candle [546/2] 1983
Kerze
Oil on canvas 95 × 90 (37⅜ × 35½)
Private Collection, on loan to the Kaiser Wilhelm Museum, Krefeld
Illustrated page 83

40 Skull [548/1] 1983
Schädel
Oil on canvas 55 × 50 (21¾ × 19⅝)
Private Collection
Illustrated page 84

41 Abstract Painting [576/3] 1985
Abstraktes Bild
Oil on canvas 180 × 120 (70⅞ × 47¼)
Private Collection
Illustrated page 85

'In these paintings I did not apply paint across the canvas in one movement. At this time I also made a couple of enormous canvases for a private collection in Düsseldorf, where I applied paint to parts of the canvas, rather than everywhere at once. Here I was trying to combine constructive elements in paintings with areas which contained destructive elements – a balance between composition and anti-composition, if you like. In paintings such as "July", for example, there is something deconstructivist and oddly imbalanced along with something else which is carefully composed.'

42 Abstract Painting [581/6] 1985
Abstraktes Bild
Oil on canvas 60 × 60 (23⅝ × 23⅝)
Private Collection, London
Illustrated page 86

In 1985 Richter described his abstract works: he called them 'my presence, my reality, my problems, my difficulties and contradictions. They are very topical for me.' (Interview with Dorothea Dietrich, 1985, p.128)

43 Claudius [603] 1986
Oil on canvas 311 × 406 (122½ × 159⅞)
Helge Achenbach, Düsseldorf
Illustrated page 87

44 Abstract Painting [610/3] 1986
Abstraktes Bild
Oil on canvas 200 × 200 (78¾ × 78¾)
Private Collection
Illustrated page 88

In conversation, Richter described the development of chromatic relationships in his Abstract Paintings during the painting process: 'I still have somehow to bring everything into the right relation. A relation that becomes more and more difficult the further a picture has progressed. At the beginning everything is still easy and indefinite, but gradually relations emerge that register as appropriate ones: that is the opposite of randomness.' (Interview with Benjamin H.D. Buchloh, 1988, p.24)

45 Cathedral Corner [629/1] 1987
Domecke
Oil on canvas 122 × 87 (48 × 34½)
Private Collection
Illustrated page 89

The photograph for this work, taken by the artist, depicts a corner of Cologne Cathedral.

46 Marcay [642/1] 1987
Oil on canvas 72 × 102 (28⅜ × 40⅛)
Private Collection
Illustrated page 90

Richter has continued to paint realistic landscapes and still lifes alongside his abstract paintings of the last fifteen years. He explained their role in a recent interview: 'landscapes or still lifes I paint in between the abstract works; they constitute about one-tenth of my production. On the one hand they are useful, because I like to work from nature – although I do use a photograph – because I think that any detail from nature has a logic I would like to see in abstraction as well. On the other hand, painting from nature or painting still lifes is a sort of diversion, creates a balance. If I were to express it somewhat informally, I would say that the landscapes are a type of yearning for a whole and simple life. A little nostalgic.' (Interview with Dorothea Dietrich, 1985, p.128)

47 Fortress at Königstein [651/2] 1987
Schloss Königstein
Oil on canvas 52 × 72 (20½ × 28⅜)
Private Collection, London
Illustrated page 91

48 St John [653/4] 1988
Oil on canvas 200 × 260 (79 × 102½)
*Tate Gallery, presented by the Patrons of
New Art through the Friends of the Tate
Gallery 1988*
Illustrated page 92

'St John' belongs to a group of works called
the 'London Paintings', which were exhi-
bited in London during 1988. The title,
along with the others of the series called 'St
James' [653/1], 'St Andrew' [653/2] and 'St
Bridget' [653/3] refer, along with the related
oil 'Sanctuary' [655], to chapels at West-
minster Abbey in London. The titles are not
meant to be descriptive, but refer merely to
associations connected with the artist's visits
to London and his experience of the city. A
further series, called 'Towers', relates in a
similar manner to other architectural land-
marks in London.

49 Betty [663/5] 1988
Oil on canvas 102 × 72 (40¼ × 28⅜)
Anthony d'Offay Gallery, London
Illustrated page 93

This picture is based on a photograph of the
artist's daughter Betty. A number of photo-
graphic facsimiles, rephotographed from the
painting, are currently being overpainted, in
the manner of Richter's treatment of recent
photographs he has taken of candles, self-
portraits, buildings and other motifs. These
groups of works derived from single images
might be termed 'unique prints'. In 1977
Richter painted two pictures from photo-
graphs of Betty [435/4 and 435/5] and in
1989 also overpainted small polaroid photo-
graphs of her.

50 Uran 1 (Abstract Painting)
[688/1] 1989
Uran 1 (Abstraktes Bild)
Oil on canvas 92 × 126 (36¼ × 49⅝)
Private Collection, Cologne
Illustrated page 94

51 Uran 2 (Abstract Painting)
[688/2] 1989
Uran 2 (Abstraktes Bild)
Oil on canvas 92 × 126 (36¼ × 49⅝)
Private Collection, Cologne
Illustrated page 95

52 Abstract Painting [695] 1989
Abstraktes Bild
Oil on canvas, 2 parts, overall size
250 × 680 (98½ × 189)
*St Gallen Graduate School of Economics,
Law, Business and Public Administration*
Illustration page 98

This is the largest of a group of sombre,
predominantly black and white abstract
paintings. They were made shortly after
Richter's monochrome cycle of fifteen
paintings '18 October 1977' about the death
of three of the Baader-Meinhof group in
Stammheim prison on that date. This work
was painted as a commission for St Gallen
University. Other related Abstract Paint-
ings include 'Uran 1' (cat.51) and 'Uran 2'
(cat.52) and the three diptychs 'November'
[701], 'December' [700] and 'January' [699],
now in the collection of the St Louis
Museum of Art.

53 Abstract Painting [726] 1990
Abstraktes Bild
Oil on canvas 250 × 350 (98½ × 137¾)
*Private Collection, Courtesy Anthony
d'Offay Gallery, London*
Illustrated page 100

54 Forest [731] 1990
Wald
Oil on canvas 340 × 260 (133⅞ × 102⅜)
Frances and John Bowes Collection
Illustrated page 101

'I called this series of four paintings
"Forest" after completion. There was no
ironic meaning intended, because of their
first exhibition in a show called "Metropo-
lis". There seemed to me a romantic mood
in these four paintings that reminded me of
a forest. In the blue, there is the sensation of
a diffuse light, which is why I came upon
this title. I applied the paint across the
canvas in two separate movements; across
the middle one can see a caesura.'

55 Forest [732] 1990
Wald
Oil on canvas 340 × 260 (133⅞ × 102⅜)
Durand-Dessert Galerie, Paris
Illustrated page 102

see cat.54

56 Forest [733] 1990
Wald
Oil on canvas 340 × 260 (133⅞ × 102⅜)
Durand-Dessert Galerie, Paris
Illustrated page 103

see cat.54

57 Forest [734] 1990
Wald
Oil on canvas 340 × 260 (133⅞ × 102⅜)
Durand-Dessert Galerie, Paris
Illustrated page 104

see cat.54

58 Mirror Painting [Grey 739/2] 1991
Spiegel Bild
Pigment on glass 110 × 100 (43½ × 39½)
Anthony d'Offay Gallery, London
Illustrated page 105

59 Abstract Painting [743/3] 1991
Abstraktes Bild
Oil on canvas 200 × 140 (78¾ × 55)
Private Collection
Illustrated page 106

60 Abstract Painting [747/1] 1991
Abstraktes Bild
Oil on canvas 200 × 200 (78¾ × 78¾)
Durand-Dessert Galerie, Paris
Illustrated page 107

Biography

1932	Born in Dresden
1951–56	Studied at the Kunstakademie in Dresden
1961	Moved to Düsseldorf
1961–63	Studied at the Kunstakademie in Düsseldorf
1967	Junger Western Art Prize, Recklinghausen
1967	Guest Professor at the Hochschule für Bildende Kunst in Hamburg
since 1971	Professor at the Kunstakademie in Düsseldorf
1978	Guest Professor at the College of Art, Halifax, Canada
1981	Arnold Bode Prize, Kassel
1985	Oskar Kokoschka Prize, Vienna
	Has lived in Cologne since 1983

Bibliography

Compiled by Helen Douglas of the Tate Gallery Library based on information supplied by Gerhard Richter.

1 Statements by the artist, and interviews
2 Books and sections in books
3 One-man exhibitions: catalogues and related publications
4 Group exhibitions: published catalogues
5 Periodical and newspaper articles

Section 2 is arranged in alphabetical order; all other sections are arranged chronologically.

1 Statements by the artist, and interviews

Gerhard Richter, *Bericht über eine Demonstration* [flier for event with Konrad Leug, *Demonstration für den Kapitalistischen Realismus*, held at Düsseldorf, Möbelhaus Berges, 1963].

Dieter Hülsmanns, 'Das perfekteste Bild' [interview], *Rheinische Post*, 3 May 1966.

Rolf Schön, 'Unser Mann in Venedig' [interview], *Deutsche Zeitung*, 14 April 1972, p.13.

Mathias Schreiber, [interview], *Kölner Stadtanzeiger*, 14 June 1972.

Peter Sager, 'Gespräch mit Gerhard Richter' [interview], *Das Kunstwerk*, vol.25, July 1972, pp. 16–17.

Irmeline Leeber, 'Gerhard Richter ou la réalité de l'image' [interview], *Chronique de l'Art Vivant*, no.36, Feb. 1973, pp.13–16.

Wulf Herzogenrath, *Selbstdarstellung: Künstler über sich*. Düsseldorf: Droste Verlag, c.1973. Includes two letters from the artist, pp.18–19.

Gislind Nabakowski, 'Interview mit Gerhard Richter über die "Verkündigung nach Tizian"', *Heute Kunst*, July–Aug. 1974, pp.3–5.

Gerhard Richter, [statement] in: *Fundamentale Malerei – Fundamental painting* [catalogue], Amsterdam, Stedelijk Museum, 1975, p.57.

Marlies Grüterich, [interview] in: *Poetische Aufklärung in der europäischen Kunst der Gegenwart* [catalogue], Zurich, InK-Halle für Internationale Kunst, 1978–9, pp.87–8.

Gerhard Richter, [statement] in: *Pier and Ocean* [catalogue]. London, Hayward Gallery, 1980, p.114.

Armine Haase, 'Malerei als Schein' [interview] in: *Gespräche mit Künstlern*. Cologne, Wienand, 1981, pp.112–17.

Armine Haase, 'Interview zur Verleihung des Documenta-Preises', *Kölner Stadtanzeiger*, 15 Sept. 1982.

Bruno Corà, [interview] in: *Terrae Motus* [catalogue]. Naples, Fondazione Amelio 1984, p.145.

Wolfgang Pehnt and Werner Kruger, [interview] in: Wolfgang Pehnt and Werner Kruger, *Künstler im Gespräch*. Cologne, 1984, pp.122–31.

Vincent Chappey, 'Kevin Wagner Brei: Gerhard Richter.' Video cassette. *Des Arts*, April 1984, (no.2).

Dorothea Dietrich, 'Gerhard Richter: An Interview', *The Print Collector's Newsletter*, vol.16, Sept.–Oct. 1985, pp.128–32.

Christiane Vielhaber, 'Interview mit Gerhard Richter', *Das Kunstwerk*, vol.39, April 1986, pp.41–3.

Gerd Courts, 'Kölner Tischgespräche' [interview], *Kölner Stadtanzeiger*, 12–13 Sept. 1987.

Benjamin H.D. Buchloh, 'Gerhard Richter: Legacies of Painting', in: Jeanne Siegel (ed.), *Art Talk: The Early 80s*. New York: Da Capo Press, c.1988, pp.105–18.

Jan Thorn-Prikker, 'Gerhard Richter/Jan Thorn-Prikker: Ruminations on the October 18, 1977 Cycle' [interview], *Parkett*, vol.19, March 1989, pp.143–53.

Gregorio Magnani, 'Gerhard Richter' [interview concerning Richter's series of paintings based on the Baader-Meinhof group], *Flash Art*, no.146, May–June 1989, pp.94–7.

Gerhard Richter, [statement in *Flash Art* reprint, September–October, 1972], *Flash Art*, no.149, Nov.–Dec. 1989, pp.110–11.

Sabine Schütz, 'Gerhard Richter' [interview], *Journal of Contemporary Art*, vol.3, no.2, Winter 1990, pp.34–46.

Johnas Storsve, 'Gerhard Richter la peinture à venir' [Interview], *Art Press*, no.161, September 1991, pp.12–20.

2 Books and sections in books

Block, René, *Grafik des Kapitalischen Realismus: K.P. Brehmer, Hödicke, Lueg, Polke, Richter, Vostell*. Berlin: the Author, 1971.

Butin, Hubertus, *Zu Richters Oktober-Bildern*. Cologne: Verlag der Buchhandlung Walther König, 1991 (Schriften zur Sammlung des Museums für Moderne Kunst Frankfurt am Main).

Dienst, Rolf-Gunter, *Deutsche Kunst: Eine neue Generation*. Cologne: M. Dumont Schauberg, 1970.

Faust, Wolfgang Max, *Gerhard Richter*. In: *Hunger nach Bildern*. Cologne: Dumont, 1982, pp.42–48.

Fuchs, R.H. *Isa Genzken: Gerhard Richter*. Rome: Mario Pieroni, 1983.

Grasskamp, Walter, 'Gerhard Richter: Verkündigung nach Tizian', in: *Der vergeßliche Engel, Künstlerportraits für Fortgeschrittene*. Munich: Schreiber, 1986, pp.44–61.

Grohmann, Willi, *Kunst unserer Zeit*. Cologne: Dumont, 1966.

Honnef, Klaus, *Gerhard Richter: Recklinghausen: Bongers*, [1976] (Monographien zur Rheinisch-Wesfälischen Kunst der Gegenwart; Bd. 50).

Kultermann, Udo, *Neue Formen des Bildes*. Tübingen: Ernst Wasmuth, 1969.

Lippard, Lucy R., *Pop Art*. London: Thames & Hudson, 1966.

Loock, Ulrich and Denys Zacharopoulos, *Gerhard Richter*. Munich: Verlag Silke Schreiber, 1985.

Nasgaard, Roald, *Gerhard Richter: Paintings*, with an essay by Michael Danoff and an interview with Gerhard Richter by Benjamin H.D. Buchloh. London: Thames & Hudson, 1988.

Ohff, Heinz, *Galerie der neuen Künste*. Gütersloh: [s.n.], 1971.

Ohff, Heinz, *Über die Notwendigkeit von Krokodilen in der Kunst oder der Kapitalistische Realismus (Eröffnungsrede)*. Berlin: Galerie Block, 1964.

Ohff, Heinz, *Von Krokodilen und anderen Künstlern*. Berlin: Galerie Arts Viva, [1982].

Richter, Gerhard, *Eis (1973/1981)*. Rome: Galleria Pieroni, 1981. Artist's book.

Richter, Gerhard, *Gerhard Richter*; con testo di Giorgio Cortenova. [Florence]: Edizioni Masnata-Spagnoli, 1975. Published on the occasion of the exhibition at the Gallery Renzo Spagnoli, Florence, Jan. 1976 and later at Galleria La Bertesca, Genoa, 1976.

Richter, Gerhard, *128 Details from a Picture (Halifax 1978)*. Halifax: Press of the Nova Scotia College of Art and Design, 1978.

Roh, Juliane, *Deutsche Kunst der 60er Jahre*. Munich: F. Bruckmann, 1971.

Rorimer, Anne, 'The Illusion and the reality' [Gerhard Richter], in: Rosemarie Schwarzwälder, *Abstrakte Malerei aus Amerika und Europa – Abstract painting of America and Europe*. Vienna: Galerie Nächst St Stephan; Klagenfurt: Ritter Verlag, c.1988, pp.95–102.

Sager, Peter, *Neue Formen des Realismus*, Cologne: [s.n.], 1973.

Thomas-Netik, Anja, *Gerhard Richter: Mögliche Aspekte eines postmodernen Bewußtseins*. Essen: Verlag Die Blaue Eule, 1986. Kunstgeschichte und Theorie; Bd. 7.

Wilmes, Ulrich, *Gerhard Richter: Eine Einführung in sein Werk und Schaffen*. Frankfurt am Main: Deutsche Bank AG, *c*.1989.

Zacharopulos, Denys, 'Abstract Paintings' [Gerhard Richter], in: *Abstrakte Malerei aus Amerika und Europa/ Abstract painting of America and Europe*. Rosemarie Schwarzwälder, Vienna: Galerie Nächst St Stephen; Klagenfurt: Ritter Verlag, *c*.1988, pp.109–123.

3 One-man exhibitions: catalogues and related publications

1964

Sept. Düsseldorf, Galerie Schmela, *Gerhard Richter*.

Nov.–Jan. Berlin, Galerie Block, *Gerhard Richter*. Includes text by Manfred de la Motte.

1966

Oct. Munich, Galerie Friedrich & Dahlem, *Gerhard Richter*.

1967

May–June. Munich, Galerie Heiner Friedrich, *Richter*.

1968

July–Aug. Cologne, Galerie Zwirner, *Gerhard Richter: Exhibition of Work*.

1970

Oct. Essen, Museum Folkwang, *Gerhard Richter: Graphik u. Studien 1965–1970*. Includes text by Dieter Honisch.

1971

June–Aug. Düsseldorf, Kunstverein für die Rheinlande und Westfalen, *Gerhard Richter: Arbeiten 1962 bis 1971*. Includes texts by Karl-Heinz Hering and Dietrich Helms.

1972

Dec. Utrecht, Hedendaagse Kunst-Utrecht, *Atlas van der foto's en schetsen*.

1973

May–July. Munich, Städtische Galerie im Lenbachhaus, *Gerhard Richter*. Includes text by Jean-Christophe Ammann.

Sept.–Nov. New York, Onnasch Gallery, *Exhibition of Paintings 1962–73*. Private view card and list of works shown only, a catalogue was not published for this exhibition.

1974

Dec.–Jan. Mönchengladbach, Städtisches Museum, *Gerhard Richter: Graue Bilder*. Includes text by Johannes Cladders.

1975

Nov.–Jan. Bremen, Kunsthalle, *Gerhard Richter: Bilder aus den Jahren 1962–1974*. Texts by Manfred Schneckenburger and Marlies Grüterich.

1976

Jan. Florence, Renzo Spagnoli, *Gerhard Richter*. Includes texts by Giorgio Cartenova and the artist.

Feb.–Mar. Krefeld, Museum Haus Lange, *Gerhard Richter: Atlas der Fotos, Collagen und Skizzen*. Text by Gerhard Storck.

1977

Feb.–Mar. Paris, Centre Georges Pompidou, *Gerhard Richter*. Includes text by Benjamin H.D. Buchloh.

1978

Sept.–Oct. Nottingham, Midland Group, *Gerhard Richter: 48 Portraits*.

Oct.–Nov. Eindhoven, Van Abbemuseum, *Gerhard Richter: Abstract Paintings*. Travelling to London, Whitechapel Gallery. Includes texts by Rudi Fuchs and Benjamin H.D. Buchloh.

1979

Mar.–Apr. London, Whitechapel Art Gallery, *Gerhard Richter: Abstract Paintings*. Includes texts by Rudi Fuchs and Benjamin H.D. Buchloh.

1980

June–Aug. Essen, Museum Folkwang, *Gerhard Richter: Zwei gelbe Striche*. Introduction by Zdenek Felix.

1981

Jan.–Feb. Milan, Padiglione d'Arte Contemporanea dei Milano, *Gerhard Richter*. Text by Bruno Corà.

1982

Jan.–Feb. Bielefeld, Kunsthalle, *Gerhard Richter: Abstrakte Bilder 1976–1981*. Travelling to Mannheim, Kunstverein. Includes text by Heribert Heere.

1984

St Etienne, Musée d'Art et d'Industrie, *Gerhard Richter*.

1985

Jan.–Feb. Stuttgart, Staatsgalerie, *Gerhard Richter: Aquarelle*. Introduction by Ulrich Loock.

Mar. New York, Marian Goodman Gallery/Sperone Westwater Gallery, *Gerhard Richter*. Text by Benjamin H.D. Buchloh.

1986

New York, Barbara Gladstone Gallery; Rudolf Zwirner Gallery, *Gerhard Richter: Paintings 1964–1974*. Includes essay by Rudi Fuchs.

Jan.–Mar. Düsseldorf, Städtische Kunsthalle, *Gerhard Richter: Bilder/Paintings 1962–1985*. Cologne: Dumont Verlag, 1986. Travelling to Berlin, Berne and Vienna. Includes text by Jürgen Harten.

Apr. Berlin, Galerie Michael Haas, *Gerhard Richter*.

1987

Feb.–Apr. Amsterdam, Museum Overholland, *Gerhard Richter: Werken op Papier 1983–1986*. Introduction by Christian Braun; includes text by the artist.

Mar.–Apr. New York, Marian Goodman Gallery & Sperone Westwater Gallery, *Gerhard Richter: Paintings*. Includes texts by Anne Rorimer and Denys Zacharopoulos.

July–Aug. London, Karsten Schubert, *Gerhard Richter: Works on Paper 1984/6*.

Oct.–Nov. Cologne, Galerie Rudolf Zwirner, *Gerhard Richter: 20 Bilder*.

1988

Jan. Munich, Galerie Fred Jahn, *Gerhard Richter: Neun Bilder 1982–1987*.

Mar.–Apr. London, Anthony d'Offay Gallery, *Gerhard Richter: The London Paintings*. Includes text by Jill Lloyd.

Mar.–Apr. Paris, Galerie Liliane & Michel Durand-Dessert, *Gerhard Richter*. Includes text by Denys Zacharopoulos.

Apr.–July. Toronto, Art Gallery of Ontario, *Gerhard Richter: Paintings*. Travelling to: Chicago, Museum of Contemporary Art; Washington, Hirshhorn Museum and Sculpture Garden; and San Francisco Museum of Modern Art. Text edited by Terry A. Neff; includes an interview with the artist by Benjamin H.D. Buchloh and texts by Michael Danoff and Roald Nasgaard.

1989

Feb.–Apr. Krefeld, Museum Haus Esters, *Gerhard Richter: 18 Oktober 1977*. Travelling to Frankfurt am Main, Krefeld, London, Saint Louis, New York, Los Angeles, Boston. Includes texts by Gerhard Storck, Stefan Germer and Benjamin H.D. Buchloh.

Aug.–Oct. Munich, Städtische Galerie im Lenbachhaus, *Gerhard Richter: Atlas*. Munich: Verlag Fred Jahn, *c*.1989. Travelling to Cologne. Edited by Fred Jahn; includes text by Armin Zweite.

Sept.–Oct. Kansas City, Nelson-Atkins Museum of Art, *Gerhard Richter*. Text by Deborah Emont Scott.

Oct.–Dec. Rotterdam, Museum Boymans-van Beuningen, *Gerhard Richter: 1988/89*. Introduction by Karel Schampers; essays by Anna Tilroe and Benjamin H.D. Buchloh.

1991

Jan.–Mar. Manchester, Whitworth Art Gallery, *Gerhard Richter*.

Apr.–June. London, Anthony d'Offay Gallery, *Gerhard Richter: Paintings, Sculpture, Mirrors*.

Sept.–Oct. Paris, Galerie Liliane & Michel Durand-Dessert, *Gerhard Richter*.

4 Group exhibitions: published catalogues

1966

Mar. Hanover, Galerie h, *Polke/Richter*.

1969

June–July. Lucerne, Kunstmuseum, *Düsseldorfer Szene*. Includes text by Jean-Christophe Ammann.

1971

Berlin, Onnasch-Galerie, *20 Deutsche*. Includes text by Klaus Honnef.

1972

June–Oct. Venice, Biennale, *Gerhard Richter: 36th Biennale in Venice, German Pavilion*.

June–Oct. Kassel, *Documenta 5*.

1974

Jan.–Feb. Brussels, Palais des Beaux-Arts, *Andre, Broodthaers, Buren, Burgin, Gilbert & George, Richter*. Includes statement by the artist.

1975

Apr.–June. Amsterdam, Stedelijk Museum, *Fundamentale Schilderkunst/Fundamental Painting*. Includes statement by the artist.

1976

Berlin, René Block, *K.P. Brehmer, K.H. Hödicke, Sigmar Polke, Gerhard Richter, Wolf Vostell: Werkverzeichnisse der Druckgrafik: Band II: September 1971 bis Mai 1976*. Berlin: Edition René Block, 1976. Introduction by René Block.

Aug.–Oct. Mönchengladbach, Städtisches Museum, *Räume: Carl Andre, Marcel Broodthaers, Daniel Buren, Hans Hollein, Bruce Nauman, Gerhard Richter, Ulrich Rückriem: (Beleg III)*. Includes statement by Gerhard Richter.

1977

June–Oct. Kassel, *Documenta 6*. Includes text by Klaus Honnef.

Oct.–Nov. Chicago, Art Institute, *Europe in the Seventies: Aspects of Recent Art*. Travelling to Washington, San Francisco, Fort Worth and Cincinnati. Includes texts by Jean-Christophe Ammann, David Brown, Rudi Fuchs and Benjamin H.D. Buchloh.

1978

Nov.–Jan. Zurich, InK-Halle für Internationale Neue Kunst, *Poetische Aufklärung in der europäischen Kunst der Gegenwart*. Includes an interview by Marlies Grüterich with the artist.

1980

London, Hayward Gallery, *Pier + Ocean: Construction Art of the Seventies*. Travelling to Otterlo. Exhibition selected by Gerhard von Graevenitz assisted by Norman Dilworth.

1981

Aachen, Sammlung Ingrid und Hugo Jung, Suermondt-Ludwig Museum, *Tendenzen der modernen Kunst*. Includes text by Renate Puvogel.

Jan.–Mar. London, Royal Academy of Arts, *A New Spirit in Painting*.

May–July. Düsseldorf, Städtische Kunsthalle, *Georg Baselitz – Gerhard Richter*. Includes text by Jürgen Harten.

1982

Kassel, Neue Galerie, Staatl u. Städt. Kunstsammlung, *Kunst der Sechziger Jahre in der Neuen Galerie Kassel*. Includes text by Bernhard Schnackenburg.

Jan.–Mar. New Haven, Yale University Art Gallery, *German Drawings of the 60s*. Includes text by Dorothea Dietrich-Boorsch.

June–Sept. Kassel, *Documenta 7*. Includes text by the artist.

July.–Sept. Basel, Kunsthalle, *Werke aus der Sammlung Crex*. Text by Jean-Christophe Ammann.

1983

Rome, Galleria Mario Pieroni, [Untitled: Isa Genzken – Gerhard Richter].

1984

Bonn, Städtisches Kunstmuseum, *Sammlung deutscher Kunst seit 1945*. Includes text by Dierk Stemmler.

Hanover, Sprengel Museum, *Nackt in der Kunst des 20. Jahrhunderts*. Includes text by Udo Liebelt.

Naples, Fondazione Amelio Instituto per l'Arte Contemporanea, *Terrae Motus*.

Sept.–Dec. Düsseldorf, Messegelände Halle 13, *Von hier aus: Zwei Monate neue deutsche Kunst in Düsseldorf*. Cologne: Dumont, 1984. Herausgeber, Kasper König.

1985

Turin, Palazzo dela Società Promotrice delle Belle Arti, *Rheingold*.

Wiesbaden, Museum Wiesbaden, *Modus Vivendi: Elf deutsche Maler*.

Berlin, Nationalgalerie, *1945–1985: Kunst in der Bundesrepublik Deutschland*.

June–July. Münster, Westfälischer Kunstverein, *Wasserfarbenblätter von Joseph Beuys, Nicola De Maria, Gerhard Richter, Richard Tuttle*. Introduction by Marianne Stockebrand.

Oct.–Dec. London, Royal Academy of Arts, *German Art in the 20th Century*. Travelling to Stuttgart, Staatsgalerie.

1986

Hanover, Sprengel Museum, *Positionen: Malerei aus der Bundesrepublik Deutschland*. Includes an essay by Klaus Honnef.

1987

Rome, Galleria Mario Pieroni, *Isa Genzken e Gerhard Richter*.

Feb.–Apr. London, Goethe-Institut, *Watercolours by Joseph Beuys, Blinky Palermo, Sigmar Polke, Gerhard Richter*. Introduction by Marianne Stockebrand.

June–Sept. Kassel, *Documenta 8*. Includes text by Roald Nasgaard.

1988

Oct.–Jan. Toledo, Ohio, Toledo Museum of Art, *Refigured Painting: The German Image 1960–88*. New York: Solomon R. Guggenheim Museum; Munich: Prestel, 1989. Travelling to New York, Solomon R. Guggenheim Museum, Williamstown, Düsseldorf and Frankfurt. Includes text by Michael Govan.

1991

May–July. Preston, Harris Museum and Art Gallery, *Models of Reality: Approaches to Realism in Modern German Art*. Travelling to Hull, Ferens Museum and Art Gallery. Includes text by Angelika Stepken.

5 Periodical and newspaper articles

Manfred de la Motte, 'Gibt es einen "Kapitalistischen Realismus"?', *Der Tagesspiegel (Berlin)*, 18 Sept. 1964.

John Anthony Thwaites, 'Last Summer on the Rhine and Ruhr', *Studio International*, vol.169, Jan. 1965, pp.16–21.

Pierre Restany, 'Mechanische Malerei', *Das Kunstwerk*, vol.20, Feb.–Mar. 1967, pp.3–19.

Rolf-Gunter Dienst, 'Lettre d'Allemagne', *Aujourd'hui*, vol.10, Oct. 1967, pp.194–9.

Jürgen Hohmeyer, 'Richter: Wenns's Knallt', *Der Spiegel*, no.34, 1968, pp.90–1.

Edward F. Fry, 'Gerhard Richter: German Illusionist', *Art in America*, vol.57, Nov.–Dec. 1969, pp.126–7.

Klaus Honnef, 'Gerhard Richter im Kunstverein Düsseldorf', *Magazin Kunst*, no.43, 1971, pp.2408–14.

Peter Sager, 'Neue Formen des Realismus', *Magazin Kunst*, no.44, 1971, pp.2533–9.

Hanno Reuther, 'Fenster in die schöne Welt: Die Malerei Gerhard Richters im Düsseldorfer Kunstverein', *Frankfurter Rundschau*, 3 July 1971.

Daniel Abadie, 'Gerhard Richter ou le saisissement du réel', *Lettres Françaises*, 23 Aug. 1972.

Klaus Honnef, 'Problem Realismus: Die Medien des Gerhard Richter', *Kunstforum*, bd. 4/5, 1973, pp.68–91.

Karl Bühlmann, 'Dokumente zur Relativität der Realität', *Luzerner Neueste Nachrichten*, 22 Jan. 1973, p.5.

Theo Kneubühler, 'Stil ist Gewalt', *Vaterland*, 23 Jan. 1973, p.11.

Klaus Honnef, 'Richter's New Realism', *Art and Artists*, vol.8, Sept. 1973, pp.34–7.

Jean-Christophe Ammann, 'Gerhard Richter', *Art International*, vol.17, Sept. 1973, pp.25–8.

Peter Stitelmann, [review of exhibition, New York, Onnasch Galerie], *Arts Magazine*, vol.48, Dec. 1973, pp.58–9.

James Collins, [review of exhibition, Onnasch Galerie, New York], *Artforum*, vol.12, Jan. 1974, pp.72–3.

Heiner Stachelhaus, 'Doubts in the Face of Reality: The Paintings of Gerhard Richter', *Studio International*, vol.184, Sept. 1974, pp.76–80.

Rolf Wedewer, 'Zum Landschaftstypus Gerhard Richters', *Pantheon*, vol.33, Jan.–Mar. 1975, pp.41–49.

Wolf Schön, 'Auf der Flucht. Gerhard Richter in der Bremer Kunsthalle' [review of exhibition], *Deutsche Zeitung*, 5 Nov. 1975.

Petra Kipphoff, 'Kissenkunst: Zerrissene Realität' [review of exhibition, Bremen, Kunsthalle], *Die Zeit*, 19 Dec. 1975, p.36.

Laszlo Glozer, 'Meister der Unschärfe', *Süddeutsche Zeitung (München)*, 9 Jan. 1976, p.14.

Peter Winter, 'Gerhard Richter' [review of exhibition, Bremen, Kunsthalle], *Das Kunstwerk*, vol.29, Jan. 1976, pp.62–3.

Peter Winter, [review of exhibition, Kunsthalle Bremen], *Pantheon*, vol.34, Apr. 1976, pp.141–2.

Axel Heinrich Murken; Christa Murken-Altrogge, 'Künstler die wichtigsten Leute der Welt', *Deutsches Ärzteblatt Ärztliche Mitteilungen*, vol.LXXIV, 1977, pp. 967–70, 1039–42, 1101–8.

Axel Heinrich Murken, 'Auf der Suche nach der Wirklichkeit: Das Menschenbildnis im künstlerischen Werk von Gerhard Richter', *Der Kunst und das Schöne Heim*, vol.89, Jan. 1977, pp.29–32.

O. Hjort, 'Mellem Virkeligheden og Reproduction', *Louisiana Revy*, vol.17, Feb. 1977, pp.10–11.

T. Worsel, 'Notes om Tysk Kunst', *Louisiana Revy*, vol.17, Feb. 1977, p.32.

P. Winter, 'Karrig, Alvorlig og Koelig', *Louisiana Revy*, vol.17, Feb.1977, pp.18–23.

Jan van der Marck, 'Inside Europe, outside Europe', *Artforum*, vol.16, Jan. 1978, pp.49–55.

Vivien Raynor, [review of exhibition, New York, Sperone Westwater Fischer Gallery], *New York Times*, 20 Jan. 1978, p.c18.

I. Michael Danoff, 'Report from Chicago: "Europe in the Seventies"', *Art in America*, vol.66, Jan.–Feb. 1978, p.57.

Barbara Flynn, [review of exhibition, New York, Sperone Westwater Fischer Gallery], *Artforum*, vol.16, Apr. 1978, p.62.

Valentin Tatransky, [review of exhibition, New York, Sperone Westwater Fischer Gallery], *Arts Magazine*, vol.52, Apr. 1978, p.29.

I. Michael Danoff, 'Richter: Multiple Styles', *Arts Magazine*, vol.52, June 1978, pp.150–1.

Marlies Grüterich, 'Poetische Aufklärung in der Europäischen Kunst der Gegenwart', *Kunstforum*, bd. 30, June 1978, pp.203–8.

Dieter Honisch, 'What is Admired in Cologne, May Not be Accepted in Munich', *Art News*, vol.77, Oct. 1978, pp.62–7.

Hamish Fulton, [review of exhibition, London, Whitechapel Art Gallery], *Arts Review*, vol.31, Apr. 1979, p.186.

Emmanuel Cooper, [review of exhibition, London, Whitechapel Art Gallery], *Art and Artists*, vol.14, May 1979, p.50.

Wulf Herzogenrath, 'Monumente – Denkmal', *Kunstforum*, bd. 37, Jan. 1980, pp.159–91.

William Zimmer, 'Richter Scaled' [review of exhibition, New York, Sperone Westwater Fischer Gallery], *The Soho Weekly News*, 20 Feb. 1980, p.23.

Claire Hague Moore, [review of New York exhibition], *Art World*, vol.4, Feb.–Mar. 1980, p.8.

Thomas Lawson, [review of New York exhibition], *Flash Art*, no.96, Mar.–Apr. 1980, p.18.

Jürgen Hohmeyer, 'Strich am Bau', *Der Spiegel*, 9 June 1980, p.202–3.

Micky Piller, [review of exhibition, Essen, Museum Folkwang], *Artforum*, vol.19, Nov. 1980, pp.95–6.

Y. Friedrichs, 'Georg Baselitz, Gerhard Richter' [review of exhibition, Düsseldorf, Kunsthalle], *Das Kunstwerk*, vol.34, Aug. 1981, pp.80–1.

Armine Haase, 'Wechselnd wild und schön hässlich: Die Paradoxe junge deutsche Malerei und ihre expressionistischen Stiefväter', *Kunstforum*, bd.47, Dec. 1981–Jan. 1982, pp.125–8.

Angeli Jahnsen, "Abstrakte Bilder 1976–1981' [exhibition review, Bielefeld, Kunsthalle], *Die Weltkunst*, vol.52, no.4, 15 Feb. 1982, pp.290–1.

'Gerhard Richter: "Abstrakte Bilder"', *Domus*, no.626, Mar. 1982, pp.70–1.

Peter Winter, 'Gerhard Richter: Abstrakte Bilder 1976–1981' [review of Bielefeld exhibition], *Das Kunstwerk*, vol.35, April 1982, pp.64–5.

P.M. Pickshaus, 'Gerhard Richter: Abstrakte Bilder 1976–1981' [review of exhibition, Bielefeld, Kunsthalle], *Kunstforum*, bd.49, Apr.–May 1982, pp.220–1.

Bernard Blistène, 'Gerhard Richter: Réflexion sur l'échec de la peinture', *Art Press*, no.67, Feb. 1983, pp.23–6.

Susan A. Harris, [review of exhibition, New York, Sperone Westwater Fischer Gallery], *Arts Magazine*, vol.57, Mar. 1983, pp.35–6.

Kate Linker, [review of New York exhibition], *Artforum*, vol.21, Apr. 1983, pp.71–2.

Peter Bode, 'Immer Anders, immer er Selbst', *Art: Das Kunstmagazin*, no.5, May 1983, pp.46–61.

A. Pohlen, 'The Beautiful and the Ugly Pictures: Some Aspects of German Art – The Found and the Constructed Pictures, *Art and Text*, nos.12–13, Summer 1983–Autumn 1984, pp.60–73.

W. Timm, 'Ostdeutsche Galerie Regensburg: So Sammelm Wir', *Kunst und das Schöne Heim*, vol.95, Sept. 1983, pp.17–24, 654.

U. Giersch, 'On Steps', *Daidalos*, no.9, 15 Sept. 1983, pp.22–33.

Martin Hentschel and Ulrich Loock, 'Gerhard Richter', *Artistes*, no.17, Dec. 1983, pp.36–42.

Denys Zacharopoulos, [review of exhibition, Paris, Musée d'Art et d'Industrie], *Artforum*, vol.22, June 1984, p.101.

Ekkehard Mai, 'Künstlerateliers als Kunstprogramm – Werkstatt Heute', *Das Kunstwerk*, vol.37, June 1984, p.43.

Stephan Schmidt-Wulffen, [review of exhibition, Wilkens/Jacob Gallery, Cologne], *Flash Art*, vol.120, Jan. 1985, pp.48–9.

'Eastern Lights, Western Lights', *Artforum*, vol. 23, Jan. 1985, pp.67, 69, 71.

Rolf-Gunter Dienst, 'Der künstliche Dschungel' [review of exhibition, Stuttgart, Staatsgalerie], *Frankfurter Allgemeine Zeitung*, 13 Feb. 1985.

Gary Indiana, 'Living with Contradictions' [review of exhibition, New York, Marian Goodman Gallery; Sperone Westwater Gallery], *Village Voice*, 26 Mar. 1985, p.91.

Rolf-Gunter Dienst, 'Aquarelle' [review of exhibition, Graphische Sammlung der Staatsgalerie Stuttgart], *Das Kunstwerk*, vol.38, Apr. 1985, pp.85–6.

Wilfried W. Dickhoff, 'Gerhard Richter: "Malen ist eine moralische Handlung', *Wolkenkratzer*, no.7, Apr.–June 1985, pp.34–41.

Coosje van Bruggen, 'Gerhard Richter: Painting as a Moral Act', *Artforum*, vol.23, pt.9, May 1985, pp.82–91.

Karen Wilkin, 'The Iceberg Show' [review of exhibition, Toronto, Art Gallery of Ontario], *Art News*, vol.84, May 1985, p.113.

'Multiples & Objects & Books', *The Print Collector's Newsletter*, vol.16, May–June 1985, p.59.

Phyllis Derfner, [review of exhibition, New York, Marian Goodman Gallery; Sperone Westwater Fischer Gallery], *Art in America*, vol.73, Sept. 1985, pp.138.

Martin Hentschel and Ulrich Loock, 'Gerhard Richter: Retrospektive in Düsseldorf 17.1.–16.3', *Nike*, no.11, Dec. 1985–Feb. 1986, pp.10–15.

Nena Dimitrijevic, 'German Art in the Twentieth Century' [London, Royal Academy of Arts, travelling exhibition], *Flash Art*, vol.26, Feb.–Mar. 1986, p.54.

Cynthia Nadelman, 'A Star-struck Carnegie International' [review of exhibition, Pittsburgh], *Art News*, vol.85, Mar. 1985, pp.115–18.

Bernard Blistène, 'Gerhard Richter ou l'abstraction de soi', *Artstudio*, no.1, Spring 1986, pp.72–9.

Barbara Dieterich, 'Retrospectiva de Gerhard Richter' [review of exhibition, Düsseldorf, Städtische Kunsthalle], *Goya*, vol.191, Mar.–Apr. 1986, pp.298–9.

Paul Taylor, 'Cafe Deutschland' [post-Neo-expressionism in Germany], *Art News*, vol.85, Apr. 1986, pp.68–76.

Renate Puvogel, 'Bilder 1962–1985' [review of exhibition, Düsseldorf, Städtische Kunsthalle], *Das Kunstwerk*, vol.39, Apr. 1986, pp.60–1.

David Galloway, 'Taking Stock' [two diametrically opposed surveys of twentieth-century German art: London, Royal Academy: Berlin, Nationalgalerie], *Art in America*, vol.74, May 1986, pp.28–39.

Anelie Pohlen, [review of exhibition, Düsseldorf, Städtische Kunsthalle], *Artforum*, vol.24, May 1986, p.148.

Walter Grasskamp, 'Gerhard Richter: An Angel Vanishes', *Flash Art*, no.128, May–June 1986, pp.30–5.

Nena Dimitrijevic, 'Alice in Culturescapes: The Fetish Status of Painting is Stronger than Ever', *Flash Art*, no.129, July–Aug. 1986, pp.50–4.

Stephen Ellis, 'The Elusive Gerhard Richter', *Art in America*, vol.74, Nov. 1986, pp.130–9, 186.

Peter Sager, 'Mit der Farbe denken', *Zeit Magazin*, no.49, 28 Nov. 1986, pp.24–34.

Roberta Smith, '17 Early Paintings by Gerhard Richter' [review of exhibition], *New York Times*, 2 Jan. 1987, p.c22.

Anna Tilroe, 'Werken op Papier van Gerhard Richter' [review of exhibition, Amsterdam, Museum Overholland], *De Volkskrant*, 20 Feb. 1987, p.20.

Roberta Smith, 'At Two Galleries, Gerhard Richter Works' [review of exhibition, New York, Marian Goodman Gallery; Sperone Westwater Gallery], *New York Times*, 13 Mar. 1987.

Shaun Caley, [review of exhibition, New York, Barbara Gladstone Gallery], *Flash Art*, vol.133, Apr. 1987, p.90.

David Cameron, 'Seven Types of Criticality', *Arts Magazine*, vol.61, May 1987, pp.14–17.

Enrique Garcia-Herraiz, [review of exhibition, New York, Marian Goodman Gallery], *Goya*, vol.198, May–June 1987, pp.364–5.

Ken Sofer, 'Gerhard Richter' [review of New York exhibition], *Art News*, vol.191, Summer 1987, p.201.

Donald B. Kuspit, [review of New York exhibition], *Artforum*, vol.25, Summer 1987, pp.115–16.

William Zimmer, 'Paintings by Richter in the Atheneum Exhibition', *New York Times*, 9 Aug. 1987.

Roberta Smith, 'Flirting with All Styles but Embracing None' [review of exhibition, Hartford Atheneum, 1987], *New York Times*, 23 August 1987, Section 2, pp.27–29.

Jill Lloyd, [review of exhibition, London, Karsten Schubert Gallery], *Burlington Magazine*, vol.129, Sept. 1987, pp.612–13.

Werner Krüger, 'Das Mass zwischen Freiheit und Form' [review of exhibition, Galerie Rudolf Zwirmer, Cologne], *Kölner Stadt-Anzeiger*, 8 Oct. 1987, p.22.

Christian Bernard, 'Gerhard Richter: Ema (Nu dans an un escalier)', *Art Press*, no.120, Dec. 1987, pp.88–9.

Ulrich Wilmes, 'Gerhard Richter', *Künstler: Kritisches Lexikon der Gegenwartskunst*, Aug.3, 1988, pp.1–16.

Marina Vaizey, 'Nurturing Talent in a Narrow Frame' [review of exhibition, London, Anthony d'Offay Gallery], *Sunday Times*, 13 Mar. 1988.

Richard Dorment, 'Commercial Face of Contemporary Art' [review of exhibition, London, Anthony d'Offay Gallery], *Daily Telegraph*, 23 Mar. 1988.

Peter Day, 'On the Richter Scale' [interview with Roald Nasgaard, Director of the Art Gallery of Ontario on the occasion of the Gerhard Richter retrospective exhibition], *Canadian Art*, vol.5, Mar. 1988, pp.80–5.

John T. Paoletti, 'Gerhard Richter: Ambiguity as an Agent of Awareness', *The Print Collector's Newsletter*, vol.19, Mar.–Apr. 1988, pp.1–6.

Roald Nasgaard, 'Art as the Highest Form of Hope', *AGO News*, vol.10, Apr. 1988, pp.1–2.

Mary Rose Beaumont, [review of exhibition, London, Anthony d'Offay Gallery], *Arts Review*, vol.40, 8 Apr. 1988, p.233.

John Bentley Mays, 'As Chips and Pop Go, so Goes Art?' [review of exhibition, Art Gallery of Ontario, Toronto], *The Globe and Mail*, 30 April 1988, p.c15.

Michael Archer, [review of exhibition, London, Anthony d'Offay Gallery], *Art Monthly*, no.115, Apr. 1988, pp.14–15.

Bernard Blistène, 'Méchanique et manuel dans l'art de Gerhard Richter', *Galeries Magazine*, no.24, Apr.–May 1988, pp.90–5, 137, 141.

Sean Rainbird, 'Gerhard Richter at Anthony d'Offay' [review of exhibition, London, Anthony d'Offay Gallery], *The Burlington Magazine*, vol.130, May 1988, pp.389–90.

Hugh Adams, [review of exhibition, London, Anthony d'Offay Gallery], *New Art Examiner*, vol.15, May 1988, p.54.

Alan G. Artner, 'Richter's Scale' [review of exhibition, Museum of Contemporary Art, Chicago], *Chicago Tribune*, 25 Sept. 1988, pp.12–13.

Peggy Cyphers, [review of exhibition, New York, David Nolan Gallery], *Arts Magazine*, vol.63, Sept. 1988, p.100.

Jeanne Siegel, 'Meta-abstraction' [The Image of Abstraction: Los Angeles, Museum of Contemporary Art], *Arts Magazine*, vol.63, Oct. 1988, pp.48–51.

Michael Kimmelmann, 'Style as Contradiction of Style' [review of exhibition, Washington, Hirshhorn Museum and Sculpture Garden], *New York Times*, 17 Dec. 1988.

Jane Addams Allen, 'Enigmatic Gerhard Richter: Trapped in a Prison of Mirrors' [review of exhibition, Hirshhorn Museum and Sculpture Garden, Washington], *Washington Times*, 19 Dec. 1988, p.D2.

Viola Herms Drath, 'Ein neutraler Maler', *Handelsblatt*, 23 Jan. 1989.

Jürgen Hohmeyer, 'Das Ende der RAF: Gnädig Weggemalt', *Der Spiegel*, 13 Feb. 1989, pp.226–32.

Bertram Müller, 'Der Tod der Terroristen', *Rheinische Post*, 15 Feb. 1989.

Michael Hübl, 'The Melancholist of Virtuosity', *Art News*, vol.88, Feb. 1989, pp.120–5.

Claudia Steinberg, 'Made in Germany' [review of exhibition, Vierzig deutsche Maler, New York, Solomon R. Guggenheim Museum], *Pan*, no.2, 1989, pp.100–5.

Jan Thorn-Prikker, 'Gerhard Richter: 18 October 1977', *Parkett*, no.19, Mar. 1989, pp.140–2.

Günther Engelhard, '"18. Oktober 1977"', *Rheinischer Merkur*, no.9, 18 Mar. 1989.

Georg Imdahl, 'Die Grauen Bilder vom Untergang der Terroristen', *Westdeutsche Allgemeine*, 21 Mar. 1989.

Hans Brender, 'Stammheim ist verdrängt und aktuell wie alles unerledigte', *Deutsche Volkszeitung*, 24 Mar. 1989.

William Wilson, 'Gerhard Richter's Hat Trick' [review of exhibition, San Francisco Museum of Modern Art], *Los Angeles Times*, 26 Mar. 1989, pp.88–90.

Peter Dittmar, 'Die erneute Erfindung der Historienmalerei?', *Die Welt*, 31 Mar. 1989.

Jean-Michel Foray, 'Du musee au site – et retour', *Cahiers du Musée National d'Art Moderne*, no.27, Spring 1989, pp.76–83.

Lewis Kachur, [review of exhibition, Chicago, Museum of Contemporary Art], *Art International*, no.6, Spring 1989, pp.64–5.

Benjamin H.D. Buchloh, 'A Note on Gerhard Richter's "October 18, 1977"', *October*, no.48, Spring 1989, pp.86–109.

Glen Helfand, 'A Single-minded Pluralist' [review of exhibition, San Francisco Museum of Modern Art], *Artweek*, vol.20, Apr. 1989, p.1.

Angeli Jahnsen, '"18 Oktober 1977"', *Weltkunst*, 1 Apr. 1989.

Elisabeth Kiderlen, 'Kein Requiem', *Pflasterstrand (Frankfurt)*, 20 Apr. 1989, pp.28–30.

Ulrich Wilmes, 'Anschläge auf die Wahrnehmung', *Pflasterstrand (Frankfurt)*, 20 Apr. 1989, pp.32–3.

Hansgünther Heyme, '"Trauerarbeit der Kunst muss sich klarer geben"', *Art: Das Kunstmagazin*, no.4, Apr. 1989, pp.14–15.

Gregorio Magnani, [review of exhibition, Krefeld, Museum Haus Esters], *Arts Magazine*, vol.63, May 1989, pp.118–19.

Martin Hentschel, 'Gerhard Richter' [review of exhibition, Krefeld, Museum Haus Esters], *Artforum*, vol.27, May 1989, p.167.

Martin Bochynek, '"18 Oktober 1977"', *Wolkenkratzer*, no.3, May–June 1989, pp.74–5.

Karen Wilkin, 'Refiguring the Guggenheim' [review of exhibition, New York, Solomon R. Guggenheim Museum], *The New Criterion*, vol.7, June 1989, pp.51–5.

Pia Phora, 'Gerhard Richter: 18 Octobre 1977', *Arte Factum*, vol.6, June–July–Aug. 1989, p.51.

Christian Huther, 'Gerhard Richter: 18 Oktober 1977' [review of exhibition, Krefeld, Museum Haus Esters], *Kunstforum*, bd.102, July–Aug. 1989, pp.351–2.

Bettina Semmer, '18 Oktober 1977', *Artscribe*, no.76, Summer 1989, pp.68–9.

Kenneth Baker, 'Abstract jestures [comic abstraction]', *Artforum*, vol.28, Sept. 1989, pp.134–8.

Isabelle Graw, 'Gerhard Richter: 18 Oktober 1977', *Artscribe*, no.77, Sept.–Oct. 1989, pp.7–9.

Luk Lambrecht, 'Overwegingen van een Schilder', *Knack*, 8 Nov. 1989.

Christoph Hahn, 'Gerhard Richters Radikale Offenheit', *Aachener Nachrichten*, 9 Nov. 1989.

Viktoria von Flemming, 'Stürzen, Kippen, Fallen, Sinken: Neue Bilder von Gerhard Richter', *Frankfurter Allgemeine Zeitung*, 17 Nov. 1989.

J.V.H., 'Prachtige Abstraktie van Gerhard Richter', *De Standaard*, 17 Nov. 1989.

'Recent Work by Gerhard Richter' [review of exhibition, Rotterdam, Museum Boymans-van Beuningen], *Flash Art*, no.149, Nov.–Dec. 1989, p.157.

Johannes Meinhardt, 'Gerhard Richter, 18 Oktober 1977', *Zyma*, no.5, Nov.–Dec. 1989, pp.2–6.

James Hall, 'Germany: Richter's Baader-Meinhof Paintings', *Art International*, vol.9, Winter 1989, p. 19.

Tony Godfrey, [review of exhibition, London, Institute of Contemporary Art], *The Burlington Magazine*, vol.131, Dec. 1989, pp.862–3.

Donald B. Kuspit, 'Gerhard Richter's Doubt and Hope', *C Magazine*, no.20, Dec. 1988, [Winter 1989], pp.18–24.

Wolfgang Röller, 'Ohne Rücksicht auf menschliche Empfindungen', *Frankfurter Allgemeine Zeitung*, 29 Dec. 1989.

Christopher Phillips, [review of installation, Munich, Städtische Galerie im Lenbachhaus], *Art in America*, vol.78, Jan. 1990, p.169.

William Feaver, [review of exhibition, London, Institute of Contemporary Art], *Art News*, vol.89, Jan. 1990, p.180.

Christopher Knight, 'Powerful Works on the Richter Scale', *Los Angeles Times*, 14 Jan. 1990.

Susan Tallman, 'Gerhard Richter 1988/89' [review of exhibition, Rotterdam, Museum Boymans-van Beuningen], *Arts Magazine*, vol.64, Feb. 1990, p.110.

Roger Bevan, [review of exhibition, New York, Marian Goodman Gallery; Sperone Westwater Fischer Gallery], *The Burlington Magazine*, vol.132, Feb. 1990, pp.161–2.

Michael Brenson, 'A Concern with Painting the Unpaintable', *New York Times*, 25 Mar. 1990.

Elizabeth Lebovici, 'Un Peu trop', *Artstudio*, no.16, Spring 1990, pp.120–7.

Peter Schjeldahl, 'Death and the Painter' [review of exhibition, New York, Grey Art Gallery], *Art in America*, vol.78, Apr. 1990, pp.248–57.

Donald B. Kuspit, 'All our Yesterdays' [review of exhibition, New York, Grey Art Gallery], *Artforum*, vol. 28, Apr. 1990, pp.129–32.

Kim Levin, 'Belief is Dangerous', *Village Voice*, 3 Apr. 1990.

Hilton Kramer, [Gerhard Richter], *New York Observer*, 23 Apr. 1990.

Barry Schwabsky, [review of exhibition, New York, Marian Goodman Gallery; Sperone Westwater Fischer Gallery, Grey Art Gallery], *Arts Magazine*, vol.64, May 1990, p.91.

'Hearts of Gold', *Performing Arts*, June 1990.

Catherine Grout, 'Le Paysage en question', *Arte Factum*, no.34, June–Aug. 1990, pp.11–14.

Maja Damjanovic, 'Gerhard Richter' [review of exhibition, New York, Grey Art Gallery], *Tema Celeste*, no.26, July–Oct. 1990, p.65.

Lee Montgomery, 'West German's Work Opens L.A.'s Lannan Foundation', *News Pilot (San Pedro)*, 6 July 1990.

Suzanne Muchnic, 'A Showcase for Controversial Art in Marina del Rey', *Los Angeles Times*, 10 July 1990.

Robert L. Pincus, 'Richter's "Oktober" a Perplexing View of the Baader-Meinhof Gang', *San Diego Union*, 22 July 1990.

Ralph Rugoff, 'Eulogy in Gray: Baader-Meinhof's Red Oktober', *LA Weekly*, 10–16 Aug. 1990.

James Lewis, 'Gerhard Richter: The Problem of Belief', *Art Issues*, Summer 1990.

Peter Chametsky, [review of exhibition, New York, Grey Art Gallery], *Zyma*, no.4, Sept.–Oct. 1990, pp.37–40.

Susan Tallman, 'Collectibles' [editions of artists' toys, artists' furniture, artists' housewares], *Arts Magazine*, vol.65, Oct. 1990, pp.23–4.

Peter Winter, [review of exhibition, Cologne, Museum Ludwig], *Art International*, vol.12, Autumn 1990, p.71.

Lenders

Stadt Aachen, Ludwig Forum 18
Helge Achenbach, Düsseldorf 43
Anthony d'Offay Gallery, London 49, 58
Di Bennardo Collection 21
Frances and John Bowes Collection 54
Crex Collection, Hallen für neue Kunst, Schaffhausen, Switzerland 11, 22, 23,
 24, 25, 28
Hessisches Landesmuseum, Darmstadt 19
Durand-Dessert Galerie, Paris 55, 56, 57, 60
Albert Eickhoff, Düsseldorf 15
Städelsches Kunstinstitut Frankfurt am Main, on loan from the Stadtsparkasse
 Frankfurt am Main 10
Dieter Giesing 35
Jung Collection, Aachen 20
Massimo Martino S.A. 6, 16
Städt. Museum Leverkusen, Schloß Morsbroich 8
Barbara Nüsse Collection 4
Private Collection 1, 2, 5, 7, 13, 14, 26, 27, 29, 30, 31, 32, 36, 37, 38, 39, 40, 41,
 42, 44, 45, 46, 47, 50, 51, 53, 59
Kunsthalle Recklinghausen 9
St. Gallen Graduate School of Economics, Law, Business and Public
 Administration 52
Tate Gallery 33, 34, 48
Museum Moderner Kunst, Vienna 17
City of Weisbaden 3
Wiesbaden Museum 12

Photographic Credits

Achenbach Art Consulting; Anthony d'Offay Gallery; Carlo Catenazzi, Art Gallery of Ontario; Christie's Colour Library; Crex Collection, Hallen für neue Kunst; Prudence Cuming & Associates Ltd.; Städelsches Kunstinstitut, Frankfurt; Simone Gänsheimer; Anne Gold; Städtische Galerie im Lenbachhaus, Munich; Massimo Martino S.A.; Vera Munro Gallery; Kunsthalle Recklinghausen; Friedrich Rosenstiel; Walter Scholz-Ruhs, Museum Wiesbaden; Galerie Stähl; Tate Gallery Photographic Department; Museum Moderner Kunst, Vienna; John Webb.

The Friends of the Tate Gallery

Since their formation in 1958, the Friends of the Tate Gallery have helped to buy major works of art for the Tate Gallery Collection, from Stubbs to Hockney.

Members are entitled to immediate and unlimited free admission to Tate Gallery exhibitions with a guest, invitations to previews of Tate Gallery exhibitions, opportunities to visit the Gallery when closed to the public, a discount of 10 per cent in the Tate Gallery shop, special events, *Friends Events* and *Tate Preview* magazines mailed three times a year, free admission to exhibitions at Tate Gallery Liverpool, and use of the new Friends Room at the Tate Gallery which opens in November 1991.

Three categories of higher level memberships, Associate Fellow at £100, Deputy Fellow at £250, and Fellow at £500, entitle members to a range of extra benefits including guest cards, and invitations to exclusive special events.

The Friends of the Tate Gallery are supported by Tate & Lyle PLC.

PATRONS

The Patrons of British Art support British painting and sculpture from the Elizabethan period through to the early twentieth century in the Tate Gallery's Collection. They encourage knowledge and awareness of British Art by providing an opportunity to study Britain's cultural heritage.

The Patrons of New Art support contemporary art in the Tate Gallery's Collection. They promote a lively and informed interest in contemporary art and are associated with the Turner Prize, one of the most prestigious awards for the visual arts.

Benefits for both groups include invitations to Tate Gallery receptions, an opportunity to sit on the Patrons' acquisitions committees, special events including visits to private and corporate collections and complimentary catalogues of Tate Gallery exhibitions.

Further details on the Friends and the Patrons may be obtained from:

Friends of the Tate Gallery
Tate Gallery
Millbank
London SW1P 4RG

Tel: 071–821 1313 or 071–834 2742

Tate Gallery Foundation

The Tate Gallery is one of the great museums of the world. It houses the National Collections of British Art since 1550, including the Turner Bequest, and of International Twentieth-Century Painting and Sculpture. Today, the Gallery attracts an ever-increasing number of visitors who enjoy its lively exhibition and education programmes.

Income is raised through a variety of methods, including commercial sponsorship, appeals, corporate membership, a bequest programme and donations from trusts, foundations, corporations and individuals. The Tate Gallery Foundation (charity registration number 295549) was established in 1986 to support the fund-raising activities of the Tate Gallery.

Tate Gallery Foundation

Patron
HRH The Duchess of York

Chairman
Mr Robert Horton

Trustees
Sir Richard Attenborough CBE
Mr Gilbert de Botton
Mr John Botts
Mr Richard Lay
Mrs Sandra Morrison
Mr Dennis Stevenson CBE
Mr David Verey
The Hon Mrs Robert Waley-Cohen

Sponsorship

Tate Gallery, London – Sponsorships since 1988

Academy (Art & Design Magazine)
 1988, Academy Forums
Henry Ansbacher & Co plc
 1988, *Turner and the Human Figure* exhibition
AT&T
 1988, *David Hockney: A Restrospective* exhibition
Barclays Bank plc
 1991, *Constable* exhibition
British Gas plc
 1989, Education study sheets
British Gas North Thames
 1989, *Colour into Line: Turner and the Art of Engraving* exhibition
The British Land Company plc
 1990, *Joseph Wright of Derby* exhibition
The British Petroleum Co plc
 1989, *Paul Klee* exhibition
 1990–93, *New Displays*
British Steel plc
 1989, *William Coldstream* exhibition
Carroll, Dempsey & Thirkell
 1990, *Anish Kapoor* exhibition
Channel 4 Television
 1991–93, The Turner Prize
Clifton Nurseries
 1988–90. Sponsorship in kind
Daimler Benz
 1991, *Max Ernst* exhibition
Debenham Tewson & Chinnocks
 1990, Turner *Painting and Poetry* exhibition
Digital Equipment Co Ltd
 1991, *From Turner's Studio* touring exhibition
Donaldsons
 1988, *Hans Hofmann* exhibition
Drexel Burnham Lambert
 1987–88, The Turner Prize
Drivers Jonas
 1989, *Turner and Architecture* exhibition
Erco Lighting
 1989, Sponsorship in kind
Gerald Metals Limited
 1986–88, education and contemporary art exhibitions programme
Global Asset Management Ltd
 1988, *Late Picasso* exhibition
Hepworth & Chadwick
 1988, *Turner and Natural History* exhibition
KPMG Management Consulting
 1991, *Anthony Caro: Sculpture towards Architecture* exhibition
Linklaters & Paines
 1989, Japanese Guide to Turner Bequest
Lin Pac Plastics
 1989, Sponsorship in kind
Olympia & York
 1990, Frameworkers Conference
PA Consulting Group
 1988, *Turner's Wilson Sketchbook* publication
 1989, Video projector
Plessey plc
 1988, Sponsorship in kind

Pro Helvetia Foundation
 1988, *Agasse* exhibition
Reed International plc
 1990, *On Classic Ground* exhibition
SRU Ltd
 1989, Market research consultancy
Swissair
 1988, *Agasse* exhibition
Tate & Lyle PLC
 1991–93, Friends relaunch marketing programme
UBS Philips & Drew
 1988, *Turner at Petworth* publication
Ulster Television plc
 1989, *F.E. McWilliam* exhibition
Volkswagen
 1989–92, The Turner Scholarships
Westminster City Council
 1989, Trees project
 1989, *The Tate Gallery Companion* (New Display Guidebook)

Tate Gallery Liverpool – Sponsorships since 1988

Ashton-Tate UK Ltd
 1988, *ICAN* exhibition
Australian Bicentennial Authority
 1988, *Angry Penguins* exhibition
Barclays Bank plc
 1989, Sculpture for the visually impaired
BASF
 1990, *Lifelines* exhibition
Becks Beer
 1990, *Lifelines* exhibition
British Alcan
 1991, *Dynamism* and *Giacometti* exhibitions
British Telecom
 1989, Salary for media van
 1990, Outreach Programme
Cultural Relations Committee, Department of Foreign Affairs, Ireland
 1991, *Strongholds* exhibition
DDB Needham Worldwide
 1988, Advertising campaign
Granada Television
 1990, *New North* exhibition
IBM UK Ltd
 1988, Commission of Invention of Tradition for the opening of Tate Gallery Liverpool
ICI Chemicals & Polymers
 1988, *Starlit Waters* exhibition
Merseyside Development Corporation
 1989, Outreach Programme for two years
Miller & Santhouse plc
 1989, Sculpture show for visually impaired
Mobil Oil Company Ltd
 1990, *New North* exhibition
Momart plc
 1989–92, Artist-in-residence at Tate Gallery Liverpool
P & P Micro Distributors
 1988, *ICAN* exhibition
Volkswagen
 1988, Opening events
 1988, Loan of media van

Donations

Towards Acquisitions for the Archive

The Sir Nicholas and Lady Goodison Charitable
 Settlement
The Henry Moore Foundation

Towards Acquisitions for the British Collection

Miss Marjorie Ball
Mr Edwin C. Cohen
Echoing Green Foundation
Ernst & Young
Friends of the Tate Gallery
Mrs Sue Hammerson
National Art-Collections Fund
National Art-Collections Fund (Woodroffe Bequest)
National Heritage Memorial Fund
The Mail on Sunday
The Patrons of British Art
Mr John Ritblat

Towards Acquisitions for the Modern Collection

Miss Nancy Balfour
Mr Tom Bendhem
Mr Gilbert de Botton
Mr Edwin C. Cohen
Mr Paul Dupee
Evelyn, Lady Downshire's Trust Fund
Friends of the Tate Gallery
General Atlantic Corporation
Sir Anthony and Lady Jacobs
National Art-Collections Fund
The Mail on Sunday
Jill Ritblat
The Hon. Simon Sainsbury
Mr Barry and The Hon. Mrs Townsley

Towards Projects and Activities at Tate Gallery, London

BAA plc
Clifton Nurseries
Mrs Dagny Corcoran
The Elephant Trust
The Gabo Trust
The Getty Foundation
The Getty Grant Program
Mr and Mrs John Hughes
The Leverhulme Trust
Linklaters and Paines
Mr and Mrs Robert Mnuchin
The Henry Moore Foundation
The Henry Moore Sculpture Trust
Save & Prosper Educational Trust
SRU Ltd

Towards Projects and Activities at Tate Gallery Liverpool

Anonymous donor
The Baring Foundation
Blankstone, Sington & Co.
Ivor Braka Ltd
British Rail Board
Mr and Mrs Henry Cotton
Fraser Williams Group
Goethe Institute, Manchester
Merseyside Development Corporation
The Henry Moore Foundation
The Henry Moore Sculpture Trust
The Pilgrim Trust
Save & Prosper Educational Trust
Stanley Thomas Johnson Stiftung Foundation
Yale University Press

Towards Buildings at Tate Gallery, London

The Esmée Fairbairn Charitable Trust
Calouste Gulbenkian Foundation
Clothworkers Foundation
The Nomura Securities Co. Ltd
Anthony d'Offay Gallery
The Office of Arts and Libraries
The Rayne Foundation
Dr Mortimer and Theresa Sackler Foundation
Waddington Galleries
Westminster City Council

Towards Buildings at Tate Gallery Liverpool

Arrowcroft Group Ltd
The Baring Foundation
Barclays Bank plc
British Gas plc
Clothworkers Foundation
The John S. Cohen Foundation
Deloitte, Haskins & Sells
The Esmée Fairbairn Charitable Trust
Granada Television and the Granda Foundation
Higsons Brewery plc
The Idlewild Trust
Kodak Ltd
The John Lewis Partnership
The Liverpool Daily Post and Echo
The Manor Charitable Trust
The Henry Moore Foundation
The Moores Family Charitable Foundation
The New Moorgate Trust Fund
Ocean Group plc
Pilkington plc
The Pilgrim Trust
Plessy Major Systems (Liverpool)
Eleanor Rathbone Charitable Trust
Royal Insurance (UK) Ltd
The Sainsbury Family Charitable Trusts

The Bernard Sunley Charitable Trust
The TSB Foundation
United Biscuits UK Ltd
Whitbread & Co plc
The Wolfson Foundation

Towards the Tate Gallery St Ives Appeal

Viscount Amory Charitable Trust
Barbinder Trust
Barclays Bank plc
The Baring Foundation
Patricia, Lady Boyd and Viscount Boyd
British Telecom plc
Cable & Wireless plc
Christie, Manson & Woods Ltd
The John S. Cohen Foundation
Cornish Brewery Co. Ltd (in kind)
English China Clays Group Charitable Trust
The Esmée Fairbairn Charitable Trust
The Worshipful Company of Fishmongers
J. Paul Getty Jr Charitable Trust
Grand Metropolitan Charitable Trust
The Landmark Trust
David Messum Fine Paintings
The Henry Moore Foundation
D'Oyly Carte Charitable Trust
Pall European Limited
The Pilgrim Trust
The Sainsbury Family Charitable Trusts
Southwestern Electricity Board
South West Gas
South West Water
Television South West
The TSB Foundation
Western Morning News, West Briton, Cornish
 Guardian and The Cornishman
Mr and Mrs Graham Williams

Tate Gallery, London – Corporate Members

Partners

Barclays Bank plc
The British Petroleum Co
Manpower UK
THORN EMI

Associates

Channel 4 Television
Debenham Tewson & Chinnocks
Ernst & Young
Global Asset Management
Lazard Brothers & Co. Ltd
Tate & Lyle PLC
Unilever